The Art of Black and White Photography

Born in Duesseldorf, Germany in 1956, Torsten Andreas Hoffmann is the internationally renowned photographer and author of illustrated books on New York, Paris, Rome, and the Himalayas.

Having spent his educational years studying art and majoring in photography, Hoffmann has dedicated most of his life to this craft. He is a teacher of workshops on composition and black and white photography, and shows his students how to find their own individual style.

Hoffmann specializes in the medium of black and white photography, as well as in the field of conceptual photography. His stunning photographs have been shown in numerous exhibitions in Germany and abroad, and have been published in many well-known magazines.

In addition to his many books, he regularly writes articles on picture design for the popular German magazine "Photographie", and he is a regular contributor to LFI, the highly acclaimed international journal published by Leica.

Torsten Andreas Hoffmann

The Art of Black and White Photography

Techniques for Creating Superb Images in a Digital Workflow

rockynook

Torsten Andreas Hoffman, info@t-a-hoffmann.de

Editor: Gerhard Rossbach
Copyeditor: Carey Feldstein and Joan Dixon
Layout and Type: Nadine Berthel
Cover Design: Helmut Kraus, www.exclam.de
Cover Photo: Torsten Andreas Hoffman
Printer: Friesens Corporation, Altona, Canada
Printed in Canada

ISBN 978-1-933952-27-7

1st Edition
© 2008 by Rocky Nook Inc.
26 West Mission Street Ste 3
Santa Barbara, CA 93101

www.rockynook.com

Library of Congress Cataloging-in-Publication Data

Hoffmann, Torsten Andreas, 1956-
 [Kunst der Schwarzweissfotografie. English]
 The art of black and white photography : techniques for
creating superb images in a digital workflow / Torsten Hoffmann.
-- 1st ed.
 p. cm.
 ISBN 978-1-933952-27-7 (alk. paper)
 1. Photography--Digital techniques. 2. Black-and-white photography. I. Title.
 TR267.H645513 2008
 778.3--dc22

2008013912

Distributed by O'Reilly Media
1005 Gravenstein Highway North
Sebastopol, CA 95472

Table of Contents

Introduction **1**

The Image in the Digital Age ... 2

Technical Information in this Book .. 2

New Filter Mode Starting with Photoshop CS3 3

Emphasize Expression ... 3

Section 1 Tools and Fundamentals **5**

1 Choosing a Good Digital Camera **7**

APS Sensors .. 8

Full Format Sensors .. 8

Which Sensor Should You Use? .. 9

Advantages and Disadvantages of Compact Cameras 9

2 An Essential Rule for Digital Black and White Photography:
Always Photograph in RAW Mode **11**

3 Drama Through the Use of Filters **15**

Examples of Color Filter Effects—The Same Subject Taken
with Different Filters ... 16

Filters in Digital Photography .. 19

The Polarizing Filter .. 19

Digital Drama with Photoshop CS2 and Earlier Versions 20

Infrared Simulation with Photoshop CS2 22

The Gradient Filter ... 24

Section 2 Photographic Genres and Concepts 29

4 Overcoming Clichéd Photos 31
Reduction Instead of Postcard Cliché 32
From Clichéd Photo to Personal Expression 33

5 Why Are Moods So Important? 39
Three Photos, One Place ... 40
Mood In a Minor Key .. 41
Distanced Coolness ... 42

6 Street Photography 45
A Foot Before Setting it Down ... 46
Jumping Child ... 47
The People in Front of the Government Building 49
Mysterious Couple ... 49
Calvin Klein ... 50
Hitchcock Atmosphere ... 52

7 What Does Landscape Photography Mean in the 21ˢᵗ Century? 53
Unspoiled Landscape With Tuareg .. 55
Persons and Landscape on Lanzarote 56
Abstractions in the Sahara ... 56
Death of Nature ... 57
Idyllic Seascape with Airplane .. 58
Landscape with Mattress ... 59

8 Architectural Photography 61
Photographing Architecture Digitally 63
Man and Modern Architecture ... 64
Concentrated Effect with Telephoto Lenses 65
Modern Glass Architecture ... 66
Model as Window Dressing .. 67

9 The Graphic Element in Black and White Photography 69
Light and Shadow as Basis of Compositional Design 71
Reduction to Verticals and Horizontals 72
The Lively Finishing Touch ... 73
Lounge Chair on the Crosswalk ... 74
Iron Footbridge ... 75

10 The Poetry of Melancholic Moods **77**

Rainy Beach ... 78

Irish Gravity ... 79

The Moment as Metaphor 80

Youth by the Fence ... 81

Madonna in the Parking Lot 82

Fog in Turkey .. 83

11 Abstracts **85**

Traces of Time .. 87

Light and Shadow ... 88

Formalism With and Without Content 89

Structures as Fantasy Stimulators 90

12 Surreal Photography **91**

Yoga ... 92

Cemetery Tombs with Volcano 93

Gate to Another World 95

Train Station Without Tracks 96

Absurd Concrete Surface 97

View in the Distance 98

13 Portraits **99**

Indian Tribesman ... 100

The Other Side of the Coin 102

The Beauty of Old Age 103

Finding the Essential in the Fleeting 104

Woman's Fate in India 104

It's Easier with People You Know 105

14 Man and Surroundings **107**

In the Shadow of the Bronx 109

Nun in Times Square 110

Man and Real Estate 111

Indian Yogi ... 111

Two Smoking Breaks 113

15 Mystical Photography **115**

Sign ... 117

Angel as Symbolic figure 118

Transience .. 119

Stony Spiral in the Sea 120

Enigmatic Relic ... 121

Cross in the Sky .. 122

16 Panoramic Photography **123**

Rotating Cameras Generate Curves 124

Straight Horizon in the Upper Section Tool 125

A Highly Interesting Panoramic Horizontal Format Composition 126

Vertical Use of a Panoramic Camera 127

Panoramic Photography Done Digitally with Photomerge 128

Section 3 Rules of Composition **133**

17 What is Pictorial Composition? **135**

Condensing an Event to a Composition 136

Landscape is More Patient 138

Details Lead to Perfection 139

Getting to the Heart of an Image 141

18 The Golden Ratio and the Elementary Construction **143**

New York Water Tank ... 144

Wave Entering the Window 146

The Axial Symmetry of Modern Architecture 146

New York Street Scene ... 148

19 Triangular Composition **151**

Dynamical Triangle .. 151

Interlocking Triangles ... 153

Central Triangle .. 154

Onion in Stone ... 155

20 Rhythm—Recurring Elements **157**

Arches, Lines, and Rhombi 158

Rhythm of Window Lines 159

Minimalistic Structure 160

The Place of the Conference—Japanese Style 161

21 Less is More—Reduction and Emphasis **163**

Arch With Sea .. 164

Reduced Nude .. 165

Digital Control .. 165

22 Pictorial Guides **167**

Three Contrast Points .. 168

Contrast Through Aerial Perspective 169

Arched Guidance of the Gaze 170

More Complex Pictorial Scene 171

23 Balance in a Photo **173**
Formats and Diagonals .. 174

24 Unusual Perspectives **177**
Headstand .. 178
Person from Below ... 179
Indian Primal Tribe Village ... 180
New York Subway .. 180

25 How to Deal with the Center of the Image **183**
Vanishing Perspective in the Tunnel 184
Child and Buddha ... 186
New York Street Scene ... 187
Circular Composition .. 187

26 Pictorial Tension Between Two Elements **189**
Airplane on the Line .. 189
Dunes in the Sahara .. 191
A Glance Out of the Picture ... 191
Spotlight ... 192

27 The Image Within an Image **193**
Melancholy with Binoculars ... 194
Backlight Projection .. 195
Ruin in Kurdistan ... 196
Square Concrete Blocks in the Landscape 196

28 Interesting Irritations **199**
The Wise Inclusion of Irritating Elements 199
Power Lines in San Francisco .. 200
Irritating Fence ... 201
Surreal Cemetery .. 201
Mysterious Lighting Spectacle .. 202

29 The Play of Forms—Conscious Repetition of Pictorial Shapes **203**
View from Schauinsland Mountain 204
Umbrella and Sky ... 205
Reflection in the Sky ... 205
Water Lilies Without Cliché .. 206

30 How to Compose with Blurred Movement **209**
Chapel in a Sea of Grass ... 210
Typical Night Photo .. 211
Long Exposure with Displacement 212
Blurred Movement in the Daytime As Well 214

Section 4 The Digital Darkroom 217

31 Black and White from Color **219**
Conversion from Color to Black and White 220
Reflection of Fire Escapes .. 223
Brightening Dark Areas while Increasing Middle-Tone Contrast 225
Adding Grain .. 226
Saving Your Images .. 226

**32 Partial Manipulation with the Lasso Tool Set and
the Magic Wand** **229**
Partial Manipulation with the Magnetic Lasso 229
Partial Manipulation of Architectural Lines with the Polygon Lasso ... 232
Partial Manipulation with the Magic Wand 235

33 Retouching **237**
More Precise Dodging and Burning than the Analog
Darkroom Ever Allowed ... 240
Include Gradient Sky Tones .. 243

34 Corrections with the Distortion Filter **245**
Shift Lenses Almost Superfluous 248
Subsequent Sharpening: Yes or No? 250

35 New Black and White Conversion with Photoshop CS3 **253**
Simulating Filters .. 255
When the Filter Calculations don't Work 256
Panoramic Photography with Photomerge of Photoshop CS3 258

Introduction

Digital photography has conquered the market at breakneck speed despite the fact that in the early years of the technology, professional photographers eyed its development with skepticism. As photographers migrated from analog to digital, they suffered through more than their share of growing pains, struggling with the new technology and doubting its viability. Following are some of the questions that were being asked:

- Is it actually possible to make large, quality prints from digital images?
- Don't digital photos look artificial?
- Do the colors look natural?
- How does digitalization affect black and white photography?

In order to answer these questions and to get acquainted with digital photography one thing was certain: it was necessary for photographers to devote time to learn the technology of the meteorically advancing digital photography. Not only was it essential for photographers to become familiar with a new, and rather complex camera technology; it was also necessary to thoroughly understand the new image manipulation programs. Many photographers initially shied away from these efforts, and as a result, traditional analog photography had to be defended by those who had not even acquired an in-depth knowledge of the digital process.

The Image in the Digital Age

Many textbooks have been written about digital cameras, digital technology, and the latest image manipulation programs, which are meant to facilitate both amateurs and professionals as they transition from analog to digital. However, one aspect seems to have been almost forgotten in the process: Digital photography goes beyond the technical and is also about images and their content—about moods and their formal arrangements. This book will help you become familiar with digital photography, and will help you to focus again on the image in the digital age.

Images have their own special language and primordial laws. Black and white photography is a medium that begs to be artistically shaped in both digital and analog photography. Certainly, digital photography technology appears complicated and must be mastered, however, the technology of photography should not always be the main subject; rather, it the technology should only serve to guide you toward the end result of expressive, artistic images.

Apart from the technical aspects of production, whether a picture was taken in analog or digital format is completely irrelevant to the presentation of the image. Therefore, to help you learn about image composition, several of the examples included in this book were produced through analog photography. While this book forgoes specifying the processes used to create analog images, it does provide information on the technical procedures used to create each digital photograph.

Needless to say, although this book deals with digital technology and provides you with essential technical information explained in simple terms, it is primarily an advanced guide to image composition. Thus, the first and longest part of this book deals mostly with content-related subjects such as landscape, architectural, portrait, and street photography. For each of these subjects, well-known examples from historical and current photography are mentioned with the aim of motivating the reader to go beyond this book and delve further into these subjects.

The second, larger part of this book deals extensively with the classic rules of image composition such as the golden ratio, triangular composition, image tension, etc. This part of the book teaches the essentials of image analysis; however, you should not view the rules of composition as recipes to be strictly followed. On the contrary, after you have absorbed these compositional rules, you will be reminded not to adhere to them at all times; rather, you should feel free to discard them when it suits your purpose, and in the best-case scenario, apply them to develop your own pictorial language.

Technical Information in this Book

Analog black and white technique is taken for granted and is not explained in this book, whereas with every digital image included the technical procedure is

briefly explained. Some chapters in this book are devoted to important technical information such as:

- The quality and features of digital cameras
- The processes of shooting in RAW mode
- Photoshop CS2 techniques that you really need for manipulating the perfect digital black and white photo, explained in a simple way
- The basics of the new black and white conversion and filter simulation features of Photoshop CS3, which became available shortly before publication of this book

Please note that the digitally photographed images in this book were manipulated with Photoshop CS2. I refer to the CS2 channel mixer in the picture legends, because at the time of writing, Photoshop CS2 was the most advanced version and it offered the best conversion method available for black and white.

New Filter Mode Starting with Photoshop CS3

In the chapters on nonspecific techniques, such as the chapter on filters, I include some CS3 manipulated images, but in general, for CS3 information, you should refer to the final chapter. Photoshop CS3 finally gives you the ability to simulate the effects of blue, yellow, green, and red filters in black and white conversion. In the final chapter, you will see examples of the innovations introduced by Photoshop CS3. I should mention that the filter calculation works very well in some, but by no means all cases. In any case, it is superior to using the camera's filter mode when taking the picture.

Emphasize Expression

Throughout this book you will be repeatedly reminded that photography is about learning to see, to compose an image, and to think pictorially. In a nutshell, this book will stimulate you to analyze images in-depth and will motivate you to find your own photographic style. To accomplish this, my photographs are used as examples to communicate the diversity of pictorial language. The knowledge you gain from the information this book provides can be transferred to other totally unrelated subjects.

One thing is certain, however: With digital photography, although the increasingly difficult techniques must be mastered, technology should never become an end in itself. It is precisely because of this that it is so important to stress that photography is not preeminently about technique, but rather is about images with content that express the photographer's consciousness while being created in an interesting way. And that is what this book is about.

Section 1

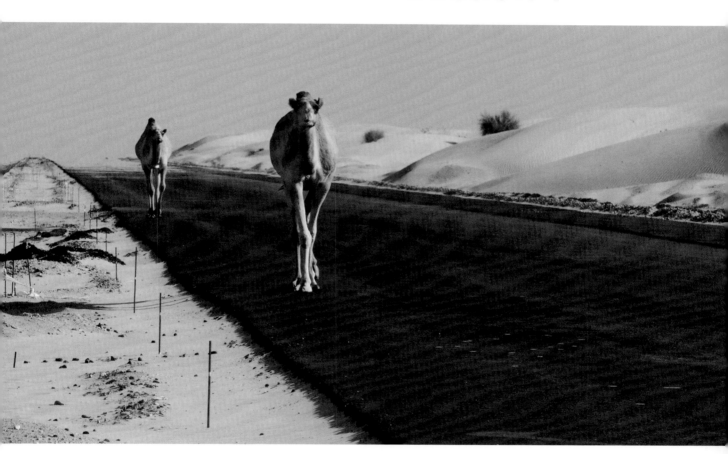

Tools and Fundamentals

1 Choosing a Good Digital Camera

In analog photography, the camera does not have the essential importance often attributed to it. Rather, it is the quality of the lens that is paramount, because the optical system and the type of film used are mostly responsible for a technically satisfactory image quality. These things are completely different in digital photography, where it is the quality of the camera sensor that determines image quality as much as the optical system. Therefore, most of the time—and in contrast to analog photography—the latest camera sensor model is in fact often the best one as well. Digital photography has evolved so much in recent years that high-quality images have become a reality; something that even a few years ago was by no means the case.

When digital cameras were in their infancy, three megapixels were insufficient to allow for large-sized enlargements. There were other problems too: image noise in night photos, moiré effects in delicate graphic structures, unnatural colors, color fringing in photo edges, and above all very slight burnt-out lights in backlit situations, making backlit photos almost impossible to shoot. In addition, shutter release delay was a problem in the early days of digital photography, making it totally useless for snapshots.

Meanwhile, all the problems mentioned above have been largely resolved. Small-frame sensors now have an average resolution of 10 megapixels and the Canon EOS 1 Mark III DS has already reached 21 megapixels, which is the maximum resolution of a small-frame sensor at the time of publication of this book. Digital backs for medium-format cameras currently have a resolution of almost 40 million pixels. These are magnitudes of resolution that an amateur doesn't

need and which only make sense if you intend to print images at least three feet long.

APS Sensors

The active pixel sensors (APS) used by most manufacturers provide a pretty good image quality, but they don't perform very well with extremely wide-angle lenses, because with a focal length extension of 1.5 you generally must purchase a 12 mm optical system to reach an actual 18 mm focal length (an extremely wide-angle lens). However, a good 12 mm optical system placed before an APS sensor with a focal length extension does not quite reach the same image quality as a good 18 mm optical system placed before a full-format sensor. These differences in quality can be noticed only in large prints (16" x 24" and larger), yet are nonetheless important.

Figure 1–1

Let's look at our comparison once again: This inartistic image perspective (figure 1–1) is the result of a test performed in front of a friendly, professional photography shop in Frankfurt; taken first with a Canon EOS 5D and the 16–35 mm-Canon-L lens with an 18 mm focal length, and then taken again with a Nikon D200 and the 12–24 mm Nikon lens at the 12 mm focal length, which corresponds exactly to the 18 mm focal length of the full format. If you enlarge both images to 100%, you will see that the Canon full format camera has an excellent resolution in the building's (figure 1–2) texture, whereas the texture can barely be recognized with the Nikon D200 (figure 1–3). However, in reality, the building has a facade corresponding to the structure resolved by the Canon EOS 5D. The standard adjustment was selected for both cameras during the test.

Figure 1–2

Full Format Sensors

On this book's publication date, the full format sensors developed by Canon and Nikon deliver such outstanding results when used with high-quality, wide-angle lenses that the images come close to the quality once only achievable with a 6 x 4.5 cm medium format camera. This is the reason many pros have switched to these digital single-lens reflex (DSLR) cameras equipped with full format sensors developed initially by Canon. Their advantage becomes especially noticeable in large prints made from wide-angle photos. Their disadvantage is the clear vignetting of the full format sensor under full aperture; but this problem can also be eliminated by slightly stopping down or by using the aperture correction of the distortion filter (lens correction in Photoshop CS3), so the full format sensor has no real argument against it.

Figure 1–3

Which Sensor Should You Use?

On the other hand, if you do not need to shoot with extremely wide angles or make enlargements of up to 12" x 18", most active pixel sensors used with good lenses will also provide reasonably good image quality. As a matter of fact, they are even advantageous with respect to the full format sensor when used in the telephoto range, because a 200 mm lens becomes a 300 mm lens, but has the more compact design and the larger depth of field of the 200 mm lens. I once again recommend a camera equipped with an APS sensor, particularly for photographing animals, for example. Needless to say, much of this becomes a price issue. At the time of this book's publication, the best camera for the money, equipped with a full format sensor is the Canon EOS 5D, which costs approximately $2,600. This camera (with its 12.8 megapixels) in combination with good Canon-L lenses allows for enlargements of almost 3 x 4½ feet if you also interpolate the pixels a bit. (You can add on 50% more pixels, for example, to define the same image using Photoshop's "image size".) If you want to enlarge poster-size prints up to 16" x 24", cameras with a lower pixel number are sufficient. Furthermore, you can use the outstanding Leica or Nikon lenses with this Canon camera body by using an adapter, thus you can use the best lenses available on the market. Image quality will be considerably superior to the results obtainable with any analog small format camera using 100 ASA film. Other reasons to use an APS sensor are the excellent subsequent sharpening tools available for it, and image noise at 100 ASA is substantially lower than the grain of a 100 ASA small format film.

Advantages and Disadvantages of Compact Cameras

The issue now arises regarding the advantages and disadvantages of compact cameras. A clear advantage of compact cameras as opposed to single lens reflex (SLR) cameras equipped with interchangeable lenses is that the compact camera sensors cannot get dirty, whereas with digital single lens reflex cameras you may be constantly battling dust. Although manufacturers have invented protective foils, it will nevertheless be almost impossible for a camera with interchangeable lenses to work totally dust-free. The problem isn't as severe as you might expect, because you can easily clean the sensors (or the low-pass filters placed before the sensor), and it is easy to retouch small visible dust particles with Photoshop.

Compact cameras are generally equipped with zoom lenses that cover a large focal length range. They are sufficient for amateur purposes, but such a zoom lens has, for the most part, disadvantages and is therefore insufficient for professional standards. Conversely, with a DSLR camera, you can use several zoom lenses for only the smaller focal length ranges and still achieve a higher image quality.

Generally speaking, most camera and lens manufacturers have invested a great deal more money and energy in the last couple of years in the development of zoom lenses than in the development of fixed focal lengths. Therefore, the quality of zoom lenses has improved so much that I can recommend many of them even for the most challenging tasks. The weaknesses of zoom lenses appear more in the distorted edges of the image than in deficient sharpness. This distortion could pose a problem for architectural photography, but this limitation has been overcome with Photoshop CS2, as it allows you to compensate for distortions with the distortion filter and the "diaphragm or lens correction" mode. In addition, you can download various so-called "plug-ins" from the Internet with which you can correct on-screen almost any lens available on the market. These correction possibilities are so good that they cannot be noticed later as artificial. Nowadays, you can even tackle professional architectural photography with digital single lens reflex cameras and zoom lenses.

In summary, it can be said that if very high quality is expected from the image, even with extremely wide angles, there is hardly a way around a single lens reflex camera with a full-format sensor and high quality lenses. If your requirements are a bit lower, cameras with an APS sensor and high quality zoom lenses are sufficient. If you demand an advanced amateur level from the image quality and you rarely need prints larger than 12" x 16", a compact camera equipped with a good zoom lens (from Leica, for example) can be quite acceptable.

2 An Essential Rule for Digital Black and White Photography: Always Photograph in RAW Mode

If you are just beginning to photograph digitally, you may be pleasantly surprised at the high-quality images that a good camera is capable of, even in the compressed JPEG format. For most situations, a skillfully taken photo in compressed JPEG mode is good enough at first glance. For the sake of convenience, it's tempting to stay with this format because it uses up a lot less memory and there is no need to determine which RAW converter to load onto the computer. However, to surrender to convenience is a mistake in spite of the apparently satisfactory image quality of the JPEG format. This is especially important for black and white photography. Most of the high-end digital cameras have—in addition to the JPEG and sometimes the TIFF formats—the option of photographing in the so-called RAW mode. As the name indicates, all available RAW data is saved the moment you take the photo. Numerous automatic image-editing steps such as white balance, sharpening, or tone value correction are eliminated at first. Instead, the data is generally stored with 12-bit or even 16-bit color depth, as opposed to the 8 bits of JPEG mode. This greater color depth means a considerably wider tonal range. In order to open the data photographed in RAW mode, a RAW converter is needed. And this is where, unfortunately, every manufacturer clings to its own proprietary and very secret concoction. Although Adobe has suggested developing a uniform RAW format, the large manufacturers such as Canon and Nikon still won't have anything to do with it. And yet, when it comes to optimum image quality, there is no way

around using the RAW format: Photographs taken with this format have considerably better light scope, which means that photos shot in RAW format reproduce the brightest spots and the darkest shadows in backlit images much more faithfully than photos taken in JPEG format. Thus, backlit skies taken in RAW format not only have more natural colors, but they also have better differentiation.

Let's look at two photos of a paraglider:

In the photo taken in JPEG mode (figure 2–1), the lit areas are not well differentiated and are partly washed-out despite having used a gradient filter that gradually darkens the sky towards the top—a typical phenomenon from the beginnings of digital photography that made good backlit photos almost impossible.

When you now look at the image captured simultaneously in RAW mode (figure 2–2) with exactly the same image data, you will see that all lit areas are still very well differentiated and traced. And that is precisely the point when it comes to a digitally taken backlit photo: If the lights in the image are "washed out", you cannot subsequently improve it.

For this reason, it is especially important in backlit photos to use the black or red blinking information indicator on your camera's liquid crystal display (LCD), available on most good digital cameras, to see in the display what sections have possibly washed-out lit areas. If you photograph in RAW mode, you can correct an underexposed photo by brightening the underexposed areas with the RAW converter. By the way, the advantage of the RAW mode in backlit images applies both to black and white, and color photography. However, for black and white photography there is one especially important criterion which demands that a photo be taken in RAW mode: You will later learn that it often makes sense to convert photos that should have a dramatic, high contrast sky with the channel mixer of Photoshop CS2 to black and white using a very high portion of the red channel, or by subtracting blue tones a great deal in Photoshop CS3. But when you do this with a photo taken in JPEG (even if it looked good in color) its tonal values will develop dirty transitions and an unpleasant image noise that you will clearly recognize in bigger enlargements. On the other hand, a TIFF file that originated in RAW mode allows a conversion done with the channel mixer that used a very high portion of red (or subtracted blue in CS3) and retains fine tonal transitions and little image noise.

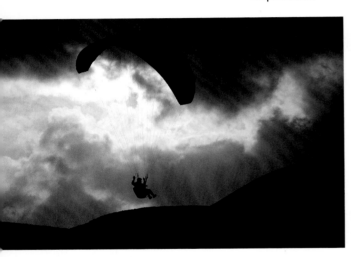

Figure 2–1

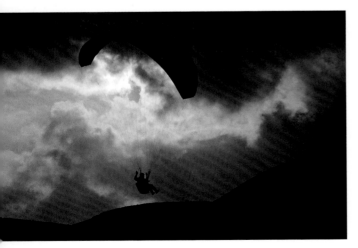

Figure 2–2

Let's look at an example. In this photo of the volcanic island of Lanzarote (figure 2–3), the task was to convert the sky to a higher contrast black and white. The best result was obtained by using the channel mixer to adjust the red channel to 100%. If the sky had been slightly hazy, a polarizing filter in a crossed (90º) position and a channel mixer adjustment would create a nice, contrasty black and white image. If you enlarge this image 100% and crop it (figure 2–4), you will see how little image noise there is in the TIFF file converted from RAW format. If you take exactly the same steps with an identical photo in JPEG format, you will see that the same crop enlarged by 100% (figure 2–5) has much more image noise and a much rougher transition in the gray tones. The difference can be readily seen in 16" x 24" prints. Therefore, the following rule applies especially for fine art prints: Always photograph in RAW mode and print from a TIFF file, because although TIFF takes up to five times more memory than JPEG, the results are worth the required memory space. In addition, there are good external hard disks with almost unlimited memory capacity (Lacie, for example) that are more economical than the corresponding number of films would have been.

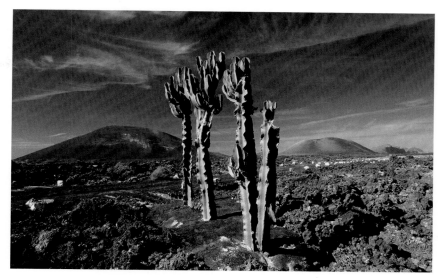

Figure 2–3

Figure 2–4 TIFF file converted from RAW format

Figure 2–5 JPEG format

3 Drama Through the Use of Filters

Various colored filters are used in analog black and white photography to change and determine gray-scale distribution and subject contrast. Good digital cameras calculate this filter effect. Which filters should you use when photographing digitally in color mode?

In analog black and white photography, filters influence the translation of the various colors to gray values and consequently affect contrast as well. The most important color filters are yellow, orange, red, green, and blue.

Essentially, a filter allows the light waves of its own color to pass through, but absorbs the light of its complementary color. For black and white photography, this means that colors in the image that are the same as the filter appear brighter in the photo, whereas those of the complementary color appear darker. The following colors are complementary: red and blue-green, orange and blue, yellow and purple-blue, yellow-green and purple, green and purple-red.

Filters are particularly useful in analog landscape photography and Ansel Adams is the premier practitioner of this technique. His most famous photograph "Moonrise, Hernandez, New Mexico" would not have had such a dark sky without the help of a red filter. As a matter of fact, he took most of his landscape photographs with filters.

The so-called blue-absorbing filters are extremely useful for landscape and architectural photography, because they darken the sky. After yellow and orange filters, the red filter is the strongest variant of a blue-absorbing filter. It has a marked effect not only on the sky, but on other exterior objects as well. Light at noon, for example, has a very high color temperature, so a red filter darkens the sky and the objects that reflect the blue of the sky; especially,

shadows are often infused with light of blue wavelength, but our eyes do not notice this effect. Thus, in a photo taken with a red filter, shadows will appear darker. A red filter also reproduces green in a darker tone, because green is the complementary color of red. With regard to design, it can be said that red filters generally create images with considerably darker areas than images taken without them. However, when used properly this filter creates a kind of magic because it magically brings out light from the darkness. Thus, it creates a pictorial effect that is similar in style to painters like Rembrandt, and especially Caravaggio. Nevertheless, the danger with the red filter is that shadows can "drown" so it's a good idea to overexpose photos taken with this filter. A red filter swallows almost two apertures, so a tripod is often a must.

On the other hand, a yellow filter swallows only half an aperture, but it doesn't darken the sky as much. In analog black and white photography, a yellow filter is a good all-around filter.

If you want to photograph a very green landscape, a green filter would be a good choice because it brightens the green of the landscape and darkens the sky, at least somewhat.

Some photography schools also recommend placing two filters on top of one another, such as a red filter + polarizing filter. But I don't think it's a good idea, because each additional filter causes a loss of image quality, albeit a very slight one. Because color filters are generally screwed onto the lens and, therefore, become another lens element, this is not the time to save money and buy a cheap product. With some very long telephoto lenses, you can also screw the filter onto the back of the lens. If possible, all filters should be from a well-known manufacturer and feature good antireflective coating so they reflect as little light as possible and, therefore, do not lengthen exposure time unnecessarily.

Examples of Color Filter Effects—The Same Subject Taken with Different Filters

With the help of a landscape photo taken of the Atlantic Ocean from the island of La Palma, let's look at the effects that the most important filters have on analog photography. Yellow, red, and green are, in my opinion, part of the essential equipment that an ambitious black and white photographer should have. Prints 1 through 4 were enlarged on grade 3 paper with the same exposure times and without any burning. They show very clearly the effects of these three important filters, but no enlargement looks convincing without extensive, additional manipulation. This example reminds us that for enlargements, image post-processing is at least as important as filter use. The best procedure is to use both, because they supplement each other.

The unfiltered photo (figure 3–1) is unsatisfactory because the pretty clouds in the sky appear too pale and lack contrast.

Figure 3–1 Unfiltered image

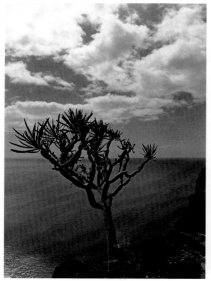

Figure 3–2 Yellow filter used

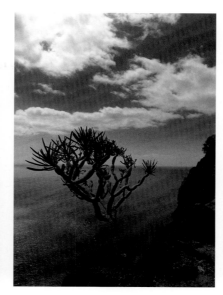

Figure 3–3 Red filter used

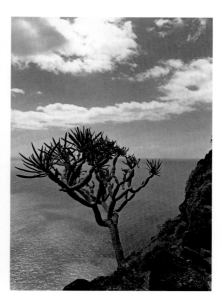

Figure 3–4 Green filter used

The photo taken with a yellow filter (figure 3–2) shows a little more contrast in the sky that could look OK with some subsequent manipulation of exposure, but then the blue sea would look darker compared to the trunk of the exotic tree.

The image taken with a red filter (figure 3–3) shows a dramatic, contrasty sky without subsequent exposure correction, but the blue-green sea that is complementary to the color of the filter becomes so dark that it can no longer be distinguished from the tree trunk.

A very different effect is achieved with the green filter (figure 3–4). The blue-green light of the sea is not absorbed (as was the case with the red filter), but almost all of it passes through the filter, and therefore, makes the sea appear brighter. The tree trunk and the leaves also look brighter and more differentiated than in all previous photos. Only the sky leaves something to be desired and still has a somewhat lower contrast than in the photo taken with the yellow filter.

The previous examples clearly show how strongly you can determine tonal values in a black and white photo. If you want a rather dark image in which only the clouds stand out brightly, then I recommend using a red filter and dodging the lower part a little bit (figure 3–5). You can see that differentiations remain all over the negative, yet the tones of the tree trunk can barely be distinguished from the tones of the sea.

If, on the contrary, you want a bright image in which the sea stands out, I recommend taking the photo with a green filter and then burning the sky in the

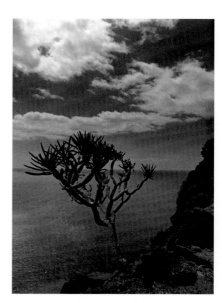

Figure 3–5 With red filter and dodging lower part

darkroom (figure 3–6). Now, the tonal values of all areas are clearly separated and differentiated; even the green tones in the landscape's lower right corner are noticeably more brilliant than in the photo taken with a red filter. This is certainly the photo that does the most justice to the subject.

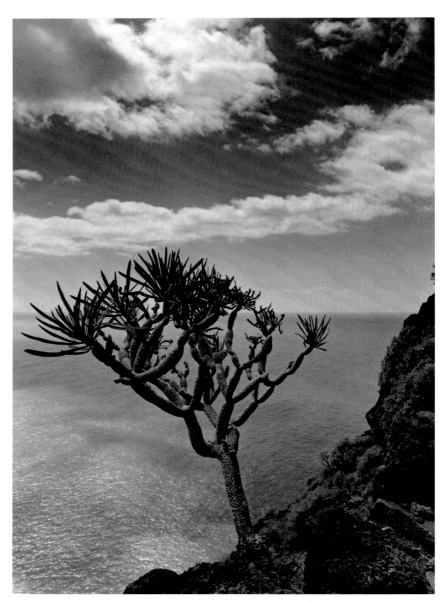

Figure 3–6 With green filter and burning sky

Filters in Digital Photography

Using filters in digital photography is completely different than in analog photography: The color filters described above lose their effect, lead to flat images, and are therefore useless in digital photography. Good digital cameras such as the Canon EOS 5D or the Nikon D3 have a program that allows shooting in black and white mode that applies the effect of yellow, orange, or red filters. However, I still recommend shooting in color mode and later using the channel mixer in Photoshop. Starting with Photoshop CS3, however, the effects of yellow, green, blue, and two different red filters can be simulated when converting to black and white. Here, I'll deal with the most suitable filters for photographing digitally. Naturally, ultraviolet (UV) and skylight filters should be mentioned in digital photography.

- The UV filter blocks out the ultraviolet light that causes some lack of sharpness.
- The skylight filter is a very slight conversion filter with a smooth pink tone that lowers color temperature a little bit, thus giving a pleasant, warmer color tone in photos taken at noon with a blue sky.

However, conversion filters such as these are useful mostly in analog photography, because digital cameras have a white balance adjustment. The most prevalent filters are the bluish KB filters that increase color temperature, the reddish KR filters that throttle color temperature, and the FL filters that eliminate the green cast of fluorescent lights. But, as a digital photographer, you might as well forget all about them.

The Polarizing Filter

Mainly, two filters are essential and, therefore, are a must in digital black and white photography: the polarizing filter and the gradient filter. *(Note: The gradient filter is discussed later in this chapter.)*

The most widely used filter is the polarizing filter, and its effect should already be well known. By rotating the filter in a cross position (i.e., at 90° with respect to the subject), two kinds of polarizing light are especially blocked: reflections of nonmetallic objects, and the sky's polarized light vibrations, thus intensifying the contrast between sky and clouds. Whereas light waves normally propagate by oscillating as a bundle around an axis on many planes going in one direction, polarized light oscillates only on one plane. To simplify matters, the polarizing filter can be understood as an infinite number of small mailbox slots that, in the instant in which they are perpendicular to the oscillating plane of polarized light, filter it out almost entirely. After all, the oscillations cannot pass through the "mailbox slots" positioned obliquely to the polarization plane.

In practice, the polarizing filter has two main effects: It intensifies the objects' own colors (almost all objects are more or less suffused by scattered light, and this scattered light lies on top, so to speak, of the objects' own color as a slight veil. Because these reflections are polarized light beams, the polarizing filter filters them out and the objects' own color becomes more apparent.

There are also many polarized light beams that scatter the light in the atmosphere and make the sky look brighter, especially in hazy conditions. This scattered light is also filtered out by the polarizing filter, especially when the camera is held at a 90° angle with respect to the sun. The sky appears a lot darker, almost black, but the clouds remain bright, thus intensifying the contrast between sky and clouds.

You can now transform the sky—which already has a higher contrast owing to the polarizing filter—with the channel mixer (Photoshop CS2 and earlier versions) in such a way that the orange or red filter effect is perfectly imitated. You can even digitally recreate an infrared filter effect, although not as thoroughly as a red filter effect.

Digital Drama with Photoshop CS2 and Earlier Versions

You can achieve the dramatic effect conveyed by an orange or red filter digitally. This photo (figure 3–7) was taken with the Canon EOS 5D and the 17–40 mm lens at a 17 mm focal length. Although this camera has a red filter simulation for black and white mode, it is better to turn the polarizing filter to the cross-position and photograph in color mode, as recommended above. During conversion to black and white, you can control the effects of the blue-absorbing filters better and more precisely with the channel mixer. Thus, you can simulate the effect of a yellow, orange, or red filter as in this color photo of a gigantic wave in Lanzarote. If you were to convert the image through adjusting the blue channel to 100% (figure 3–8), the sky would remain relatively bright compared to the original color photo, but the polarizing filter effect would make it a little darker with respect to reality. If you want to achieve the effect of an orange filter, a mixture of 50% red channel and 50% blue channel will provide the desired result as in this photo (figure 3–9). This is the most convincing image because it has a strong contrast coupled with a dark and dramatic sky. The photo with red filter effect (figure 3–10) has been mixed together with the 100% red portion of the channel mixer. It is almost a little too dramatic; some may think the sky is too black.

However, with photos not taken in RAW format the gray-scale tonality in the sky is no longer smooth enough after the contrasty transformation with the channel mixer. But even in this case, you can mask this undesired effect using Photoshop tools. A sky with a slightly unsteady tonal gradient is barely noticeable if you add grain structure to the image. A size 14-grain structure with 50% contrast comes quite close to an analog image taken with 100 ASA film. If you have transformed the photo with the channel mixer or with "reduce saturation",

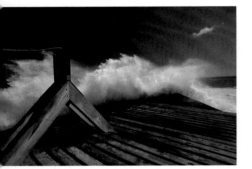

Figure 3–7

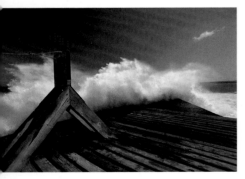

Figure 3–8 Conversion with blue channel at 100%

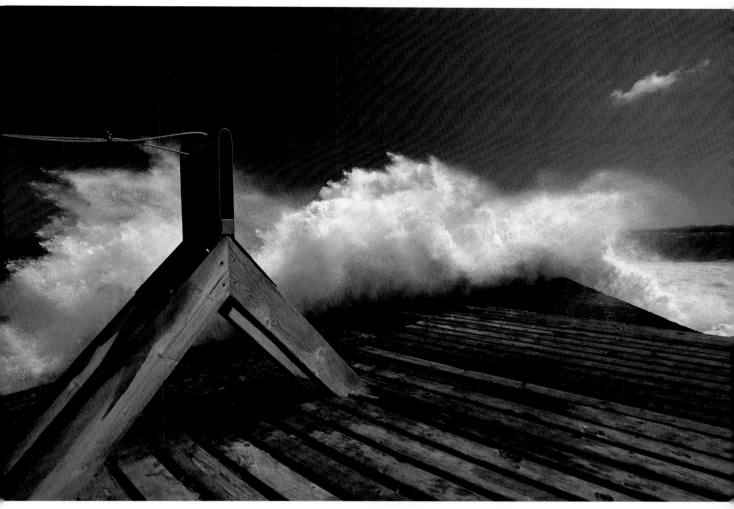

Figure 3–9 A mixture of 50% red channel and 50% blue channel provides the effect of 100% orange channel.

the grain appears in color. However, you still need to take out the color with the "reduce saturation" tool or with the gray-scale mode after using the contrast filter/grain combination, even if you already processed the image in black and white. This is only an emergency measure; it is better to photograph in RAW format in the first place, because then the transitions remain smooth after conversion using the 100% red portion of the channel mixer.

In this image, the attachment point for the rope is included in this photo to serve as a graphically interesting element in the composition because, without it, an essential fixed point for the eye would be lacking.

Figure 3–10 Red channel at 100%

Infrared Simulation with Photoshop CS2

By using the channel mixer, you are able to convey the impression of infrared photography reasonably well. Contrary to the simulation of blue-absorbing filters, infrared simulation is not really convincing with every subject. Let's look at two examples that really cry out for a touch of infrared.

Example One: Beyond 100% in a Color Channel

If you use the channel mixer beyond 100% in a color channel, the objects of the color channel lose sharpness: In infrared photography, this effect is especially sought after because infrared film reacts with chlorophyll in the green of leaves. To create the infrared impression digitally, I recommend setting the green channel to 180%; thus, green will be reproduced very brightly and will partly dissolve into a lack of sharpness. If you now add a 20% red channel and then subtract 100% in the blue channel (i.e., setting the indicator at minus 100%), the overall result is once again a 100% mixture. Although the green of the trees and grasses becomes markedly brighter, the green trees and grasses remain

Figure 3–11 Same image using typical gray tone conversion

Figure 3–12 Effect of infrared photography using channel mixer and added grain

unconvincing due to their lack of sharpness. A relatively coarse grain structure placed over the image solves this problem. I recommend a size of 50 for the grain structure placed over the image. (Clicking on "reduce saturation" will convert it again to black and white.) Such a coarse grain (size 50) is characteristic of infrared film. The created image (figure 3–12) is quite attractive. The green of the trees, and especially the grasses in the meadow, are much brighter than in the image converted through the gray tones (figure 3–11). The overall impression of this park in Fürstenlager Auerbach on the Mountain Highway is rather mysterious, almost mystical. The trees look as if they will lay down on the hollow, as if they are taken with a fisheye lens. In fact, the trees were crooked and this is the result of using a full-format Canon EOS 5D camera with a 17 mm wide-angle lens.

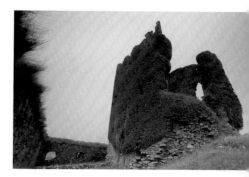

Example Two: Infrared Adds a Mystical Effect

The infrared effect is even more suitable for this old Irish ruin (figure 3–14). Here, the brightening effect of the green as opposed to the image converted to gray tones (figure 3–13) is more easily seen.

Figure 3–13

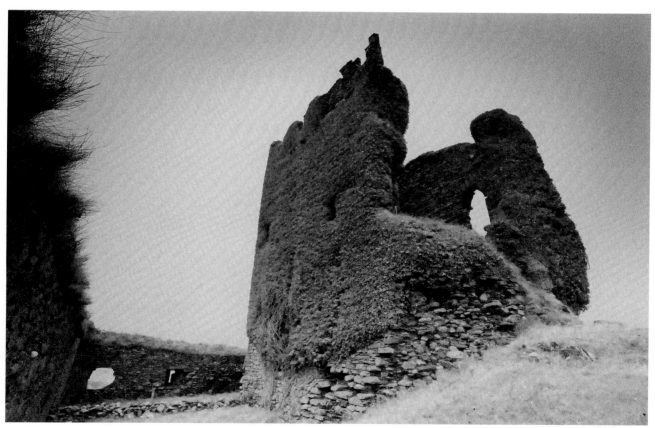

Figure 3–14

If you look at the detail in the grass, you can notice that—as opposed to the image of the grass converted to gray tones (figure 3–15)—the detail has lost resolution and looks outshone (figure 3–16). This effect closely resembles an infrared representation and fits the character of this old ruin found in south-western Ireland very well; the mystical effect of the ruin has been increased a great deal. The photo was taken with the 17 mm focal length of the 17–40 mm lens and a Canon EOS 5D.

Figure 3–15 Typical gray tone conversion (detail)

Figure 3–16 Infrared simulation (detail)

You can still find many enchanting ruins still standing in the middle of the Irish landscape. These ruins are relics from the past, from another era, in which the mystery of time can still be clearly felt. The infrared effect enhances this mysterious impression.

Note: Photoshop CS3 now features direct infrared simulation, but it is limited and does not work with all images, as you will see in the final chapter.

The Gradient Filter

Surprisingly, the gradient filter is rarely used, but it is virtually essential for digital photography. The color of a gradient filter starts in the middle of the filter and becomes denser towards the top. In typical filters, the difference between coated and clear surfaces is one to two aperture stops. I recommend neutral gray filters with a 2-aperture rating, because they achieve a pleasant light balance in backlit conditions. In principle, the gradient filter is used especially in landscape photography to balance the considerable difference in brightness between sky and foreground, especially under backlit conditions. A gradient filter is primarily useful when the skyline is not crooked, because all elements jutting above the skyline (skyscrapers, for example) will also be gradually darkened—an undesirable effect. Naturally, you can brighten the elements again in both analog printing and in digital processing with the dodging technique.

The gradient filter is unjustifiably included with effect filters, but generally you can barely notice its "effect". Used correctly, the gradient filter achieves no more than adding detail to a sky that lacks detail in backlit photos. In analog photography, the gradient filter is often indispensable, especially when using slide film, because the image cannot be subsequently manipulated any further, at least not without digitizing.

A risk in digital photography is that lit areas can burn out in backlit situations, thus losing all their detail. This risk is greater than when you use a good film. Therefore, when you take a backlit photo such as this one, (figure 3–17), a gradient filter is essential. Without a gradient filter, all the clouds in the sky lose their detail and not even Photoshop can restore it. The photo taken with a gradient filter (figure 3–18) shows the difference: Although the brightest areas in the clouds have some detail, the lower part of the image is not darker. The photo has the right amount of drama because the bright clouds create an oval shaped frame over the sunken ship.

When buying a gradient filter, I recommend a disc type that you can simply place in front of the lens to precisely set the gradient. Another option is an adapter that you can screw onto the filter thread. This type of adapter

Figure 3–17 Without the use of a gradient filter

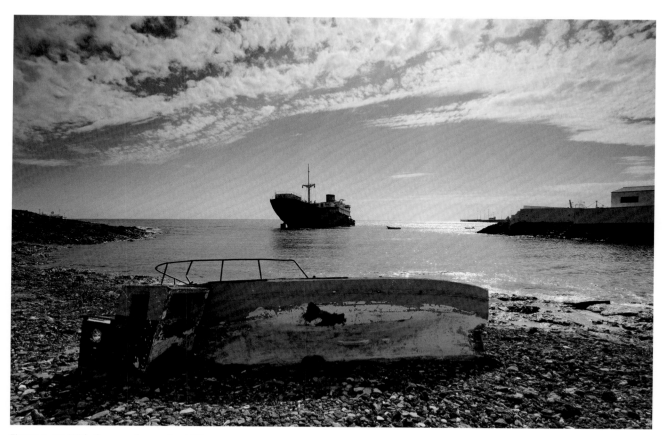

Figure 3–18 With the use of a gradient filter

has a support for the gradient disc so you can displace it upward or downward as needed. The Cokin Company makes good, economical gradient filters.

You can use a gradient filter to add drama to a picture that otherwise would have been rather gray and boring. The lighthouse of Westerhever near St. Peter Ording has often been used in advertisements, but on a gray day the sky certainly doesn't provide much drama (figure 3–19). No problem: The gradient filter adds drama. I can place the filter higher or lower to enhance or lessen the dramatic effect of the sky (figure 3–20). As a result, the photo of the Westerhever lighthouse has drama and depth.

Figure 3–19 Without the use of a gradient filter

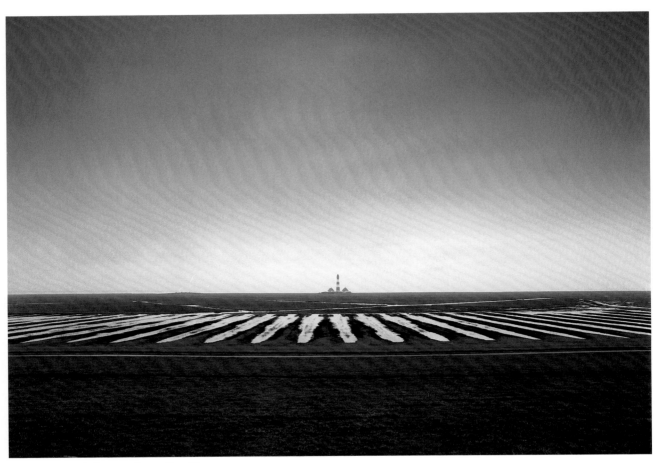

Figure 3–20 With the use of a gradient filter

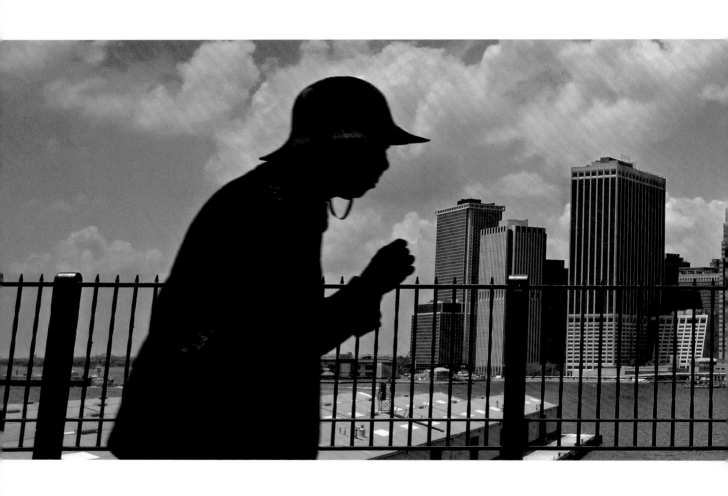

Section 2

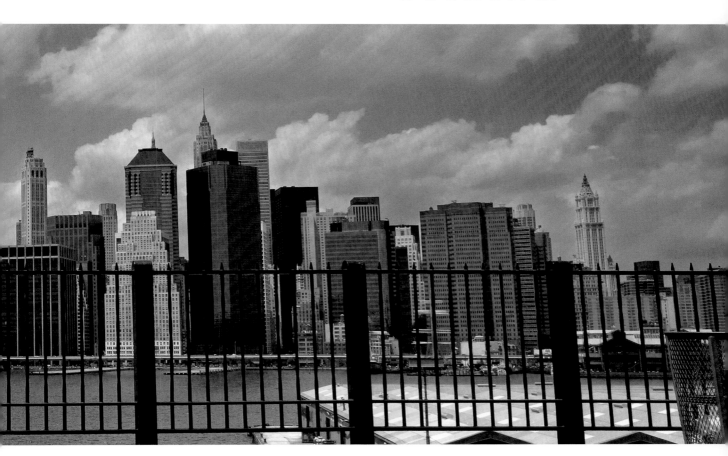

Photographic Genres and Concepts

4 Overcoming Clichéd Photos

After the previous brief, yet important technical discussion, you are ready to focus your attention on the most essential element—the image!

If you want to improve your photographic skills, ask yourself if something is worth photographing. Think about what you really want to express in your photographs. You may be tempted to photograph clichés, such as the Cathedral in Cologne, the Eiffel Tower in Paris, and the Brooklyn Bridge in New York.

What characterizes a clichéd photo? A clichéd photograph is a shortened, simplified reproduction of a popular idea or image; it's a poor copy, an imitation. Clichéd images do not need to be profoundly experienced by the photographer or audience, and they do not result from original thinking. Recently, for example, the city of Cologne published a precise street map for tourists that included the supposedly best places from which to shoot the city's attractions. Does this directive promote independent, creative thinking? Not at all! Postcards are the best example of clichéd photos, generally showing popular urban attractions that are always under a clear blue sky.

Cliché: A phrase, expression, or idea that has been overused to the point of losing its intended force or novelty, especially when at some time it was considered distinctively forceful or novel.

Clichéd photos quickly lose their effect. Andy Warhol's photographs very clearly demonstrate this rapid loss with his serially reproduced Mona Lisa: The more often an image is reproduced, the more it will lose its power. This rule is indeed true in times of a pictorial deluge; as a photographer, you cannot take this

seriously enough. The endless Mona Lisa reproductions have almost degraded the original painting to a cliché. As a photographer, I advise you not to add more clichéd images of the world to the almost infinite number that already exist, but liberate yourself from such clichés.

Be honest and ask yourself: When am I tempted to photograph a popular image and when is a photograph my own original image? You can liberate yourself from photographing clichés by answering the following personal questions:

- What really interests and fascinates me?
- In what facets of the exterior world do I most likely find myself?
- What are my most prominent emotions?

Photography can express your feelings, because for every emotional and mental facet you can find the corresponding facets in the external world. When you understand photography from this perspective, you automatically stop producing clichéd images.

A photo always shows two qualities:

- It shows an authentic instant in the exterior world.
- It shows the photographer's inner world of feelings and ideas.

"Everyone walks toward the image carried within", as the photographer Edouard Boubat once remarked. A painter tries to bring inner images to the canvas, while the photographer finds places in the world that resemble his internal images. The outstanding black and white photographer Robert Hausser always relied on his "gut feeling" to find places in the world that expressed his inner world.

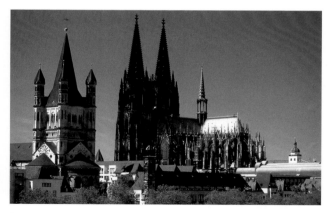

Figure 4–1

Reduction Instead of Postcard Cliché

If you really want to photograph popular attractions, the way in which you photograph them is important. When you photograph common attractions, the reduction of form and color can make a photograph far superior to the clichéd image.

Reduction: The rewriting of an expression into a simpler form. The act of reducing complexity.

For example, almost every postcard portrays Cologne Cathedral with the adjacent St. Martin's church included in the image (figure 4–1). However, a reduced perspective of the cathedral is much less common (figure 4–2). You could photograph the cathedral with a 100 mm telephoto lens in the morning light to make the popular image, or you could take a better photograph by reducing the perspective and shooting with a 200

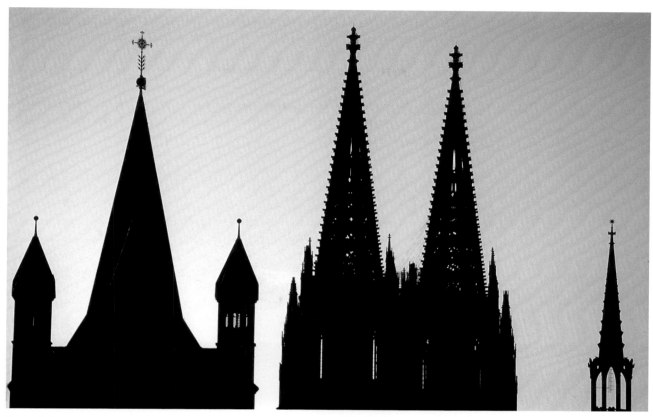

Figure 4–2

mm telephoto lens at dusk from the same location with the bright sky behind the cathedral. The improved photograph portrays the spires of Cologne Cathedral and adjacent St. Martin's church silhouetted against the almost monochromatic gray sky. It is unquestionable that this image with its extreme reduction in form and tonal values is far superior to the popular image. It also shows how similar a clichéd photo and an artistic abstraction can be to each other: they both use the same perspective, but each uses a different optical system and lighting.

From Clichéd Photo to Personal Expression

For many years, the New York skyline with the Brooklyn Bridge and the World Trade Center were the clichéd photos of New York City (figure 4–3). To some cultures, the clichéd skyline photographs may not just symbolize New York or the USA, but also symbolize a cliché of western

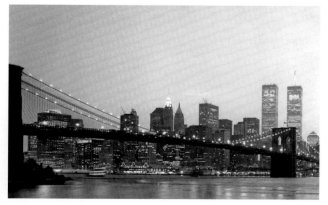

Figure 4–3

capitalism. This photo is a repetition of an endlessly photographed cliché and, therefore, shows no personal contribution, in spite of its sharpness and appealing gray tones.

However, New York's frequently reproduced skyline can be shown very differently (figure 4–4): A group of gymnasts practice in the middle of "midtown", an untypical combination that has not been already shown repeatedly. The legs of the four women project to the upper part of the image, as do the skyscrapers. The photographer composed the image so the women would not block each other when they were stretching their legs and arms towards the sky. In addition, the low perspective guarantees that the women's legs would be higher than all the skyscrapers except for the Empire State Building. The second-highest building is an extremely important element of the composition, because it provides the vertical symmetrical axis. If you cover it, you will notice that the image loses it center. The clouds, roughly triangularly arranged, give the photo its mood.

The photo was taken with a 28 mm wide-angle lens that fuses foreground and background. The clouds get their drama from a medium-red filter that was used carefully so the shadows did not become too dark. Digitally, this photo

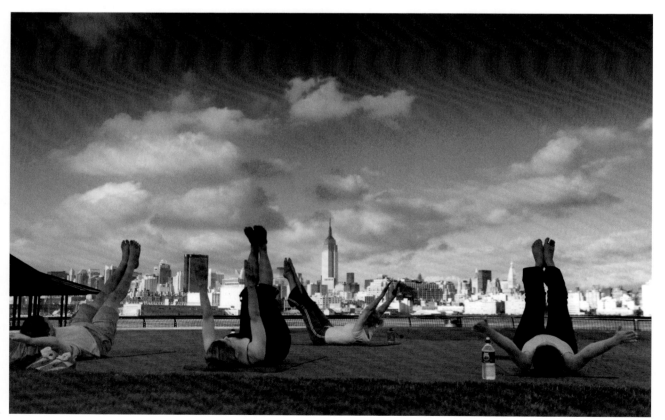

Figure 4–4

could have been converted by using of the red channel mixer to nearly a 100% adjustment.

Many images, apart from the universally known skyline, are just waiting to be discovered in New York. The numerous steel bridges are ideal subjects for photographic abstracts (figure 4–5). The tiny speck in the photo is a person, embedded in this abstract shape of steel triangles. Photography can create a fusion of elements that differ greatly, for example, as in the fusion between the person and the bridge's steel structure. You can almost feel the frailty of the human in contrast to the power of the heavy steel supports. A feeling of heaviness pervades the image due to the dark areas that fill the upper part of the photo. The photo might express that the person loses importance in modern architecture, that the person is just a template or a small cogwheel in a Kafkaesque gear. However, you might interpret the photograph differently. Pictorial language is free and, therefore, is open to many interpretations.

The photo was taken with a 28 mm telephoto lens that fuses foreground and background.

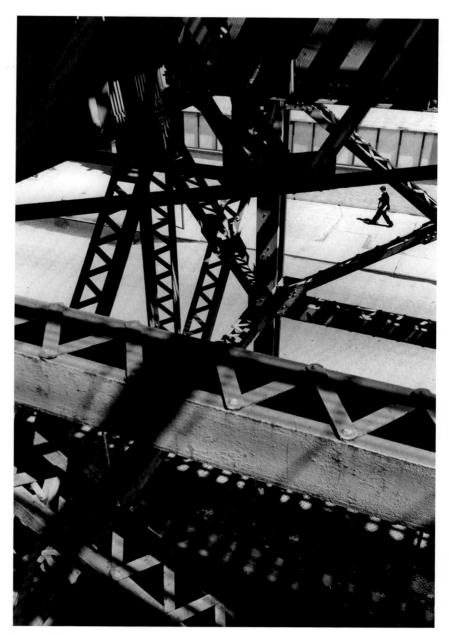

Figure 4–5

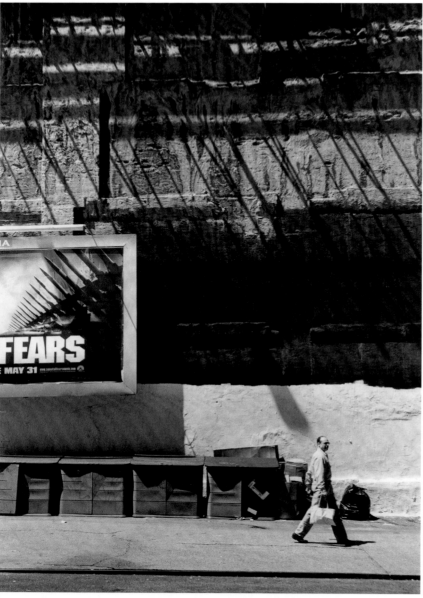

Negative feelings such as fear and anxiety can also be expressed through photography (figure 4–6). The photographer left the spotlessly clean neighborhoods of New York to find the shadow of a fire escape on a rather morbid wall of a house. The diagonal shadow of the fire escape matches the diagonal shapes of the poster with the clear imprint of "fears", which is a picture within a picture. Trash cans on the curb and a person carrying a shopping bag suggest normality. The image's atmosphere is menacing because only the lower third of the image is bright, whereas the upper part is dark and dominant. Additionally, the structure of the house wall is reminiscent of a bunker rather than a normal apartment house. It is more common for the upper part of images to be bright; therefore the inverse brightness appears menacing in an image. The atmosphere that permeates the image is more prominent than the actual place where the photo was taken. The photo was taken with an analog camera and a normal lens.

Figure 4–6

A menacing atmosphere can be cre-
ated in other ways. This scene in the
New York subway (figure 4–7) shows a
woman placed in such a way that she
seems to be in total distress: A wide-
angle lens makes her appear small,
she sits in the lower left corner and is
confronted by a man whose cropped
back occupies about one-third of the
image; this perspective makes him
look threateningly large from below.
From a pictorial perspective, the
woman has no escape. To her left is a
railing; to her right is the large back of
the man whose face is hidden from
view. The neon lights emphasize the
circles under her eyes and she looks
pensively, almost fearfully, towards
the man. Even if this scene were
totally harmless in reality, the picto-
rial drama gives the impression that
the man is threatening the woman.
The advertisements behind the
woman, on the other hand, give the
image an ironic twist as two elegantly
dressed young women snuggle close
to each other. This portrayal of youth
might also distress the woman in
another way because, (as opposed to
the models) she's no longer the
youngest. In the upper left corner,
another ad shows a bearded young
man with unkempt hair wearing a
scarf with the American flag and car-
rying a large clock in his right hand
and a peace sign in his left. These ads
contrast with the apparently charged
atmosphere between the sitting
woman and the standing man.

The photo was taken with an ana-
log Nikon F4 using Fuji Neopan 400
film pushed to 800 ASA.

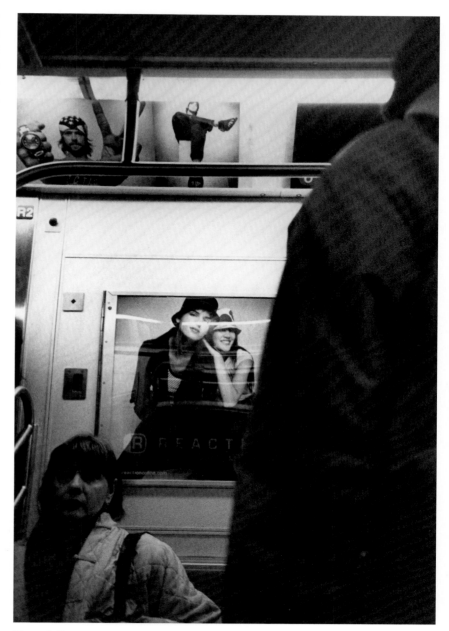

Figure 4–7

5 Why Are Moods So Important?

Just as in music, photography can express emotions. How is it possible to capture emotions in the emulsion, and to generate tones and gray tones that equal the major or minor keys of the music scale?

There are many expensive cameras on the market that can give us the highest technical pictorial quality, but even these outstanding cameras cannot create atmospheric photos; only the person behind the camera can do that. The photographer can compose a perception of the world in a tight image. Well, what makes a tight image? First, it is the pictorial content, but it is how you place that content in the image that determines the impact it will have. The following three photos taken at a beach in Lanzarote show how differently the same content can look.

As in music, images are perceived mostly at the sentimental level. Music conveys emotions that can move us to different states. This is hardly any different in photography. Images show us realistic contents, but these are wrapped in emotions, as in music. And, these emotions are communicated to the viewer in the same way in which a concert attendee hears the emotional tones of a musical composition. Photographs that lack mood may cause indifference to the viewer. However, emotionally charged photographs have the power to evoke certain emotional states when they have captured a mood in all its intensity: Emotional expression is achieved only when the flow of enthusiasm becomes part of the act of photography. Without enthusiasm and a profound, internal participation it is almost impossible to create an emotionally charged photo.

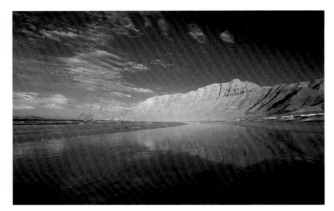

Figure 5–1

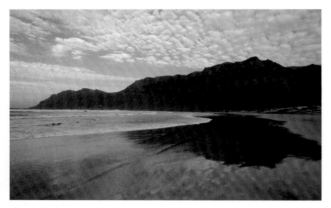

Figure 5–2

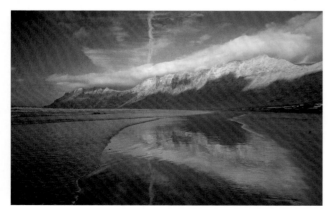

Figure 5–3

External landscapes with their various moods can reflect internal landscapes—also called "landscapes of the soul"—and their intensive expression is the art of successful, subjective photography.

Three Photos, One Place

These three photos show exactly the same view and yet they convey three entirely different moods:

In the first photo (figure 5–1) the sun lights the rock face, while the sky remains very dark. The very same rock face is almost black in the middle photo (figure 5–2) and the sky is full of rather bright, sheep-like clouds. In the lower photo (figure 5–3), a long streak of clouds snuggles up to the rock face, which—covered in light and shadow—appears to have checkered pattern.

All the photos were taken from the same spot and yet they are very different from one another.

As is shown here, a mood is not only characterized by the object, but by the weather and lighting conditions. Light is the miracle that is the basis of every photograph. Light is a mystery that illuminates objects and can make them appear radically different, as is the case in these three photos. The same mountain chain appears one time bright and transparent and another time almost black. To understand the mystery of light is one of the challenges of photography, because light is the most important element responsible for the dominant mood in a photo. The beautiful beach seen in the foreground, on the Canary Island of Lanzarote, provides a good, basic mood in all three photos, which can be compared to a musical theme that is played in a major key.

The photos were taken digitally with a 17–40 mm wide-angle zoom lens with the Canon EOS 5D, and they were later converted to gray values with a channel mixer.

Mood In a Minor Key

If the mood evoked by the three photos of the shining beach is analogous to a musical composition played in a major key, then you can compare this photo to a musical piece played in a minor key. Here, a mysterious path bordered by cypress tress disappears into the fog (figure 5–4). Fog is generally well suited for reinforcing mystical, mysterious pictorial moods. All pictorial means have been applied to pull the viewer toward the vanishing point. It's not only the central perspective that leads the viewer to the vanishing point, but the direction of the light as well. Yet the latter unfolds its magic only after the sky was overexposed by a factor of five in the lab (burned gradually towards the top); thus, the vanishing point became the brightest point. Not only the direction of light, but the subject also gives the image its mystic mood. In classical times, cypresses were often painted because they pointed to the heavens beyond: The well-known painting "The Island of the Dead" by Arnold Böcklin is an example. Cypress trees are often planted in cemeteries because of this symbolism.

The photo was taken with an analog camera using a 24 mm lens.

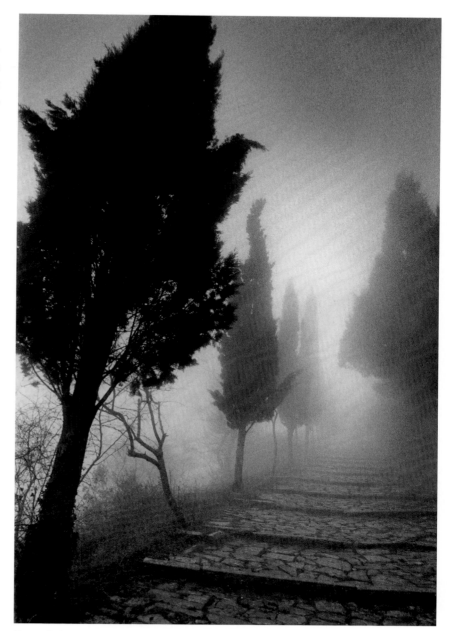

Figure 5–4

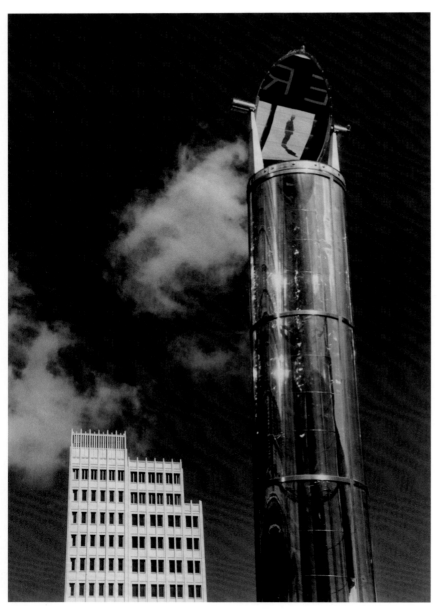

Figure 5–5

Distanced Coolness

In addition to a cheerful, melancholic, or mystical mood, it is also possible to express a cold, calm, or even menacing mood. Although the architecture of the new Potsdam Square in Berlin has an interesting design, it gives a cold impression. The person in the photo is mirrored in the truest sense of the word, maybe even symbolically. Is he being swallowed by this modern architecture? Is the architecture reducing him to a template, to become meaningless? These are questions that this photo (figure 5–5) evokes. Even such a cold impression is expressive. Regarding the composition, two radically different architectural elements dominate the photo and the two clouds connect them.

The photo was taken with an analog camera using a normal lens and a yellow filter to intensify the contrast of sky and cloud.

This photo suggests a jump to the depths (figure 5–6). Giant inflatables were fastened to the rooftops of various Frankfurt skyscrapers for Church Day in 2001. Can such a cold presentation trigger suicidal thoughts? Not really, but it certainly does not evoke a cozy feeling. The backlit cloud intensifies the menacing mood. However, darkroom manipulation gave the photograph, which was captured with an analog camera, the dark tone so important for the mood it conveys. The effects of exact filtering of tones (in this case yellow), successful darkroom work, and skillful image manipulation in Photoshop cannot be emphasized enough. The landscape photos of Ansel Adams would not have had their intensity had they been developed in any run-of-the-mill lab. Pictorial tones, whether digital or analog, must be worked out with utmost precision if they are to be compared to musical tones. Pictorial tones evoke moods that allow photos to express their power!

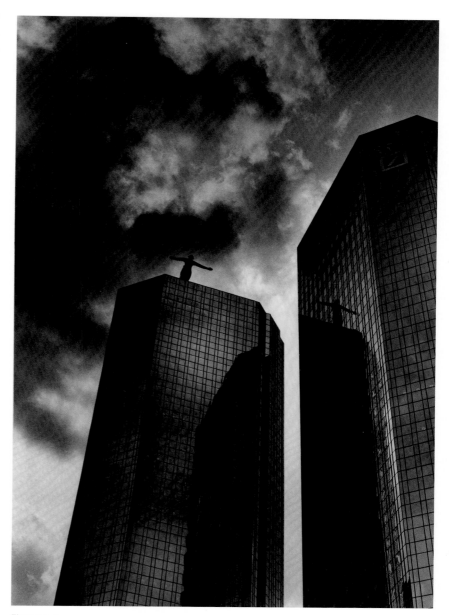

Figure 5–6

6 Street Photography

Good photography does not always have to capture special moments; it can also devote itself to the seemingly trivial and commonplace.

Photographing people on the street is a challenge. How do you skillfully integrate strangers into a pictorial composition and still manage to maintain discretion?

So-called street photography has a long tradition. As early as the late 19th century, photographers started turning their attention from the ivory towers of static, staged, and idealized artistic photography to life "on the streets". This direction often mirrored social reform. The camera served as an objective analytical instrument for documenting the dark side of early industrial modernism with its dramatic upheavals. The social fabric of large cities, in particular, underwent dramatic changes. Lewis W. Hine, for example, documented child labor in the USA as early as 1907, and his work was instrumental in the adoption of laws that outlawed the practice. Hine's image of a young boy selling newspapers on the street became famous. In the photo you can even see the shadow of the photographer and his camera on the tripod!

However, the high point of street photography started in the 1920's, bolstered by the introduction of the Leica camera. Photographers let themselves be carried away by the flux of the metropolis with its paradoxical, ambiguous universe and they photographed freely from the hand. Aesthetics changed: What was accidental, casual, surprising, fleeting, and also trivial in urban events became the subjects of these photographers. The camera served as an extension of their subjective view. The metropolitan stroller with the camera was born: The fleetingness of seemingly trivial moments of social phenomena became important to photograph, and of less interest were specific events.

The line between street photography and social documentary photography became blurred, as can be seen in the photos taken for the Farm Security Administration (FSA) Project by Edward Weston or Dorothea Lange, for example. Though often impressive, social documentation emerged from it—especially when seen retrospectively—and street photography also snatched moments from the flow of events and identified the photographer as creator of his own reality. Everything seemed to be worth photographing: The chaotic discontinuity of modern life released the photographic subjects of street photography from its hierarchy. Henri Cartier-Bresson's decisive moments are still spectacular today and reveal moments of very special importance. In the 1960's and 1970's Gary Winogrand or Lee Friedlander completely devoted themselves to the banality of everyday life; be it a dog that sits on a deserted street that has remarkably boring architecture, or a man wearing a hat walking by a McDonald's restaurant (something Edward Hopper could have painted). Street photography, despite all the apparent triviality of its subjects, is no less than an encyclopedia of the times.

The seemingly meaningless (yet meaningful) simplicity of everyday life can be captured in a photograph. How do you approach street scenes and give importance to the seemingly meaningless in a photograph?

A Foot Before Setting it Down

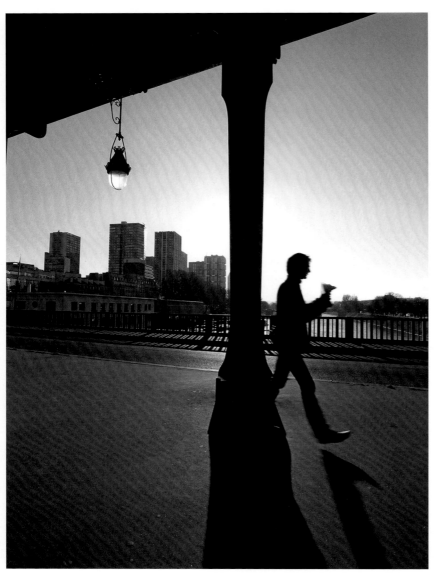

Figure 6–1

This photo (figure 6–1) also shows a banal scene: A man with an ice cream in his hand walking by nondescript skyscrapers. And yet, there is a certain magical feeling to the scene. This magic is due to several factors: The backlight gives the image its mood. The bridge over the Seine with its pillar creates an interesting graphic structure; the lamp is an anachronism that lends a bit of nostalgia; and the person is just putting down his foot,

while the leg's shadow shows below. This banal moment has been captured and enhanced to become something special through the proper use of light, composition, and design. If you see a person walking from faraway, as is the case here, and you know in which direction they are headed, it is best not to set the camera in position. People often change their course and walk behind the photographer because they want to be courteous and not block the photographer's view. To prevent their change of course, aim the camera in another direction at first and then change it to the desired position at the very last moment. However, it certainly helps to plan the composition beforehand. In this photo, the pillar divides the image into the vertical golden ratio. Pictorial tension has been created between the man walking out of the picture at right and the left part with its skyscrapers and street lamp.

Jumping Child

The moment captured in this photo (figure 6–2) also seems banal. The photo is about nothing more than a child starting to run down a flight of steps in Rome. And yet the image goes beyond this common life moment. The viewer sees the scene as if the child will jump into unknown depths, because the camera hides the steps and shows only the projecting part and a leap into the street. The child's silhouette fills the image and the photographer has captured the moment of jumping. The child's right leg is swinging forward, and the child's raised right arm stresses the dynamism of movement; a leap into unknown depths is perfectly suggested here.

How is such a street photo created? When the photographer invests enough time planning it, of course. To prepare for this photo, the composition had to be carefully set in advance. The 105 mm telephoto lens takes care of a tight perspective.

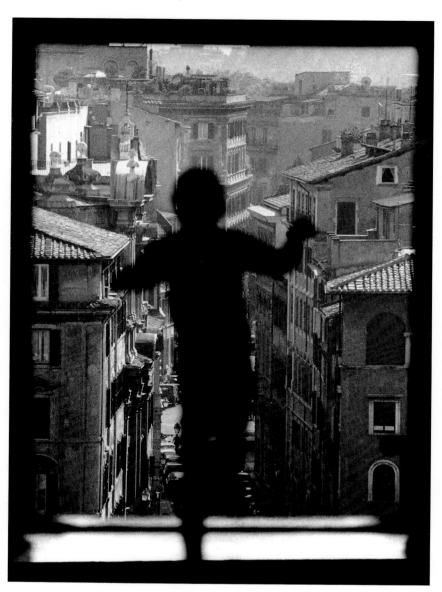

Figure 6–2

Because a short exposure time (1/500 sec) had to be chosen, there was hardly any depth of field, and the plane of focus naturally had to be set on the detailed background. With these settings, the subject would then be slightly unfocused to the viewer. The photographer had to wait about 10 minutes and make sure to shoot at just the right millisecond so the jump into the unknown depths could be suggested. Photographing the especially decisive moment was one of the primary interests of Henri Cartier-Bresson. He is the grand master who could almost always get to the photographic heart of the most complex situations.

This photo would not have been possible with the early digital cameras due to their minimal, yet crucial shutter release lag. Since then, manufacturers have solved the problem of the shutter release lag so well that it is no longer worth mentioning.

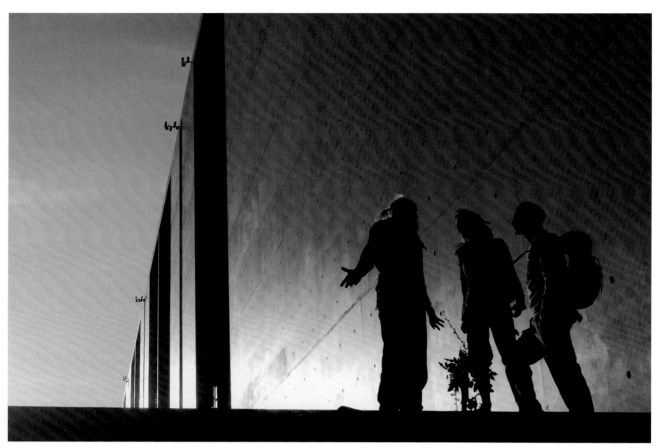

Figure 6–3

The People in Front of the Government Building

This scene (figure 6–3) takes place directly in front of the Parliament Building in Berlin's government sector. A man with a braid, who can certainly be described as a typically eccentric Berliner, gesticulates in front of two young men. It is truly street photography to capture such a moment. Backlighting is especially suitable for black and white photography, because it can show architecture and people in a highly graphic way. If the government building presented a bombastic, almost sterile impression, the brief human gathering infuses some life into the scene. In fact, man and architecture really do not go together in this photo. Although the three persons have been reduced almost to silhouettes, the impression is that they would normally feel more at home in other premises. This makes us contemplate the quality of modern architecture: Surely, such a government building expresses power and coldness; does it overpower people and make them feel like strangers in their surroundings? These three persons, however, assert themselves against the architectural coldness through their intense discussion.

The photo was taken digitally with the 70 mm focal length of a 70–200 mm Canon-L zoom lens. The image was converted to black and white in Photoshop using the Grayscale mode.

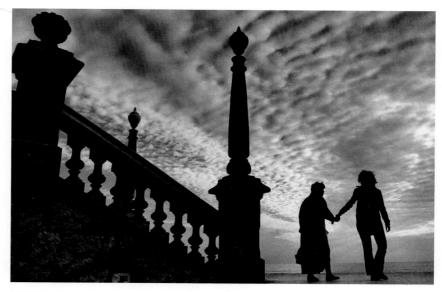

Mysterious Couple

Although nothing special appears to be happening in this image (figure 6–4), backlighting and the finely textured, fleecy clouds of the sky give it a special atmosphere. A nicely decorated railing also gives it a special, romantic mood. A somewhat strange

Figure 6–4

couple is seen coming down the stairs. Although only the couple's silhouette is seen, you can clearly recognize a rather young man who is taking a considerably older and stooped woman by the hand. Are they mother and son? Or is it a real couple such as the one seen many years ago in the famous movie "Harold and Maude"? There is a certain melancholic element to the image; youth and old age give each other a hand. The image suggests that they are inseparable companions.

The composition is strong, because it leads the viewer's eye through the image from left to right and travels down the steps with the couple, but stops at the man who turns to the stairs, thus keeping one's focus in the picture. If

Figure 6–5

you reverse the composition, it loses this effect, as you see the couple first and then the stairs; the impression that the couple has just come down from the flight of steps is lost (figure 6–5).

Calvin Klein

This image (figure 6–6) shows a seemingly inconsequential scene in New York, typical of street photography: Two men walk by a bus stop that has a Calvin Klein ad posted. Photography often can relate things to one another that have nothing to do with each other, or—as is the case here—as they relate to each other unknowingly for a fleeting moment. This ability is, however, precisely the magic of photography: It can capture two men so perfectly in an image (as happens here) that you cannot help but associate them with the reclining beauty in the Calvin Klein poster. The men seen here could be part of the advertisement: They are roughly the same age as the woman in the poster and wear suits

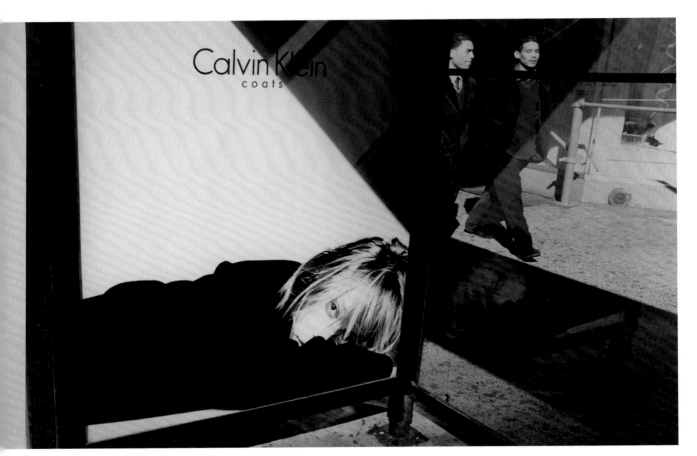

Figure 6–6

that could be from the Calvin Klein brand. Their walk is dynamic, whereas the reclining woman lazily looks at the passers-by. The woman poses as a passive person. Naturally, she also exudes eroticism; because she is reclining and looking directly at the viewer a subliminal invitation is suggested. Both men should feel the invitation of her eyes, but they ignore it and hurry onward.

Advertising and reality influence each other: Good advertising recognizes and strengthens the latest trends, or conversely, sets trends that influence people. This relationship between people and advertising is the central theme of the photograph.

The image is composed of triangles. Both men move toward the bright triangle and the dark triangle is subdivided into two smaller triangles by the metallic column of the bus stop. Although both men are headed out of the picture, the diagonal line of the bright triangle leads the viewer's eye back into it.

The photo was taken with an analog camera using a 28 mm wide-angle lens.

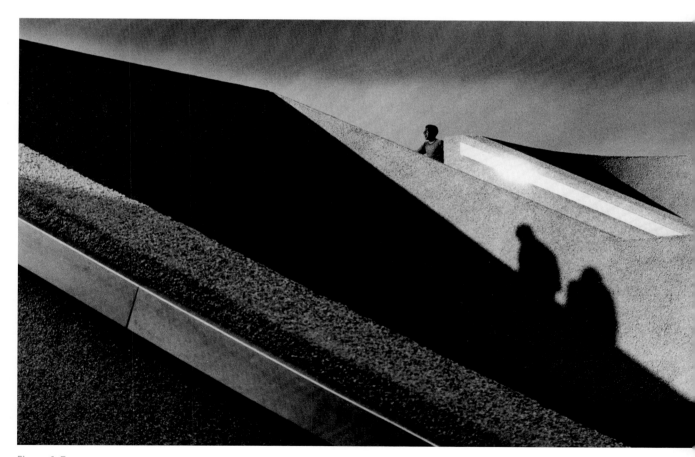

Figure 6–7

Hitchcock Atmosphere

The photo on the previous page (figure 6–7) is also a banal, everyday scene; once again it is the special atmosphere that makes the picture interesting. The railings of the subway shafts in Paris create the so-called negative diagonal from the upper-left to the lower-right corner. The eye, which "reads" a picture from left to right, is led out of this photo, but the shadows of both persons return the viewer's attention to the center of the photo. All the figures turn away from each other; even the figure of the lower shadow turns away from the upper figure. The dominant diagonal middle shadow gives the photo a feeling of heaviness, and the concrete adds an eerie, almost sinister quality.

Street photography preserves the moments that occur right next door and on the street; it makes a statement about everyday life and the feeling of being alive.

7 What Does Landscape Photography Mean in the 21st Century?

On hearing the words "landscape photography" you probably think of Ansel Adams, who is one of the world's most famous photographers. He put his stamp on landscape photography like no other photographer has, traveled throughout the most beautiful places of the U.S., and used all the technical means at his disposal to make landscapes appear heroic. Using the zone system, he divided the earth into 10 different black, white, and gray tones—each one aperture apart. In every photo, he used the zones to determine what area of the gray value curve of his negative he should expose. Just as important for creating his pictorial moods were his correct use of filters and his perfect darkroom technique. His photo "Moonrise, Hernandez, New Mexico" is one of the world's most celebrated photographs. What makes his images exceptional are not only their special atmosphere and their exact tonal values, but also the large format that shows every needle of a fir tree. Ansel Adams took photography of unspoiled nature to the highest reaches.

What innovations can landscape photographers make to surpass Adams? Is it really possible to show unspoiled, idyllic landscapes in our modern world? Surely, the answer depends on what you demand from photography. The serious amateur or semi-professional will make high demands; the representation of unspoiled, idyllic scenes in today's world will probably not be satisfactory. After all, you cannot achieve the quality of Ansel Adam's photographs with a small-format camera, be it analog or digital.

In contemporary photography, there are almost no important photographers who take idyllic scenes. Thomas Florscheutz may be one of the few exceptions, but he does not show landscapes. Instead, he shows extremely

abstracted, yet aesthetically pleasing botanical photographs. Otherwise, unspoiled landscapes are at least extremely rare or they are abstracted in contemporary photography, such as in the following examples:

- Michael Kenna shows landscape moods in his atmospheric black and white photos (in his book "Night Work," for example) consisting partly of sea, sky, and a minimal foreground of a couple elements. However, the few subjects in his images unfold their power due to special lighting.
- The Japanese photographer Sugimoto has reduced his seascapes even more. Sugimoto's images show only two surfaces: the sky and the sea in black and white are placed exactly in the middle (in defiance of classical composition rules), so viewers see only two areas of equal size with two different, almost monochromatic, gray tones.
- Michael Wesely reduces and abstracts his work in another way: This contemporary photographer—whose photos sell briskly worldwide—positions the camera horizontally during exposure, so his photos are reduced to nothing more than washed-out stripes. When the photos are seen from a distance, they resemble the scanner bar codes in supermarkets.

However, another approach started developing since the 1950's: the showing of breaks. In the modern industrialized countries you can hardly photograph an unspoiled landscape without being exposed to the criticism of showing a "lie" or "making it all prettier". In painting, the realist movement of the last century—as opposed to the naturalist movement—not only represents a pure world, but depicts social conflicts as well. Playwright Bertolt Brecht wrote a great deal about the realist movement and this movement can in fact be applied to photography. The realist movement represents the essential character of the environment instead of its superficial appearance. One of the best-known contemporary photographers is Leipzig's Hans Christian Schink. He shows the merciless attacks of the modern world against the landscape (for example, the way newly built highways or railway bridges intrude into the East German landscape). In his large-format photos, you can clearly see how concrete almost violently destroys the fragility and harmony of nature.

Photographer Heinrich Riebesehl of Lower Saxony focuses on images of pure boredom. In his well-known "Agrarian Landscapes" he purposely takes unexciting photos of the boring cultivated fields of his state under gray skies.

One of the few Magnum photographers with an interest in landscape is the Czech, Josef Koudelka. His panoramic landscapes, however, reflect no unspoiled world, but instead show abandoned tracks of human intervention in a landscape so barren that you could imagine he captured his images in a post-nuclear catastrophe.

It would be a pictorial lie to offer only the images of an unspoiled contemporary world in contemporary photography. To show only unspoiled nature, you should not show the clichéd image of an idyll, but abstract the image or create something mystical so the image goes way beyond the idyllic; a couple of examples of this are presented in the following sections.

Unspoiled Landscape With Tuareg

This photograph (figure 7–1) approaches a cliché, yet it may be legitimate because it shows one of the last unspoiled landscapes of this world, the Sahara. Thus, all pictorial means have been used to suggest the openness and wildness of this landscape. The covered Tuareg has turned his back to the viewer and has therefore become a figure we can identify with; his thoughts become ours as both of us take in the seemingly endless panorama of rocks, sand, and sky. This image suggests the full unity and harmony of humanity and nature. And, it is not a lie because the Tuareg are in harmony with their environment in ways that are absent in western industrial societies. A small break from nature in this photo is the large wristwatch worn by the man. The wristwatch indicates his contact with western civilization. Naturally, it is legitimate to take such photos in the 21st century to record a piece of unspoiled world on a chip or negative.

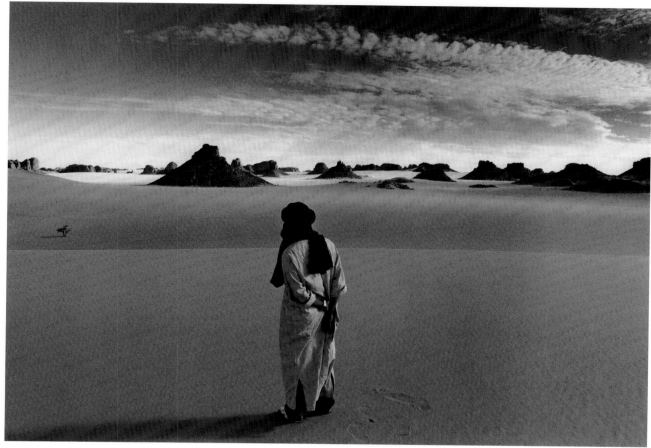

Figure 7–1

Persons and Landscape on Lanzarote

Figure 7–2

Unfortunately, the relationship of man and nature nowadays resembles this photo taken in the Timanfaya National Park on the Canary Island of Lanzarote: A woman wearing white sports clothes and floppy shoes carries a backpack, handbag, and video camera. She looks a bit lost and distracted. A man stands beside her and talks on the cell phone. In the center of this image, you can see a row of camels on which tourists sit somewhat clumsily. The scene (figure 7–2) takes place before a monotonous volcanic landscape. Both figures in the foreground stand on a paved road next to a curb that leads into the landscape. Humans and landscape do not appear connected, but rather they seem to repel each other. Humans experience nature as part of a short camel ride in the mass convoy, a totally different approach to nature than the Tuareg's of the previous photo. Here, nature is presented on a platter, as is the case in America's national parks: Visitors drive by in a car, stop occasionally, look beyond the barricades, and exclaim, "Oh, great!" With that approach, you cannot possibly experience nature in all her actual force and wildness, because there is no need to work hard in order to come close to her. Thus, nature and humans remain alien to one another, as is the case in this critical "landscape photo" that characterizes the museum-like human approach to nature in today's world.

The photo was taken with a 20 mm wide-angle lens.

Abstractions in the Sahara

If the unspoiled beauty of a landscape must be shown, you should avoid the conventional shots. A way out of this trap is to create an abstract composition of the landscape with the camera—make a landscape's abstract structure the subject of the image (figure 7–3). Saharan dunes and their interplay of light and shadow are tailor-made for this. Especially long focal lengths allow for better abstractions because they show only a cropped image of reality. In this photo, the interplay of two similar curves look as if they could be painted with an ink brush. Another important pictorial element is the curve of the small dune in the upper left corner, without it there would be no element of tension in the image.

However, it is not essential to travel to the Sahara in order to create an abstract image. The mud flats of the German North Sea coast or other local landscapes can also be excellent subjects.

The photo was taken with a tripod using the 300 mm focal length at aperture 22 to have the necessary depth of field in the sinuous dunes.

Death of Nature

The low mountain landscape seen in Germany's Harz region, for example, looks rather conventional in photos (figure 7–4). It is rather difficult to make an interesting photograph of this pretty landscape, which is ideal for hiking and enjoyment. Yet, the German forests are in peril: Only 40% of German forests are healthy. The message in this photo is the death of the forest. I used all pictorial means at my disposal to show the death of trees in an impressive and sacrilegious way. The twilight atmosphere requires a long exposure that would have been boring without the use of a flash because the entire foreground would have become pitch-black and the trees would have been perceived only as silhouettes. It was therefore important to combine the long exposure with a short flash. The flash could not be used frontally as I did not want to illuminate the trees in the foreground because the mood would have been lost. Therefore, the flash had to be used from the side, behind the first row of trees to give a part of the dead trees a three-dimensional look. Thus, the mood evoked by the light was perfect; the rising half-moon gives the scene its final touch. Differing from a conventional Harz landscape, the photo now has an allegorical scene that poses questions of how man deals with

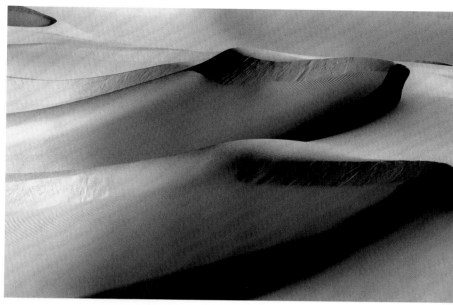

Figure 7–3

Figure 7–4

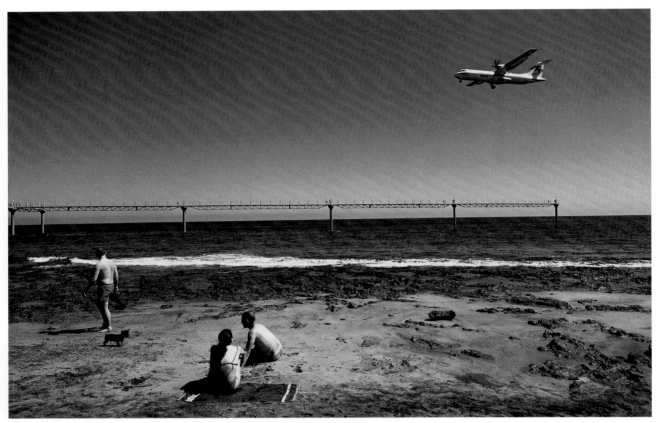

Figure 7–5

nature, and its atmosphere points to something mystical. The photo was taken with a 28 mm lens.

Idyllic Seascape with Airplane

A couple sits on the beach, the woman turns toward the man, he looks away from her and towards a small dog. Another man stripped to the waist walks out of the picture. It could have been the most harmless scene (figure 7–5) in an unbroken idyll, were it not for the lights on the horizon illuminating the approach path of an airport. The lights are on stilts in the sea and in the upper right an airplane approaches to land. This makes the photo look surreal; the modern background has broken the idyllic scene. It's important that this photo is formally composed. Take the airplane away and the image loses its balance. The airplane prevents the eye from moving out of the picture with the figures; instead, they eye stays among the people and the airplane, moving back and forth. The figures and the airplane create a compositional triangle. Any movement out of the picture is caught by a counterweight.

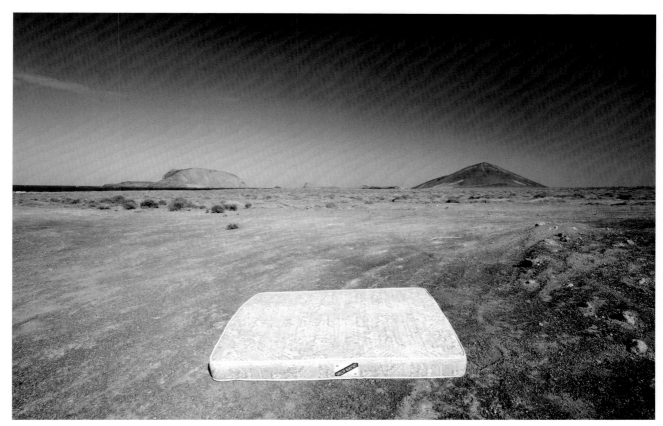

Figure 7–6

The somewhat droll landscape scene was taken with a 20 mm lens; the negative was scanned and manipulated with Photoshop. The middle-tone contrast was increased by about 30%. This image was captured with an analog camera using an orange filter, which helped to darken the sky and sea, to heighten the mood, and to give it a bit of a menacing feel, because of the filter's blue-absorbing properties.

Landscape with Mattress

In this image (figure 7–6), the viewer's gaze into the wide-open space of the landscape is obstructed. A mattress lies across the road, something that is surely not expected in such an arid landscape of the Canary Island of La Graciosa. The viewer can think about what to do with such a strange mattress. If he could turn his head 180 degrees, he would see garbage dumped more or less behind his back, and the mattress is an extension of this dump. And yet, the photo would have been completely uninteresting without the mattress, because the foreground would have been too empty. Needless to say, even this

photo does not symbolize what you probably imagine as being good landscape photography in the classical sense.

It was photographed digitally with the 19 mm focal length of a 17–40 mm zoom lens with the Canon EOS 5D. A polarizing filter turned 90 degrees with respect to the sun has darkened the sky. The transformation to Grayscale using the red channel of the channel mixer and a slight increase of middle-tone contrast enhance the mood and increase contrast.

In my opinion, these days landscape photography should touch on how the modern world affects the environment without moralizing too obviously. It is a subtle tightrope walk between the yearning to experience an unspoiled, unbroken environment and the reality that, unfortunately, banishes this unspoiled environment into local enclaves with museum-like characteristics.

8 Architectural Photography

The term "architectural photography" is often associated with those somewhat sterile photographs taken on behalf of a client for the simple purpose of showing architecture in the way the architect intended. This kind of photography is still taken nowadays with a professional (large-format) camera. A large-format camera allows the position of the film and optical planes to be adjusted relative to one another in order to correct architectural perspective in all focal lengths. Everything must be perfect in such photos: There should be no distracting elements like big cars to divert attention from the buildings, the light must be succinct, and the sky interesting. Frequently, architectural photos are taken in the "magical hour" (especially for color photography) when exterior light mixes with interior light.

Increasingly, architectural photography was made feasible with medium-format cameras and good shift lenses, but the digital method with a good back, or even a full-format camera with small-format sensor, has become the norm. Photoshop now offers options for correcting distorted architectural lines.

Looking at artistic photography, there are very few big names that are associated particularly with architecture. One of them is the recently deceased photographer, Reinhard Wolf. He was made famous by his marvelously atmospheric photographs of New York's skyscrapers, taken from all perspectives and in magical light. The enormous structures don't look cold; instead the viewer gets the feeling that the buildings have a soul.

Another of his projects was to photograph industrial buildings in Berlin in such a way that the viewer could almost recognize faces in them. Reinhard Wolf is one of the very few artistic photographers that lovingly presented individual buildings in his photographs. It is typical for professional architectural

photography to exclude the personalized, abstract view most of the time; Wolf's inclusion of that view is what has made his photographs so original.

The most famous photographers who specialize in architecture are Bernd and Hilla Becher. They are at the opposite spectrum as Reinhard Wolf, who tried to intensify his buildings to the mystical plane through magical light. The Bechers, on the other hand, photograph their buildings—whether industrial plants, water towers, or ruins—as neutrally as possible. It is their philosophy to let the object speak for itself, to be as uninfluenced as possible from extreme lighting or perspective. They work only under gray skies and try to photograph every building from a middle viewpoint. Yet their photos do have a mood. Both founded the Becher School in Düsseldorf, from which the world's three most successful photographers graduated: Thomas Ruff, Thomas Struth, and Andreas Gursky. Thomas Struth also took some rather impressive black and white architectural photos in Naples, yet it would be wrong to categorize him as an architectural photographer.

Naturally, many other photographers take urban photos. Andreas Feininger's or Berenice Abbott's frequently shown photos of New York are certainly some of the best-known examples.

As in landscape photography, a rather critical approach has become the norm in contemporary architectural photography. I have already mentioned Hans Christian Schink's images of concrete architecture. In his often shown series, "Neon Tigers", Peter Bialobreszki shows the faceless architecture of giant new buildings under neon light in Asia's exploding metropolises. In principle, he photographs his buildings only under transition lighting; the flood of neon lights of Asian metropolises mixes with the skylight at dusk and virtually floods the buildings. This effect gives the ugly giant buildings a certain gracefulness, and this effect is intensified by a careful overexposure of the images. Whether this approach really does justice to the character of modern Asian architecture is another matter.

Yet another approach to representing architecture is seen in the works of Harald Mante, who loves to make abstract the architecture of southern European countries. For example, he makes the Greek walls, windows, and roof overhangs look like abstract pictures. In his well-known instructional books, he often works with these abstractly designed shape and color examples. However, the thought of using architecture as an abstract interplay of shapes is not new. As early as the turn of the 20th century, the Russian Photographer Alexander Rodtschenko turned the world on its head, so to speak. Like Russian constructivism, he used architectural lines abstractly to emphasize the line interplay of oblique lines and shapes; the shape and not the content was clearly the dominant element in his representations. After the Russian Revolution, dynamism became part of the new expression, and this expression of dynamism and faith in progress is reflected in Mante's architectural photos of the ultramodern buildings of the era.

How can you, as a photographer without a large-format camera, approach the subject of architecture in a lively way?

Figure 8–1

Photographing Architecture Digitally

A large facility management company commissioned this digital photograph (figure 8–1) for their office decor. The almost 13-megapixel resolution obtained with the full-format sensor of the Canon EOS 5D allows the photo to be printed to a width of almost 48" without the naked eye perceiving the pixels. And, this width is achieved despite the fact that the resolution at this size is less than 100. Naturally, pixels can be calculated even smaller through Photoshop's image size function (which works rather well) if the size is not exaggerated. Even at this size, sharpness is still amazing and can be compared to the resolution obtained with an analog 4.5 x 6 medium-format camera. The photo was taken with the 17 mm wide-angle lens, which can almost capture in one picture (much like a fish-eye lens) the entire roundness of the Omega House building complex in Offenbach. The bare tree has a powerful graphic effect because it is an organic counterweight to the architecture. The trunk is located at the left perpendicular dividing line and subdivides the image. Because the Canon's sensor takes in a wide range of light, it was easy to obtain enough definition both in

the bright sky and in the dark tree trunk. The image was converted to gray values in the channel mixer, the shadows were slightly brightened with the Shadow/Highlight tool, and the middle-tone contrast (found in the same tool) was increased by about 20%. In such a photograph, a shift lens is not needed, because distortion is an intended element of the design.

Figure 8–2

Man and Modern Architecture

This photo (figure 8–2) is quite different from the previous one. Here, a shift lens was needed to prevent the Frankfurt Tower and its reflection from appearing to fall over.

To liberate modern architectural photos from appearing sterile, you must apply several photographic principles. What makes this photo so interesting is that it mixes different planes to the point of almost penetrating each other. The various reflections within the architecture of the Frankfurt Fair Grounds create this composition. Particularly important to the composition are the architectural beams, however, because they give the photos its varied abstract structure. Another feature that makes the photo interesting are the three persons located on different planes. The people are silhouetted; shadowed figures that appear almost overpowered by the modern architectural backdrop, even to the point of looking unimportant. The Fair tower is surely one of the prettiest skyscrapers in Frankfurt as it majestically projects into the sky. However, in contrast to such architecture, people appear smaller and seem to lose their importance. This photo captures this tension between man and heroic, striving architecture; it shows man interwoven with the skyscraper's abstract structure, and that makes the photo interesting.

Without the Mamiya 50 mm shift lens, which corresponds roughly to 32 mm in small-format, the tower and its reflection would appear to fall over as mentioned above. This appearance of tilt is caused when a camera with a normal, wide-angle lens is positioned at an upward angle causing the plane of the sensor (or film) and the plane of the building's face to not be perpendicular. The next and subsequent photos prove that good architectural photographs can be taken without using shift lenses.

Concentrated Effect with Telephoto Lenses

Both photos shown on the previous two pages were taken with wide-angle lenses. These lenses created a powerful architectural effect, but telephoto lenses would create the opposite effect in architectural photography. Both photos represent architecture's static side. Using a 100 mm telephoto lens generally results in the straight alignment of buildings, which makes it an alternative to the pricey shift lens. Naturally, the degree of distortion in a telephoto lens depends on the angle of the camera in relation to the building. In this photo (figure 8–3), the focal length was 280 mm. With such a long focal length, almost all the lines appear parallel. The picture shows the graphically interesting interlacing of two fire escapes in a modern office building in Offenbach. The composition is a photographic architectural abstraction. The picture was digitally photographed and converted to gray values with the channel mixer. The Shadow/Highlight tool brightened the shadows a little bit.

The composition has a symmetrical axis: Two steel supports run through the vertical center and reflect both spiral staircases. The risk in such a composition is that it can often appear stiff, but this photo overcomes this problem by showing two differently sized spiral staircases. Apart from its axial symmetry, the photo comes alive from its pictorial rhythm: The arched shape of the spiral staircase is repeated five times, thus creating this rhythm. The rectangle in the lower part of the image provides a counterweight to the arched shapes of the staircases.

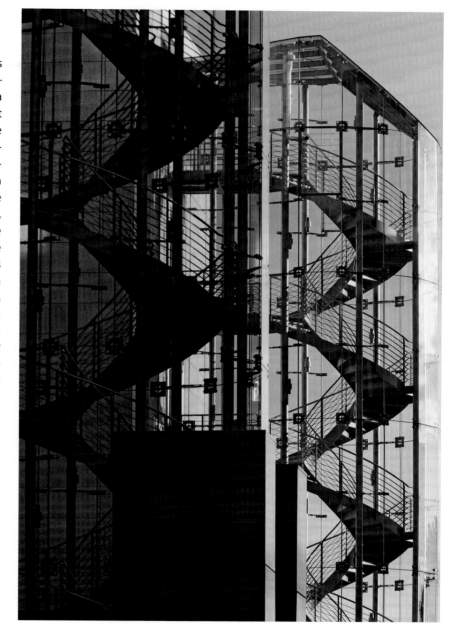

Figure 8–3

Figure 8–4

The second photo (figure 8–4) gives the impression that the buildings are very close to one other. The 200 mm lens not only causes this effect, but also does not create any falling lines in the image. This photo shows an interesting graphic interaction of horizontal and vertical lines of two modern buildings in New York with old, ornate houses embedded between them. This photo's abstract composition rests on an exciting graphic web of light and shadow, bright and dark surfaces, perpendicular and horizontal lines, and a few playful organic forms. It shows that architectural photography is not necessarily slick and cold. In this analog photo, it was very important to define the shadows by dodging the right and lower sections. And during scanning, it was also important to make sure that the left arrow of the histogram was fully on the edge of the shadowed areas.

Modern Glass Architecture

Modern architecture is often very clearly and simply structured and comes to life from the transparency of its large-scale glass construction. And yet, how do you photograph a building such as this one that does not have any ornate or strong graphic structure (figure 8–5)? A shift lens would be lethal here, because the distortions created by an extremely wide-angle lens would create especially interesting effects. However, the building by itself on such a gray day would not have been interesting enough. When I photographed the building I could not use the interior lighting, so it made sense to me to add a second element: the angle formed by the street sign perfectly imitates the lines of this building in Berlin's downtown scene. The sign symbolically encompasses the building and is a graphic element that also contains a strong black tone, thereby creating the proper counter tension to the rather gray building and helps create an interesting photo in spite of the boring weather conditions. It was also very important to use a gradient filter to gradually darken the upper part of the sky. This compositional aid also adds tension to this photo. The digital photograph was converted to black and white using the Grayscale mode. Afterwards, the middle-tone contrast was increased a little with the Shadow/Highlight tool. If you don't have a gradient filter, the effect can still be created with Photoshop; however, a photo taken with a real gradient filter generally looks more natural than when you add a gradual darkening later.

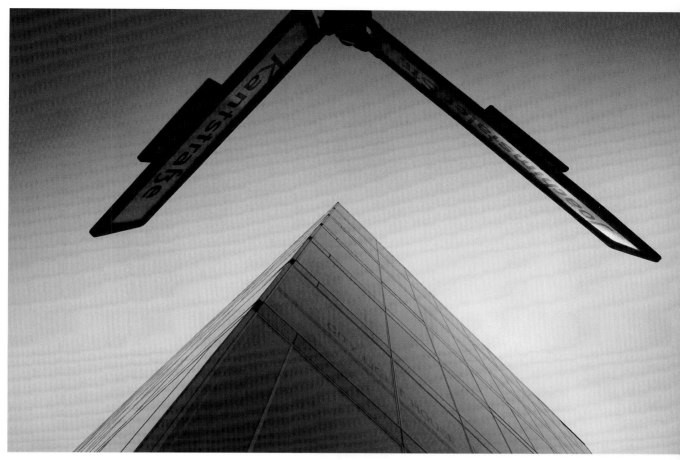

Figure 8–5

Model as Window Dressing

A large project development company that designed the new Western Port Tower in Frankfurt commissioned this photo. The view from this interesting structure was grandiose, so it made sense to enhance the view to a sacred sphere with all compositional aids. A model serves as an identification figure for the viewer, following in the footsteps of German romantic painter Caspar David Friedrich, who often did just that (see, for example, his "Wanderer Over a Sea of Fog"). A human standing in front of the wide expanse of a landscape or an urban setting invites you to identify with him or her, especially if the figure's back is turned to you or if the figure is reduced to a silhouette. A suitable and strict axial symmetry contributes greatly to the photo's sacred expression. The woman becomes the vertical symmetrical axis, from which the window triangles are perfectly mirrored. The gradient filter used here darkens the sky appropriately and provides a good contrast to the city's architecture that is illuminated

by the sun. Frankfurt is a fascinating city for black and white photography because its numerous modern office buildings provide fascinating contrasts and design structures.

This photo was taken digitally and converted to gray tones with the channel mixer (90% red channel and 10% blue channel).

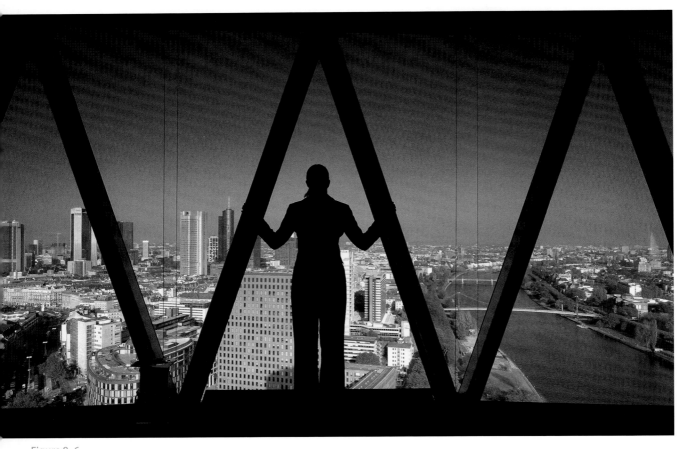

Figure 8–6

9 The Graphic Element in Black and White Photography

Black and white photography restricts the image to black, white, and gray tones. You can even eliminate gray tones in a black and white image to create a strong composition. Reduction is a very important design element—not just in photography, but in modern art as well. Many painters (such as Piet Mondrian) gradually moved from a complex composition to simple shapes, to the point of almost reducing the picture to a monochromatic surface.

However, black and white photography is about something else: An image without color emphasizes the graphic form. In black and white photography, pictorial content is based on a more or less graphic, abstract image structure. Photojournalism can also strongly convey the content, such as in this basic graphic structure. A fundamental component of black and white photography is the interaction of light and shadow. Looking through the viewfinder, it is essential to abstract and design the interaction between light and shadow. This is easier said than done, because it is not always so easy to ignore the influence of color. In analog photography, it can mean using a red filter, for example, in order to reduce the photo's colors to one color, namely red. The photo becomes almost monochromatic and thus it is easier to imagine it in black and white. With good digital cameras it is possible to take one test photo in black and white mode and view the image on the camera's display. The final picture should be taken in color mode, however, and converted to black and white with an image manipulation program.

The Russian photographer Alexander Rodchenko (mentioned earlier) was one of the first photographers to allow the abstract, graphical structure of an image to dominate its content. In "Girl with a Leica", one of his most famous

photographs, he tilts not only the bench on which the young woman is sitting to make it a diagonal, but he also uses a monochromatic play of light and shadow scattered over the entire scene. The photo does not intend to show the girl as an individual; it is all about a fascinating compositional design.

Another outstanding personality, this time of post-war Germany, was Otto Steinert, whose works helped post-war photography reach new heights. Under the concept of "Subjective Photography", he postulated the photographic medium as the expression of one's own feelings and moods. He was a master of abstract structures, radical crop, contrasty prints, and the representation of sometimes surrealistic moods. His negative prints and solarizations follow the tradition of Man Ray and László Moholy-Nagy. His best-known photo shows a moving, blurred pedestrian photographed from above with a tree trunk surrounded by a graphically interesting, circular rusty grid. The emotionally charged "Subjective Photography" created with the help of all graphic elements had a profound and long influence on post-war photography until the rather down-to-earth Becher school gradually created a sort of movement against it.

One of the early masters of graphic design was the Hungarian photographer André Kertész. Many of his works now rank among the most famous photographs of the last century. His photograph of a fork on the edge of the plate is an example of one of the first very simple, abstracted, minimalist representations of an object and its shadow. Kertész was one of the first photographers who captured the ordinariness of everyday life in a wonderfully graphic way. It's sad that he had to suffer the loss of many of his negatives twice in his life. He was a friend of Brassai's, whom he also impressively portrayed.

Such graphic black and white photography does not play an important role in contemporary art. However, black and white photography characterized by such pictorial compositions is still very much in demand in photojournalism. The war photographer James Nachtwey is an example of how someone can combine good graphic design in the tradition of Cartier-Bresson with the incredible emotional charge of a tragic subject matter. Nachtwey is certainly the best-known war photographer of modern times. A film made about him has helped to make his work known to a wider audience. Not without reason, he works in black and white, because with color photography there is always the risk of putting an attractive, esthetic veil over things. A moody sunset in orange would surely be counterproductive to depicting the intentions of war.

The grand master Henri Cartier-Bresson also consciously chose to work in black and white. He was unsurpassed when it came to capturing decisive human moments; he incorporated these moments in a complex pictorial event in which the abstract, graphic composition was the perfect fundamental element. This photographer stressed the graphic blending of man with his more or less architectural surroundings.

Light and Shadow as Basis of Compositional Design

In this unspectacular photo (figure 9–1), light and shadow are the real subject matter. The family has been reduced to shadows. The paving of the curb is deteriorating. In the middle of the image, a large piece of concrete has broken loose, and the cracks in the concrete create interesting, organically flowing lines everywhere in this photo. In addition, the concrete stone blocks create a network of lines that flow uniformly. This network, made up of uniform and organic lines, is an element of tension with respect to the interesting shadows. Here, the design has reduced reality (i.e., people) to their shadows only. The photo was taken in New York and proves that the skyline with the Brooklyn Bridge does not always have to be the only interesting pictorial subject. You can probably take images such as this one right in front of your doorstep; you only must change your way of looking. Instead of setting your sights on reality, look downward to discover the world of shadows. Once you do this, you may capture the exciting moment that will result in a successful composition, which is created by the interesting graphic structure of the shadows.

The photo was taken with a 28 mm lens.

Figure 9–1

Axial symmetry: An important compositional concept that is referred to many times throughout the text, therefore the reader should become familiar with its definition.

Axial symmetry refers to the popular definition of symmetry as mirroring in respect to an axis. Axial symmetry primarily differs from other kinds of symmetry by containing objects that mirror each other. Furthermore, the mirroring objects relate to each other across a given axis that is either marked or unmarked.

The axial symmetric picture consists of two mirroring parts which start out by counterbalancing each other compositionally, thus often creating compositions that are statically in balance.

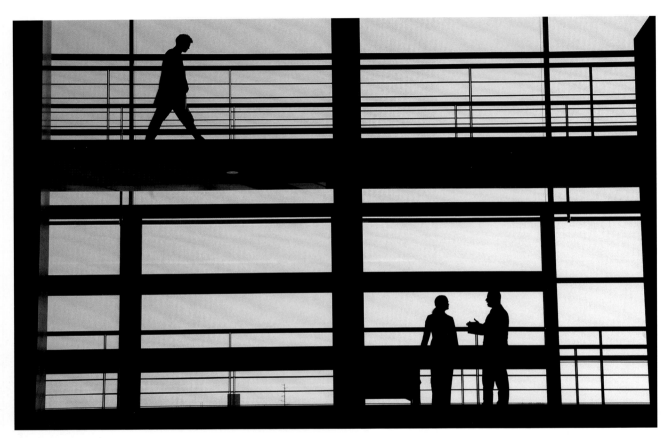

Figure 9–2

Figure 9–3

Reduction to Verticals and Horizontals

This photo (figure 9–2) of the Frankfurt stock exchange is an image that suffices with almost no intermediate tones, and therefore has an extremely powerful graphic impact. The photo is characterized by axial symmetry, and although the perpendicular beam in the center also indicates the vertical axis of symmetry, the image would be stiff and boring without the human element. The silhouettes of the three persons make the photo interesting. In the lower floor, we see a man and a woman in conversing, while a man walks by above them. The walking man has been captured in such a way that one can clearly see his quick pace and his dynamic movement. This graphic abstraction of people in modern surroundings is pure black and white photography.

The photo was taken digitally with a 200 mm focal length under backlit conditions. Looking at the histogram (figure 9–3), you can see that almost all medium tones are missing. When measuring the exposure, it was essential not to allow any light to burn out and to have some texture in the shadows of the beams. In good digital cameras, such as the Canon EOS 5D, it is possible to adjust a mode on the Info key that, when blinking, indicates where the lights have burned out. If burn out has occurred, try to underexpose the photo a bit until nothing important blinks any longer in the display. By photographing in the RAW mode, you can brighten the areas that have become too dark without losing texture in the lit areas.

The Lively Finishing Touch

In this photo (figure 9–4), it was important to move away from the rather colorful design of Frankfurt's Zeil shopping arcade and create an abstract, graphic pattern within the entire architectural variety found in this arcade. To organize the various structures in this photo, it made sense to create a basic symmetry on which the composition could rest. Thus, the escalator becomes the vertical symmetrical axis from which the image to its left and right has a roughly matching symmetry. This symmetry, however, is not rigid, but is broken up by sufficient detailed shapes. The photo's basic graphic structure is thus an interaction of long diagonal lines and short horizontal lines, as well as of many smaller rectangles that make up the floor structure. Embedded into

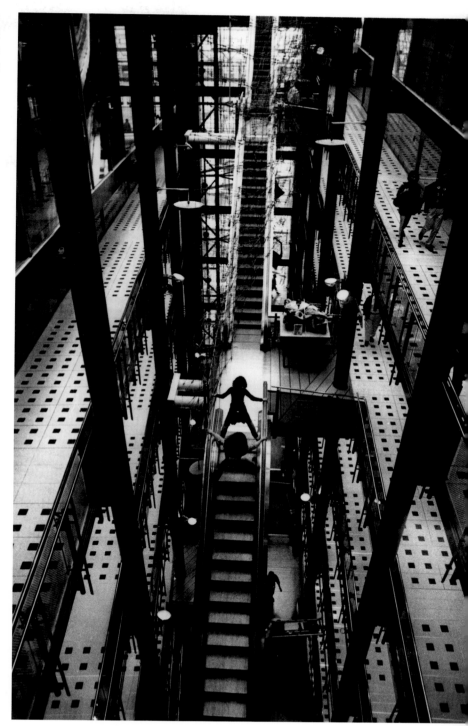

Figure 9–4

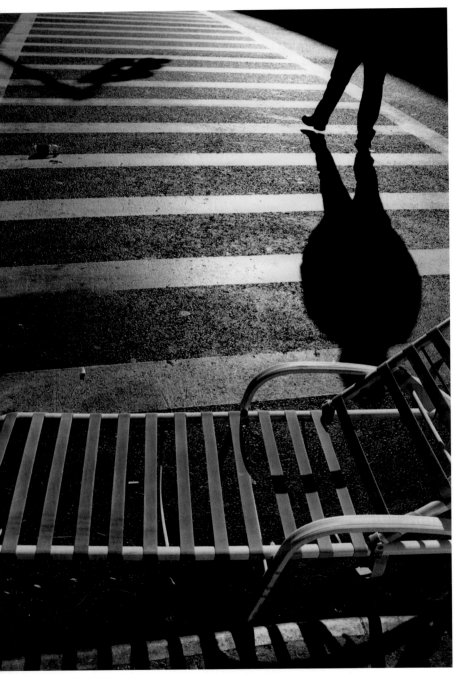

this pattern lays the photo's finishing touch: a girl in the middle of the scene who extends her arms and legs. A second girl follows behind, but she doesn't stand out as much. The girl in the center of the picture breathes life into the photo, because without her the architecture would have been too rigid.

Needless to say, it was necessary to wait a long time until this scene could be taken with the 20 mm lens.

Lounge Chair on the Crosswalk

This photo (figure 9–5) reminds one of a Hitchcock movie. A broken lounge chair lying in the middle of a crosswalk obstructs the view. On the crosswalk you can see nothing more than a discarded water bottle, the shadow of a traffic light, and the legs of a man's shadow. Houses around the crosswalk are not included in the photo, and even the end of the cross-walk is hidden from view, as is the actual shape of the man. Perhaps all these unknown elements are what lend a somewhat eerie quality to this photo. The graphic structure also gives its content a marked pictorial rhythm: The gradually narrowing lines of the crosswalk match the rhythm of the lounge chair's lines that are per-pendicular to them. Once again, with-out the cropped man and his shadow this scene would have been rather monotonous. Here, a person has been embedded into an abstracted scene characterized by a pictorial rhythm that has graphic impact.

Figure 9–5

Iron Footbridge

LIFE manazine photographer Andreas Feininger repeatedly stressed how important it is to thoroughly examine an object before photographing it. This applies, naturally, only to immobile objects, not to snapshots. The iron footbridge in Frankfurt is such an immobile object, and therefore it made sense to first look carefully at it from all viewpoints in order to find its most photogenic angle. Such a steel bridge is ideal for creating a more or less intense graphic abstraction. Thus, this photo (figure 9–6) gets its esthetics almost exclusively from the shadows on the bridge; especially from the pictorial rhythm seen in the gradually narrowing rosettes of the railing, but also from the intense shadows of the supports. This composition would not have sufficed without the person's legs approaching the viewer. The gradually receding shadows on the bridge create a movement towards the distance, and the approaching person, on the other hand, creates a forward, counteracting movement. This counterplay gives the photo its dynamic quality. Once again, there are hardly any middle tones here, making this photo a graphic reduction.

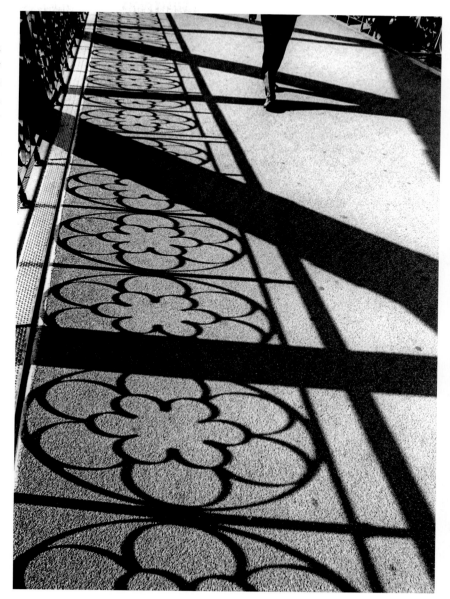

Figure 9–6

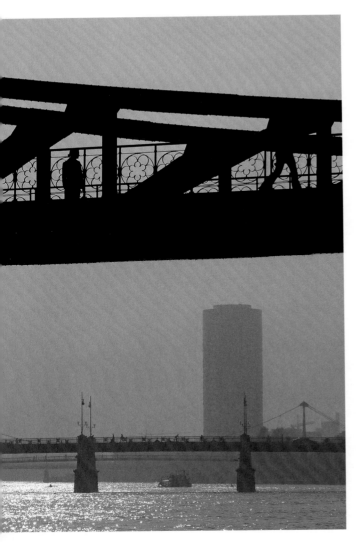

Another approach to photographing the same iron foot-bridge is seen here (figure 9–7). This photo's strength comes from the mood infused by the backlight. In spite of the backlight, it is very graphic, as can be read in the histogram (figure 9–8), because the diagram swings only in the black areas and in a rather bright gray area. In the upper part of the photo, the iron footbridge stands out graphically from the background; two persons give the photo some additional life—a standing figure in the upper left and another one reduced to show only legs on the upper right. Three more bridges provide an additional graphic element in the lower part of the photo. In addition, the new Westhafen Tower rises majestically over the river, which is shimmering in black light.

The photo was taken digitally and proves, as mentioned several times before, that a good digital camera can tackle backlight outstandingly as long as you underexpose the scene a bit and make sure not to burn out any lit areas. In particular, these photos show that the range of light that can be handled with the RAW mode is significantly greater than with JPEG mode. In any case, you must precisely control such a backlit photo with the help of the histogram and the blinking display to check for burned out lights in order to determine the correct exposure value. It is a good idea to test the exposure before taking the actual picture.

Pictorial rhythm and graphic structure are the basis of black and white photography; it is always exciting to detach oneself from color and get involved in the very specific rules of black and white photography.

Figure 9–7

Figure 9–8

10 The Poetry of Melancholic Moods

In our contemporary society, which is characterized by suppression, melancholy is often frowned upon. Yet, what would art or the world of photographic images be without the special poetry of melancholic moods?

Although, in today's fun-loving society a melancholic person is seen as a spoilsport, Leonardo da Vinci saw melancholia as a special quality that was an important prerequisite of the artistic personality. However, in former times melancholia was not linked mainly to taking everything seriously; rather, it was defined as an impulse to seek out the depth and true nature of things in a quest to turn away from life's superficialities. If you carefully read about the lives of numerous composers, writers, or visual artists you will notice that melancholy characterized their lives. How much would the world lack if it didn't have Hermann Hesse's writings, Rainer Maria Rilke's poems, Van Gogh's canvases, Caspar David Friedrich's grand landscapes, Edward Hopper's urban scenes, Ferde Grofé's suites, or Rachmaninov's piano concertos? From this you can discern a fundamental truth: It is the nature of many artists to pour the "unbearable lightness of being" into an art form and to fathom the deep nature of things. Why should photography, as an artistic way of representing the world, not also participate in this expression? And it is especially in photography, as we have seen above, where the tendency is to produce pretty, clichéd photos. In reality, viewing a sunset is certainly a fascinating and exhilarating experience, but it's nearly impossible to avoid creating a clichéd photo of a sunset that has already been seen innumerable times! A photo will only then be really successful if, whenever possible, it does not compare badly with reality at all.

A photograph of a sunset will usually compare very badly with the real thing; but photos of much more banal subjects that are intensified in a composition

can sometimes express more than the real subject. How many photographic artists have succeeded to intensify banal subjects by converting them to master photographs? This is a much greater art than just photographing impressive moments such as sunrises, sunsets, or grandiose images of landscapes and cities, many of which have become clichéd photos. With this in mind, a plea for including melancholic moments in photographs should be understood.

With that said, it is one of the biggest mistakes to follow the rule to leave the camera at home when it is raining or the skies are gray, because the changing weather conditions can also tell stories or be allegories. However, many photographers fail when attempting to shoot in the rain, which is almost impossible to capture with the camera. Only backlighting is capable of making rain clearly visible on film or sensor. In the cinema or on television, rain is usually lit with strong backlights. If you want to capture rainy conditions on photographs, try including damp windowpanes of all kinds in your images. Or you can photograph at night, as Robert Hausser did in his impressive photo with the rain being illuminated by a street lamp at night, falling on a bench and the asphalt, and photographed with a slightly long exposure.

A melancholic mood can be expressed through changing weather conditions, as does the representation of abandoned places or objects (most of the works by Robert Hausser can attest to that). The feeling of melancholy can also be vividly reflected in the human countenance and tell the story of that person's life. A master of melancholic poetry is the photographer Josef Sudek. He has infused all his subjects, whether landscapes, cities at night, abandoned gardens, or still lifes, with a hint of melancholy that does not depress the viewer but instead stops and grants him a moment of contemplation.

Rainy Beach

A beach generally means sun, blue sky, sand, and an easy life, but in the next photo we see a leaden sky viewed through raindrops. Yet, the sky and raindrops are exactly the poetry in this image. "It's as if every drop would tell a story", said Mario Hene about rain. "Panes are slowly getting blind", reads his praise to rain running down the windowpane. Friedensreich Hundertwasser also loved rain above everything else, to the point of even naming his houseboat "Rainy Day". Rain does have a certain poetry to it, if you can discover its magic. Thus, this image (figure 10–1) of a rainy beach in Lanzarote is a lot more interesting and moody than a beach photographed for the hundredth time under intense sunlight, or even a sunset over the sea.

The photo was taken digitally with a 35mm focal length and the Canon EOS 5D; sharpness was adjusted to the background. In spite of an aperture 22, the raindrops in the foreground are not in focus, and this is exactly what makes this photo interesting. Even with professional zoom lenses, it is difficult to work with depth of field, because they generally do not have depth of field control.

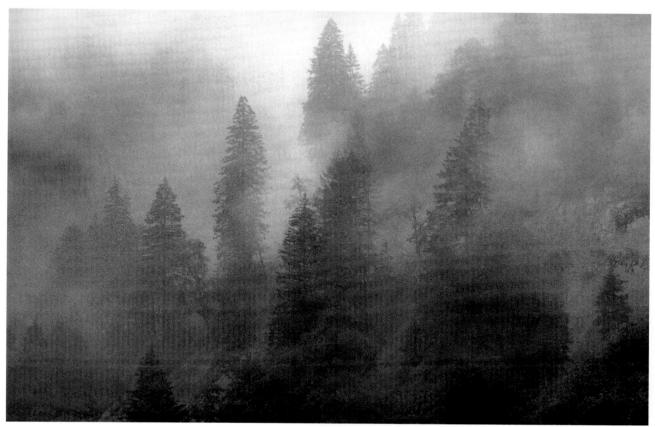

Figure 10–6

Fog in Turkey

Here, fog settles like a delicate veil on the tall evergreen trees of the Katschkar Mountains in eastern Turkey (figure 10–6). Without the fog, such a forest land-scape would have looked rather commonplace, but the fog adds an extra some-thing to the image—a breath of fairy tale melancholy. It appears as if elves and fauns could live here, just like Arnold Boecklin often painted them in his land-scape canvases. Fog creates a delicate interplay of the most varied shades of gray that were enhanced in the darkroom through careful dodging and burn-ing in.

The photograph was taken with the analog Nikon F4 and a 200 mm tele-photo lens and enlarged on grade 4 paper. The relatively large grain of Kodak's Tri-X Pan is actually perceived as pleasant in such a foggy picture. However, you can obtain the same impression of film grain digitally.

These examples will hopefully motivate you to find inspiration in gloomy and melancholic moods that may lead to poetic images. After all, these senti-mental tones belong to the varied range of existence.

11 Abstracts

Photography took the place of 18th and 19th century naturalistic painting. Starting with impressionism, painting went in its own direction and has increasingly liberated itself from a natural way of viewing the world. The exception was the realistic movement that emerged from naturalism. In painting, the realistic movement had the task not only to depict reality, but also to represent deeper traits of reality.

Photography had taken over the representation of nature, but photography also had to liberate itself from the restricted representation of reality. Thus, the movement to take photography out of the convention of the realistic representation began at the turn of the century with the Russian photographer Alexander Rodchenko, and in the 1920's with Hungarian photographer László Moholy-Nagy and his famous "Photograms".

It may seem that an endless variety of abstraction methods have been used in photography. However, what does abstraction really mean? According to the dictionary the meaning of abstraction is "detachment from material things". Thus, abstract thoughts start detaching themselves from objects and developing their own inner life, and exactly the same holds true for pictures. If painting makes reality into an abstract and presents a new creation of shapes and colors, then the fact is that photography is always the portrayal of an objective world. And yet, for photography, the concept of "abstraction" also means a detachment from the world of objects. When, for example, the abstract structure of a picture becomes the meaning, photography has detached itself from the actual object. Although pictorial meaning is based on an abstract structure, as frequently stressed in the example images throughout this book, most viewers are accustomed to noticing only the pictorial meaning. Only when the

subliminal pictorial structure is seen abstractly (i.e., detached from the object) and found to be interesting will the pictorial meaning become powerful. In order to test the abstract structure of a very objective photo, it's a good idea to turn the image upside down, because then it will be easier to "lose" its connection to reality and its abstract basic structure will become visible to the eye. This structure is the basic pattern that pervades the image, the interplay of lines, shapes, and structures of all kinds. A master of abstract design was the painter Vassily Kandinsky. He developed an entire philosophy about how the most varied shapes could be placed next to one another to create tension. He saw this as an act of creation.

In photography, the art of good design is to work out a composition for the subjective interplay of forms that is the basis for all objects, and to frame the objects with the viewfinder in such a way that an exciting abstract pictorial structure is created. In summary, meaning can become dominant over form, meaning and form can be balanced, or the abstract shape can eclipse meaning. A detailed view can sometimes tell a bigger story than a complete view.

However, it is risky to photograph structures because one can quickly fall into rigid formal images that have lost their meaning. The photos taken in amateur photo clubs are full of these kinds of structural pictures. Although they are certainly good for practicing composition, because they train you to abstract reality, they are purely formal pictures. The pictures should be about meaning that has become so abstracted that through the photograph you come close to the nature of the respective object.

On the other hand, the abstraction may be so successful that you can see a well-known object in a new way. For example, the Dadaists declared their collages (old, ripped-off advertisements and the like) to be art and placed them in museums. They detached these old, tattered advertisement scraps from a conventional concept to see them in a new light and rediscover their tactile appeal and sensory nature.

Kurt Schwitters was a Dadaist artistic leader, and in photography, the surrealist László Moholy-Nagy was one of the masters of abstract structures. His photograms of faces were abstract, but also deeply spiritual. In his best-known portrait, he placed his own cheek on the photographic paper. The photo resembles the image of a planet in the night sky.

Just as one cell in our body contains the fingerprint of the entire body, a detail should provide information about the entire structure from which it originated and not be a formal end in itself.

Figure 11–1

Traces of Time

Those things in which time has etched its traces can be especially interesting. They are found mostly in southern countries, because in Germany such objects, whether they are disintegrating walls or rusted-out gates, quickly become casualties of renovation. Naturally, there are still a couple of exceptions, as is the case here in Brunswick (figure 11–1). It is a mystery how time changes everything that we humans attempt to straighten out and order into a uniform monotony, converting it back to the original organic state. This image almost lets you feel the texture of the wall. It is important for structures not to become the object itself, but rather to describe a mysterious content. After all, the palace around the corner is really the conventional subject to be photographed, rather than this dilapidated wall. We must liberate ourselves from such clichéd ideas, and rethink what is worthy and not worthy to be photographed. After all, the letters on this wall tell a story about the riddle and passing of time.

The photo was taken with the normal focal length of an analog Nikon F4.

Figure 11–2

Light and Shadow

This photo (figure 11–2) is characterized by a diagonal pattern of shadow lines that create a strong contrast. It shows the right side of a rusty door whose hinge can still be seen in the top. The dividing line between the door and its surrounding wall lies exactly in the section on the right vertical hamonic dividing line. The image lives from the structure's tactile appeal, emphasized by the sunlight falling obliquely on it, which creates shadows even from the small uneven areas of the door. This delicate structure is overlapped by the rough structure of the two large shadows, the four small shadows, and by the shadow in the upper right corner. These long shadows lend the photo its power and tension. The door is in Jerusalem's Old City, and the effect of time is noticeable here as well. You should not forget that when looking at such an image, you can detache yourself from the concept itself. In other words, if you associate the photo just with the concept of "old rusty door" and reduce it to this concept when looking at it, you devalue the picture. Images are much more than the linguistic concepts that attempt to explain them. The more you detach yourself from such concepts, the more you will allow an image such as this one to exert its influence through its varied textural appeal and be able to enjoy it.

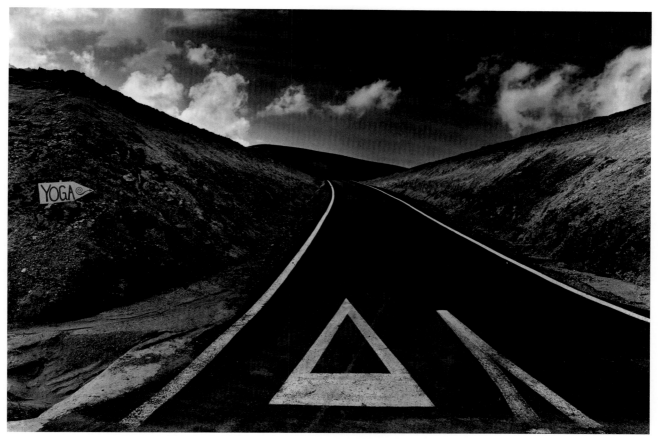

Figure 12–1

the dark, merciless surroundings. However, it is above all extremely surprising because nobody would think that a comfortable place where yoga could be practiced could really exist in this environment. Black is the dominating color on this extraordinary Canary Island, as is also the case in this photo. It was important to bring out the white highway stripes in the darkroom and to increase their contrast as well. In addition, the sky had to be burned in so no "white hole" would appear on top and the clouds could stand out dramatically from an almost black sky.

The photo was taken with an analog camera using a 20 mm wide-angle lens.

Cemetery Tombs with Volcano

The next photo (figure 12–2) was taken on the Canary Island of La Gomera. "What are these dark, strange, and mysterious rectangles?" asks the viewer. They lend the image, together with the volcano protruding above them, a surreal effect. These are the tombs of a cemetery in which long ago the dead were

Figure 12–2

placed, as was custom in more southerly latitudes. The photo, therefore, does not only refer to the layers of the subconscious, from which countless ideas about death have originated, but it also points to the spheres lying on the other side. We are reminded of the paintings of Italian artist Giorgio di Chirico, whose favorite subjects were the Italian totalitarian architecture premises infused with surreal effects.

This photo doesn't drift towards something idyllic; a telegraph line runs obliquely through the sky and creates a division. Compositionally speaking, the photo has a latent folding symmetry in which the Teide Volcano in Tenerife, the island opposite La Gomera, creates the central focal point. A layer of clouds over the mountain crosses the image, moving from bottom left to upper right at about the same angle as the descending telegraph line. This "crossing" lies exactly above the volcano's summit, thereby mirroring its shape once again. The folding symmetry can be recognized in the perpendicular imaginary axis of symmetry, which runs exactly through the middle of the volcano and the middle of the "crossing".

Such subtle elements give photographs a clear pictorial order and, with it, more power. As in the previous photo, the sky was burned in the darkroom towards the top in order to stress the dramatic element.

You should implement subtlety when presenting images with a surreal effect in photography, because photographs always depend on the "actual reality", unless you create an image with Photoshop, in which case the appeal of authenticity that is so essential in photography is lost.

Gate to Another World

This photo (figure 12–3) depicts two worlds that seem to clash against each other, and they are so close that the effect is surreal. Here we see the sacral world bump mercilessly into the secularized, realistic, and pragmatic world of the 20th century. Yet in these circumstances, the gate to another world remains open. Two persons stand, so to speak, at the threshold of both worlds and hesitate to walk across the gate. Hamburg's Nikolai church ruin stands amidst the modern architecture of the 1960's and 70's that took no notice whatsoever of the distinguished surroundings of the huge ruin. Thus, this photo has a somewhat unreal effect, reminiscent of Orson Welles's film "The Trial", which was based on Kafka's disturbing novel. In the story, it was only the door of a giant office building that would open, and it led to an equally gigantic sacral space. With this, Kafka insinuated the interconnection of capital and church.

In this photo, however, it is important to note that the viewer is within the sacral space and looks out to the uncomfortable architecture from a homelike perspective. Both persons seem to come towards him, but in the end they don't dare to enter this space.

The photo was taken with a 24 mm wide-angle lens.

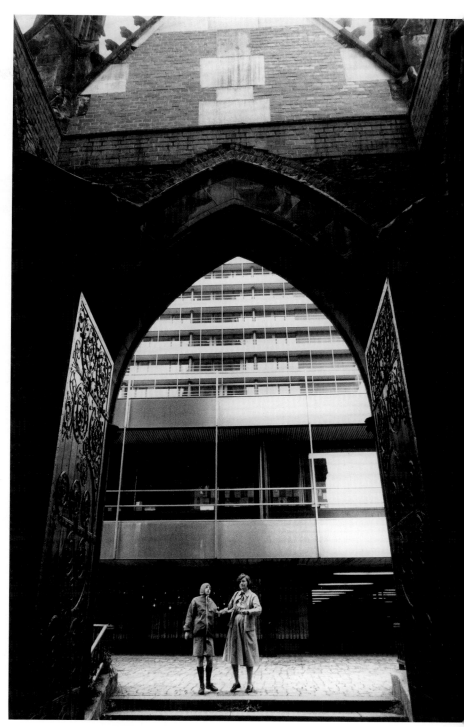

Figure 12–3

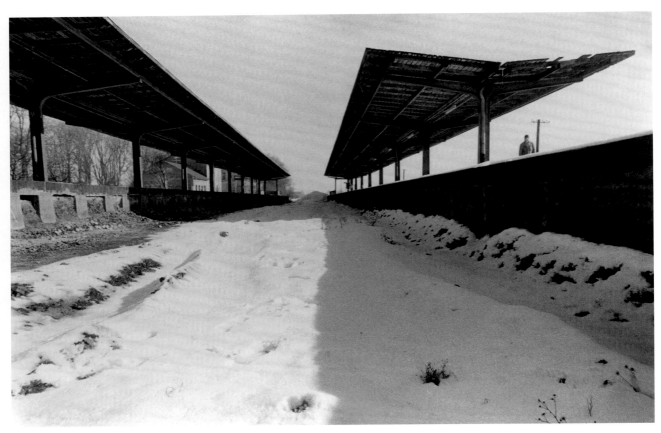

Figure 12–4

Train Station Without Tracks

This photo (figure 12–4) has a totally surrealistic effect: A sizable train station with two platforms, but without tracks, and yet a passenger who seems to be waiting for a train. It is a scene that apparently makes no sense at all. Reason must be put to work in this image, you want to solve the puzzle but the image does not provide an explanation; this is precisely what makes the photo so surreal. Still, I owe the viewer an explanation: The photo shows the Jerxheim train station located on the former border with East Germany near Helmstedt. At one time, the main Hanover to Magdeburg railway line passed through here, but after the border that separated East and West Germany was built, the main line was moved. The tracks were taken out, and only a secondary line between Wolfenbuette and the village of Jerxheim remained. This small one-platform track is on the other side of the platform on the right, so the passenger is really waiting for a small suburban train. Since then, the two platforms seen here have been demolished and replaced by a small, new platform for the train providing service to Wolfenbuette. The Jerxheim train station seen at left in the

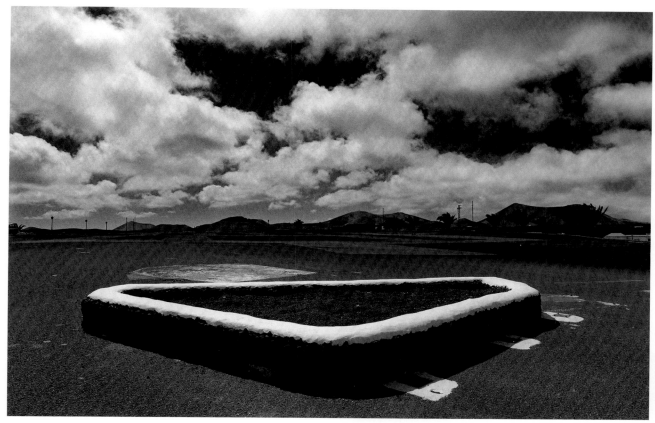

Figure 12–5

background is now a private building. The photo also gives the impression of an isolated, abandoned place.

The photo was taken with an analog camera using a 28 mm wide-angle lens.

Absurd Concrete Surface

This scene (figure 12–5) also has an unrealistic and absurd effect: black and white masonry on a giant tarred surface that leads into the distance. In the background, this gigantic concrete slab is bordered by a couple of power pylons, some small volcanoes, and several palm trees to the right. The image, which is devoid of any humans, elicits questions: What is the purpose of the concrete surface in the foreground that only contains black rocks? What is the use of the giant slab in this deserted place? Here, free associations can be given free rein: Does the area have anything to do with the military? Is it a former landing strip or is it used in the large celebrations of the Mancha Blanca village of Lanzarote? This place does have a special meaning, because in the 1930's an

island volcano erupted and its lava flows almost obliterated the town. The villagers then built the patron saint a special chapel situated behind the photo.

The picture was taken with an analog camera using the 35 mm lens of the middle-format Mamiya 645 (which corresponds to a 21 mm wide-angle lens in a small-format camera). Afterwards, the negative was scanned. A gradient filter was necessary when shooting the picture so the low-lying clouds of the marvelous, backlit sky would be contrasty enough, but the light areas would still have definition.

View in the Distance

This photo (figure 12–6) looks surrealistic because it incorporates three viewpoints: The view towards the bottom to a skyscraper below, the view towards the front, and the view towards the top into the sky. It is a photo of an American skyscraper taken with a triple exposure. The three viewpoints are so enmeshed in one another that they remind the viewer of the inner images often seen in our dreams or imagination: One image appears to be replaced by the following one in a matter of milliseconds. The person stands before the window, raises the arm to the forehead, and either looks down or is immersed in thought. The levels of reality mutually penetrate each other. The image provides plenty of opportunities for subconscious associations: flying, jumping to the depths, levitating, infinity, and much more. It stimulates thoughts of a fantasy.

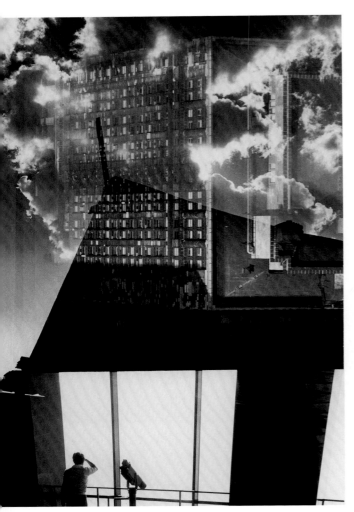

Figure 12–6

Technically speaking, in a triple exposure you must be careful to underexpose each exposure by one to two stops, as three exposures must be accomodated in the gradation curve of a single negative. In principle, the multiple exposure technique is controversial in artistic photography, so I only use one example of it. The important factor is to have a pretty good idea where the different elements will be placed in the picture and what effect the composition will have when the elements penetrate each other. With digital cameras, which allow multiple exposures (e.g., bracketing), this is naturally easier because you can see the composition immediately displayed on your camera's liquid crystal display (LCD) screen.

13 Portraits

It is the widely held belief that a good portrait is generally a well-lit depiction of smiling, young, and dynamic faces. However, such a depiction is often superficial, because the artistic depiction of a person should be more than just good compositional lighting: Every person has an individual personality and spiritual world and a close relationship to surroundings, which undoubtedly leave their mark. A sophisticated photograph of a person should attempt to show the individual traits of the person (including wrinkles and spots) as well as the factors from the surroundings that have influenced the person. Such portrait photography can be achieved both from maintaining a certain distance and an intimate knowledge of the person. Obviously, it is easier to take photos of friends or acquaintances than of strangers, and it is also very tempting to mount the telephoto lens on the camera and shoot voyeuristic portraits.

Usually, a better alternative would be to photograph strangers by approaching and getting to know them. If you decide on this method, it's a good idea to engage in a longer conversation before making a portrait, and you should also attempt to ask more unconventional, personal questions in order to get to know the person a little better. When doing this, it should not be a problem to have a brief, yet more intense relationship with the person and to move beyond conventional conversational topics. The individual being portrayed will remember such a conversation very well, and the photographer, in turn, will get a deeper understanding of this person, the prerequisite for a good portrait. After such a long conversation, you can bring out the camera. Ideally, it would be best if someone else would remain in the room to continue the conversation so you can concentrate on taking the photo.

There are many vivid examples of good and artistic portraits in the history of photography, but there are bad ones as well. Photography began with portraits of the bourgeoisie whose aim was to hide, rather than show, the sitter's real personality. In the mid 19th century emulsions in photographic plates were not very light sensitive, photographers had to expose for a long time, and sitters had to remain still by leaning on columns or other objects. This resulted in numerous mediocre portraits that were taken in a partially aristocratic ambience. Disdéri was such a portrait photographer who produced visiting cards (cartes de visite) that were not much more than souvenirs. But even for a celebrity such as Nadar, clothing was almost more important than personality, because it was regarded as a second skin that sometimes said more about the person.

The innovation of faster emulsions soon liberated photographers from shooting this kind of photography. Naturally, many photographers such as Eugène Atget or Bill Brandt could now go outside, and with this development came the demand to depict people in a more realistic way. Edward Steichen, Paul Strand, and Alfred Stieglitz are good examples. "I am American. Photography is my passion. I am obsessed with the search for truth", said Alfred Stieglitz about himself in 1921. His portraits, as those of Paul Strand, fulfill this demand.

On hearing the word "portrait", one invariably thinks of Richard Avedon's innovative portraits of the 1970's. His minimalist portraits taken before a neutral background framed by the black film border have become famous everywhere. No glossing over of any kind, the harsh, pitiless lighting characterizes his portraits, and yet they do not play with a haptic surface that would make the viewer forget the person's inner self. They are deep personality studies obsessively photographed with love. Avedon himself has given this opinion about his photos, "Young people never say much to me. I will rarely discover something attractive in a young face. But when I look at the downward-pointing mouth of Somerset Maugham or the hands of Isak Dinesen, I can find so much recorded there, there's so much to read there if one could only decipher it. I mean that most of the people in my book are saints on Earth. Why? Because they are possessed". Because he was possessed as well, he is therefore undoubtedly the most distinctive antithesis to the highly traded portraits of the Becher School follower Thomas Ruff, who has consciously covered up any indication of an individual character in his portraits.

Indian Tribesman

This photo (figure 13–1) was taken at a distance from the person (in other words, with a telephoto lens). It is the result of a long stay in a remote Indian village, so it's no quickly shot voyeuristic image. It shows an older man of the Todas tribe in southern India. The viewer should notice that the interplay of light and shadow in the man's clothing and turban causes the photo to come to life. If an employed portrait studio photographer would have used such lighting,

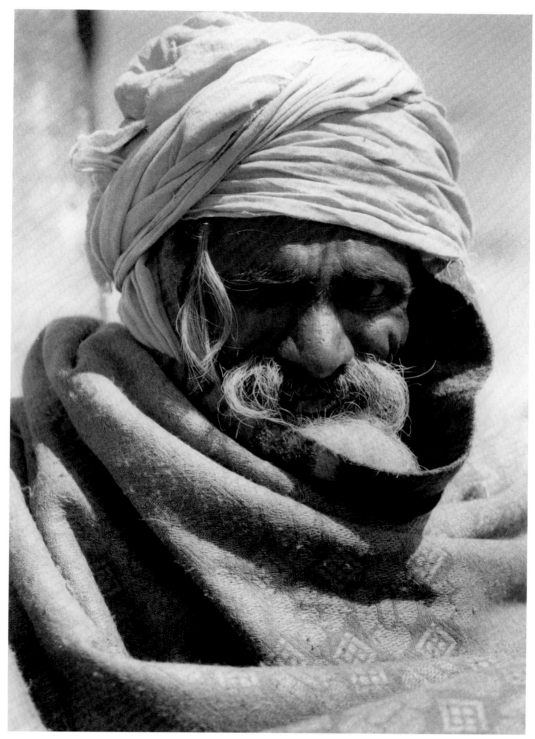

Figure 13–1

however, he would probably be fired, but in this kind of more sophisticated photography, you must free yourself from such conventions. It is precisely the contrasty interplay of light and shadow that emphasizes the expressive force of the person's face. Naturally, it is essential not to allow eyes and mouth to get lost in the shadows, but to remain clearly recognizable by printing the image on Grade 2 (soft) paper. The fact that this person has lived all his life in a different world from ours is clearly shown here. Just his head and body covering, as well as his expression, show us that he has retained the customs of his remote village near Ooty in southern India where he has lived all his life. Certainly, time goes by very differently here, and the profound roots that this person has to his region, tribe, and family contrasts to the somewhat looser affinity to life typical of the western world. This tribesman, photographed with an analog camera and a 105 mm lens, personifies prehistory.

The Other Side of the Coin

Contrary to the previous photo, which expresses pride, security, and roots to the past, this image (figure 13–2) shows more the aimlessness and loneliness of humans.

The shadows of unemployment, poverty, and neglect keep growing in western societies, and for these reasons social critique photography has a great deal of legitimacy. This homeless man in New York City willingly allowed me to photograph him in his favorite spot. It was ironic, even almost cynical, that on this very day a row of posters titled "The Elegant Universe" were hanging behind him, thus opening up a whole range of interpretations for this image. The row of posters to the left suggests that they go on forever. The fact that the man was willing to allow me to photograph him indicates that he had not yet given up and had kept his dignity. Taking such a photograph is certainly a tightrope walk, because on the one hand it is very important not to degrade the person with the camera, and on the other hand a good portrait must also be able to tell, or at least hint at, the story of someone's life. It cannot be the task of a photographer who sets high standards for his work to keep up appearances, but in the end it

Figure 13–2

is precisely the fully individualistic—in this image also long—life story that makes every person unique: and the art of successful portrait photography is to bring this out.

The photo was taken with an analog Mamiya 645 and a 35mm wide-angle lens.

The Beauty of Old Age

According to the classical ideal of beauty, young and smooth faces are always preferred, and a portrait studio will likely use soft lenses to eliminate any hint of wrinkles. And yet, isn't a facial landscape of the elderly perhaps more interesting than a young face? Here, we depict a life that has stretched over 90 years and experienced, among other things, two world wars, all of which have left traces. This image set out to capture the multilayered character of this woman and to catch the instant that does justice to her personality. Part of the task was to emphasize and not to conceal wrinkles and uneven spots: For example, the axis of the mouth does not run parallel to the axis of both eyebrows. A conventional portrait studio would have photographed

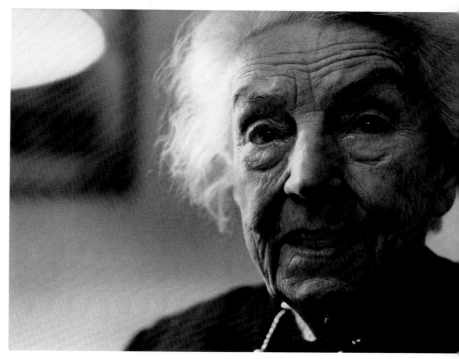

Figure 13-3

the lady from the left side to compensate for this unevenness. A photograph taken from the lower right, however, emphasizes these unparallel axes and therefore accentuates her character.

Her expression and the slightly raised left eyebrow in the photo betray a skeptical, maybe somewhat fearful attitude, and yet the entire face expresses integrity and dignity. It is precisely this dignity, and therefore also the beauty of old age, that make the portrait so convincing.

The photo was taken with an analog camera using a 50 mm lens with Kodak Tri-X Pan pushed to 800 ASA. The natural interior light was sufficient to shoot with f/4 at 1/60 s.

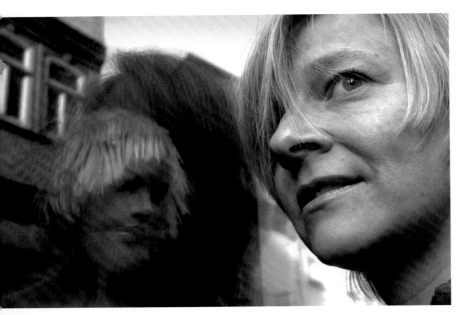

Finding the Essential in the Fleeting

Taking a good portrait captures an instant that reveals something about the person that goes beyond that instant; it is the art of good observation to recognize the essential in the fleeting. The woman's facial expression is relaxed and rested in the brief moment captured by the photo (figure 13–4), while her eyes look very alert and a bit mischievous. Looking at her, you would recognize personality characteristics such as sensitivity and intelligence. The special attraction of this photograph obviously lies in the fact that the woman resembles the mannequin in the display window—the young, blonde, pretty and a bit naive cliché—and she even has the a similar haircut. This obvious parallel of an external attribute formally invites the viewer to make all kinds of comparisons, especially to realize that the woman does not really fulfill the cliché mentioned above.

Figure 13–4

The photo was taken digitally with the 32 mm focal length of the zoom lens and converted to a black and white image with the Grayscale mode.

Digital photography has enormous advantages for portraits because one can recognize facial expressions quite well in the camera display with the enlargement mode and, therefore, can correct unexpected surprises immediately by re-shooting the photo.

1 Starting point
2 Circular viewing path
3 | 4 Negative image diagonals

Woman's Fate in India

Compared to the fate of Indian boys, the fate of Indian girls runs even less according to their wishes. Girls are, first of all, less welcome because parents must later pay a sizeable dowry and secondly, the birth of boys is regarded as God's blessing. This young girl (figure 13–5) is also from a world that is alien to us, from the rather poor Indian state of Orissa. Although she is 10 years old at most, she already has the expression of an adult, even that of an older woman. Without showing it, the photo tells a story of child labor, poverty, and oppression already evident in early childhood. It can readily be seen in this image that this girl has prematurely lost her childhood innocence. Her expression is not caused by the act of posing for the camera; it was the same before. If I had encouraged the girl to smile, I would have had a more cheerful, but less sincere photo. This photo critically shows once more a sociological problem by not

stopping at the so-called superficial beauty. The contrasty interplay of light and shadow intensifies the expressive force of the face. Needless to say, it was important in the photographed image to retain definition in the eyes and mouth, so the photo, which was taken with an analog camera, was printed on soft paper (Grade 2).

This portrait was taken with the 105 mm telephoto lens.

It's Easier with People You Know

You can easily approach acquaintances, and even touch or photograph them in more intimate situations. The blunt crop of the next portrait (figure 13–6) is what makes it powerful: Only one eye is clearly seen, while the left side of the face remains fully blurred. The nose emerging from the blur can barely be recognized, but the eye is razor sharp and the hand on the right side leads once again to blurriness. The image has a certain poetry: The eye reveals some fearfulness and melancholy, the woman places her hand on her mouth, while the other hand touches her face. What kind of story is hidden in this small detail? Is the hand comforting the face or maybe the photo is telling the story of a romance? Well, the photo does not give us a clear answer and that is precisely what makes photography so fascinating—that it is open to many interpretations. Even if the story behind the image remains mysterious, it is nonetheless emotional.

The photo was taken with a fully opened analog camera, and a light-sensitive 50 mm lens on a very sensitive film.

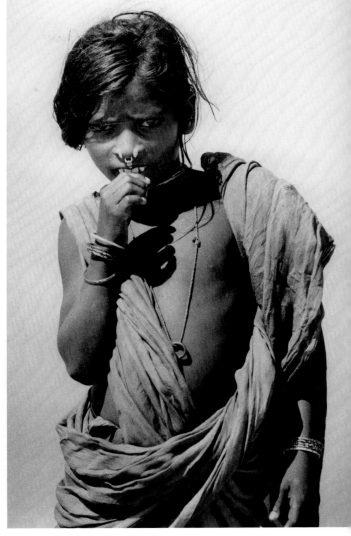

Figure 13–5

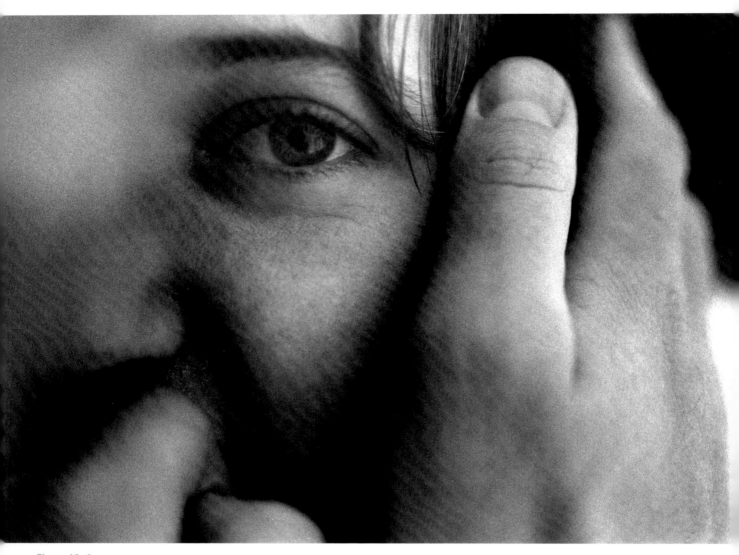

Figure 13–6

14 Man and Surroundings

Photography can showcase the surface of things, as do the large portraits by Thomas Ruff, one of the world's most expensive artistic photographers. Apart from Andreas Gursky and Thomas Struth, he is probably the best known of the Becher School photographers. To support his viewpoint, he takes portraits of people with a large-format camera, just as if he would take a meaningless passport photo that says nothing about the sitter's personality. He then enlarges this "neutral" photo, to a size of almost 7 feet. If you initially get the impression that it is a passport photo, as you come closer to the image, the face starts disintegrating into its surface components. Standing directly before it, you see only a collection of pores, pimples and other skin blemishes in vivid sharpness. The character that cannot be captured becomes nothing more than a surface when seen close-up. Photographs conceived and enlarged like this do indeed capture just the surface because the nature of a person cannot be glimpsed in these photographs.

Throughout the history of photography, countless photographers have vividly demonstrated that photography is quite capable of going well beyond the depiction of surfaces to reveal personalities. Most of the time, photographers recorded a human significance by placing people in surroundings that would say something about them.

Whereas in the late 19th century it was stylish to portray the bourgeoisie in their ambience, one of the first photographers who left the studio to capture people in places having a different special atmosphere was Eugène Atget. Apart from impressive character studies that don't shy away from disreputable

professions (rag pickers or prostitutes, for example), he also vividly showed in his portraits Paris at the turn of the 19th century.

Similar successful fusions of people and their surroundings are also the trademark of the photos taken by the sensitive British photographer Bill Brandt in the early 1930's. He felt attracted to the victims of the new disease of the bourgeoisie: depression. He set out to portray the poor and suffering of his times with a lot of compassion (think of his well-known photos of unemployed miners riding bicycles to collect coal). Another one of the "Sociologists of the Eye" is the famous August Sander, who attempted to typify of an entire country (Germany), structured according to the profession of its inhabitants. His best-known photo of a baker is also a fusion of a person and his everyday surroundings. August Sander even had the opinion that every profession created its own type of person, who would then be photographed by him with some attributes from his professional surroundings.

Fashion photography also dealt over and over again with the fusion of model and surroundings. Naturally, the goal here was not to characterize the model with her traits, but rather to attach external attributes to the model when choosing the surroundings in order to stimulate potential buyers. Often, fashion photography is criticized for its superficiality, but the history of photography proves the opposite: French fashion photographer Jeanloup Sieff has developed a highly unique style in a powerful way. He almost never photographed his models on the catwalk, but placed them in surroundings that were frequently so moody or droll that the atmosphere would almost dominate the models. He often fought it out with editors (of Harper's Bazaar, for example) who thought that the clothing got lost in his images. Most of the time, however, he prevailed, and eventually became one of the most sought-after fashion photographers precisely because of the way he fused natural-looking models in especially atmospheric surroundings.

A highly successful fusion of the person and personal space was the book "The German Living Room" by Herlinde Koelbl and Manfred Sack, published in the early 1980's. The German and his ambience were characterized across all social strata, and their work characterized that historical period as well.

In my opinion, the best fusion of a person with his surroundings can be seen in the book "East 100th Street" by New York photographer and Magnum member Bruce Davidson. After tiring of industrial photography, he decided to photograph Harlem. "I had to make contact with people once again in a way that not only demanded observation and commentary, but participation, a giving and taking, that allowed me to come back to myself". He spent two years working with a tripod and a large-format camera in New York's 100th Street and everyone quickly knew him as the "Picture Man". He took photos for people; every sitter who requested prints was given them. The result was an expression of close participation in the lives of these people and of togetherness. His touching photographs are not images of a voyeur, but of a photographer who earnestly cared about Harlem's residents. Thus, his photos are not really

pictures that expose ridicule and abuse, but rather images of deep humanity that nevertheless look inside the dark side of society.

In the Shadow of the Bronx

This photo (figure 14–1) can be regarded as a small homage to Bruce Davidson. It is by no means the product of a long relationship, but instead of a brief encounter in which the person in the image confided to me, among other things, that he had been unemployed for a long time. I was impressed by the intensity of his features that seemed almost incapable of smiling any longer. It can be clearly seen in his face that this man had lived a tough life—yet he introduced himself wearing a jacket and a clean shirt with a bright collar. He undoubtedly had a sense of pride. However, it was very important for the photo to characterize him in his surroundings, and in spite of the blurred background, the back alley of an American metropolis can be recognized. The twin attributes of brick buildings and fire escapes are enough to place him. In spite of the 400 ASA film, I could only take the photo with the light-sensitive normal

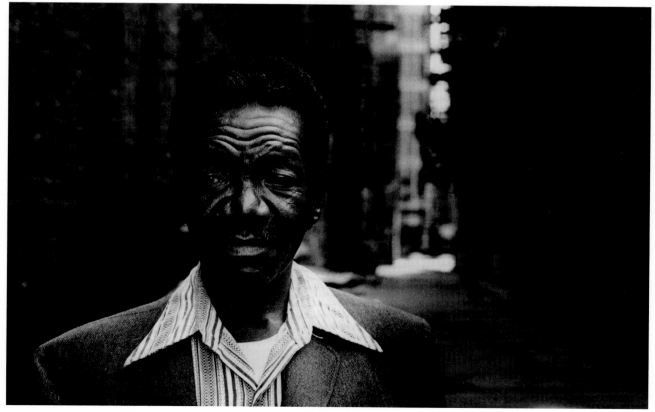

Figure 14–1

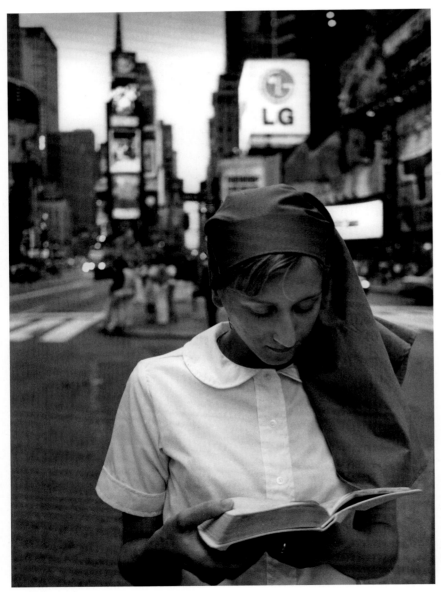

Figure 14–2

lens and a relatively large aperture. It was essential to emphasize the man's features, and the light falling from above was perfect for this job because it made his wrinkles stand out and provided some facial highlights. I had to burn in the surroundings (i.e., house facades) quite a bit in the darkroom to make this unity of man and surroundings more a sociological "shadow image". The Bronx is considerably larger than Manhattan and yet is barely mentioned in a tourist guide to New York—is this a sociological collective suppression? This photo also shows how strongly this individual is rooted to his surroundings by how he clearly fuses with them; you get the impression that he feels quite at home here.

Nun in Times Square

This young sister (figure 14–2) provides a strange contrast to lively Times Square. Oblivious to the flashing advertisements, cars, and hustle and bustle of countless pedestrians in the pulsating center of New York, she stands in the middle of the street engrossed in her study of the Bible—an anachronism in the modern world. The kind of life and surroundings that have motivated this young woman to follow her religious trajectory cannot be glimpsed in this photo, but her sensitive expression does radiate a sense of calm amid the rather noisy and restless surroundings of the large city. She certainly and successfully asserts herself against her surroundings by not allowing the hustle and bustle to swallow her. Even the photo-taking process (I had requested her permission) did not diminish her concentration on the Bible. A 28 mm wide-angle lens was the right one to use here, because you can recognize the background even with an almost full aperture. After all, it was important to wait for early dusk so the neon signs would be clearly recognized in the background.

Sign

This photo (figure 15–1 and figure 15–2) shows a cloud front moving above an arid landscape that gives the image a magical effect. Two marked streaks of clouds cross a vapor trail; the right trail is finger shaped and toward the lower end you can even discern the shape of a fingernail. An interpretation of a "sign of God" would naturally be a clichéd interpretation and would only be permissible with the wink of an eye. However, that such a clearly recognizable finger in the sky suggests the mystical is certainly indisputable.

This photo was digitally taken and all technical means at my disposal were used to emphasize the effect of the sky. First of all, the polarizing filter was turned 90 degrees to intensify the contrast between sky and clouds. During black and white conversion, the channel mixer was used with 100% red channel. The pictorial effect achieved resembles that of a red filter on an analog camera. If such an image is converted with 100% of the red channel, it is essential to have a TIFF file converted from the RAW mode. If this photo had been taken in JPEG mode, an unbearable noise would have been created in the image upon conversion using a 100% red channel, and the tonal value gradations would not have been fluid. In spite of the fact that the conversion using a 100% red channel achieves a

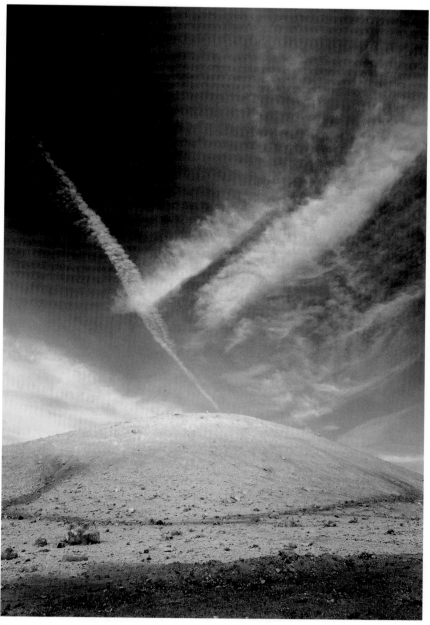

Figure 15–2

magical effect in a TIFF file, the transitions in the sky are just fluid enough to justify this conversion. In this photo, the contrast using the middle tone contrast of the Shadow/Highlights tools was increased a little as well. A less effective pictorial effect is achieved in a photo that was converted using the Grayscale mode, which can be easily seen in the smaller print (figure 15–1).

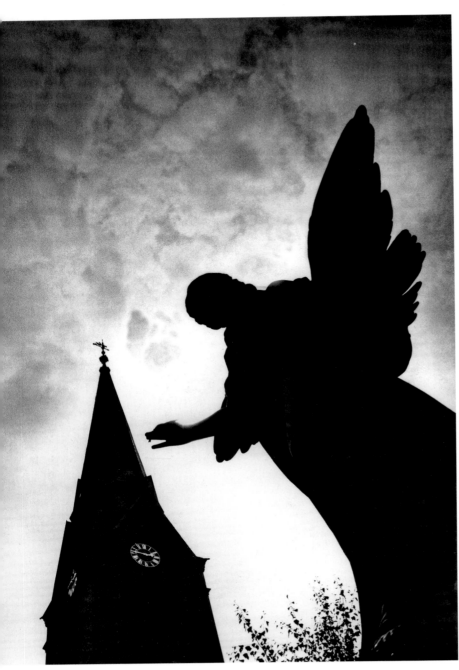

Figure 15–3

Angel as Symbolic figure

Many years ago, the entire Hamburg suburb of Moorburg became the victim of the wrecking ball so that the port of Hamburg could be expanded. Only the church and cemetery were left standing. This exclusion shows that even in our rational, secularized age we still respect places of worship. Here (figure 15–3), you can see the silhouettes of a statue of an angel in the cemetery and the form of the church standing out against a dark and dramatic sky. The angel dominates the composition, symbolically raising a hand in front of the church as if wanting to protect it.

The idea of angels lies at the core of Christian doctrine, but is also quite important in anthroposophy or other esoteric disciplines. It is amazing how many people believe in the existence of angels in our western world today.

In this photo, the angel should naturally be understood as only a symbol, as a figure that may be an agent between the world as perceived by the senses and the invisible metaphysical world. Regardless of how this world may appear, the photo points to it, hints at its existence, and may motivate the viewer to think about the numerous biblical or mythological stories that have dealt with the idea of angels.

The successful angel photos of photographer Herlinde Koelbl demonstrate that angels remain loved today.

This photo was also taken with the 24 mm wide-angle lens under strong backlighting. The sky had to be burned in quite a bit in the darkroom.

Transience

This photo (figure 15–4) taken in an Irish cemetery shows transience: A tombstone has always been the symbol of the transitory element of human life and raises the question of the existence of the hereafter. What happens afterwards? Does the soul survive? Are the promises of religions true or not? Nobody can answer these questions with certainty. "Believe in everyone who searched for truth, but trust no one who has found it", remarked German journalist Tucholsky. And yet, a mystical photograph is capable of raising existential questions despite the fact that it cannot answer them. At least it points to other spheres and touches on subjects such as transience. This image is not just about the passing of human life but also about the impermanence of the tombstone itself; its broken upper part lies simply by the pedestal.

The photo was taken digitally at f/16 with the 25 mm focal length of the 17–40 mm L lens made by Canon and converted with the channel mixer. I used the Shadow/Highlight tool for increasing the medium-tone contrast by about 20%. I incorporated a 15% gradient in the sky with the Gradient tool to gradually darken the upper part of the sky and create a more forceful impression of depth. The lower part of the tombstone was brightened a bit with the Dodge tool. The overall contrast is attractive and not exaggerated for a typically gray Irish day.

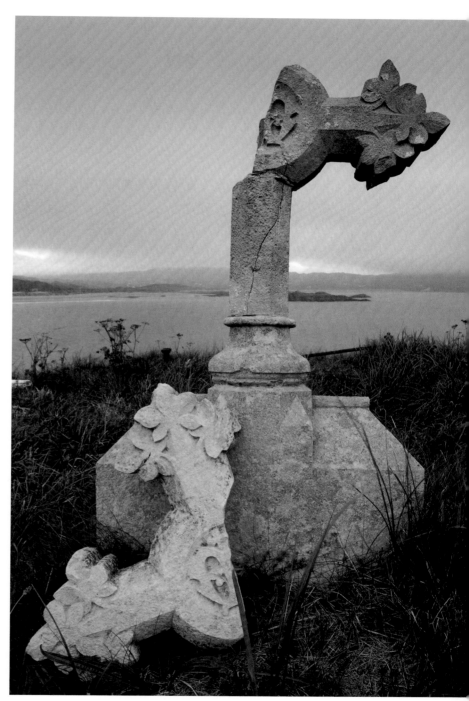

Figure 15–4

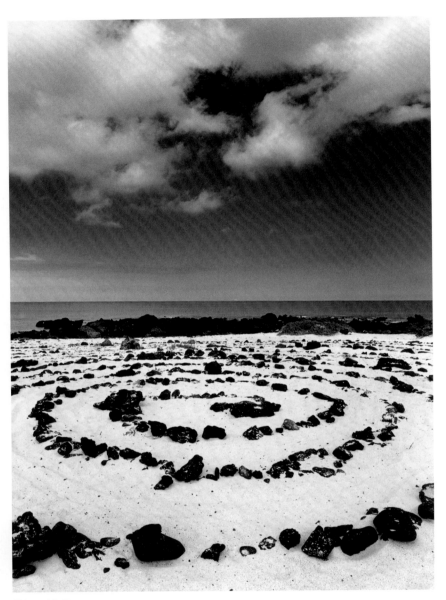

Figure 15–5

Stony Spiral in the Sea

Photos without obvious religious symbols, but with a mystical message, can also be created. Nobody knows the origin of this spiral on Lanzarote, it may be the product of land art or a yogi group or whatever. In any case, this spiral is somehow out of place on a white, sandy beach; it is puzzling and alien to the viewer. The spiral is a basic and important shape not only in mathematics and biology, but in social science as well. There are archimedic and logarithmic spirals in mathematics, but especially in nature the spiral is a basic element, because many plants have spiral structures. This shows that the spiral is an essential component of creation from which many different natural elements originate and develop. Therefore, this photo not only puzzles the viewer, but also invites the viewer to think about deeper connections. The photo was easily and minimally composed because it contains only four elements: the spiral, the sea, the sky, and the bright clouds.

The photograph was taken with the 35mm lens of the analog Mamiya 645 camera (21 mm in small-format) and a red filter.

Enigmatic Relic

This photo also has a metaphysical personality, because it leads directly to the enigmatic, invisible, and past world. This relic near Egridir Lake in Turkey forces the viewer to ask the questions: What is the importance of this architectural relic? What used to stand here? Why is there a power line up there on the structure? These are questions that cannot be readily answered. The backlighting emphasizes this enigmatic quality. The dark sky with the bright, fleecy clouds intensifies the pictorial effect of this photo. The mood of this image could be described as mystical, and by the end of this paragraph the reader will surely conclude that the original meaning of the word "mystical" does not really fit here. Maybe the word "enigmatic" is a better choice. Photography has limits that will always remain in the realm of the visible, but it is nonetheless capable of interpreting the visible world in such a way that the invisible is hinted at, and existential issues about borderline areas can be raised such as the existence of God, the mystery of time, or transience. As is the case with the nature of pictorial language, the questions remain, and the answers are never one-dimensional or dogmatic, but ambiguous and open.

The photograph was taken with an analog camera, a 20 mm wide-angle lens, and a red filter. Yet, in spite of this red filter, the sky had to be burned in towards the top in the darkroom so it could unfold its full effect.

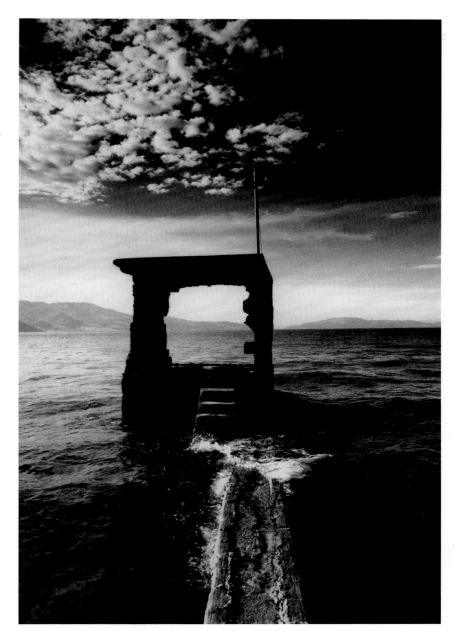

Figure 15–6

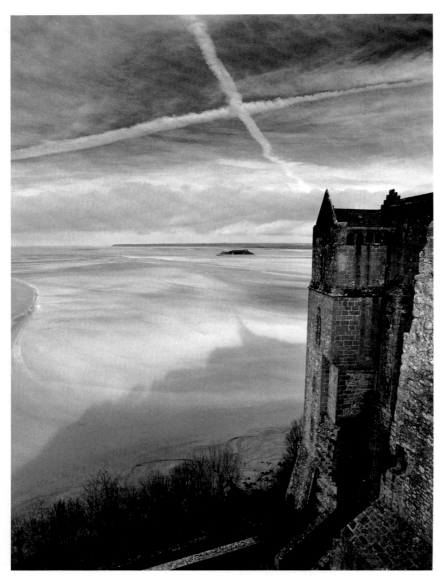

Figure 15-7

Cross in the Sky

The sky is vital in photographs because it leads to infinity, and infinity is a concept beyond human comprehension. Generally, a photo with many clouds gives it a certain mood, sometimes even a dramatic mood. In this image, the sky is dominated by the shape of a cross, formed by the vapor trails of two crossing airplanes. To the right, you can see an old, massive wall whose shadow on the mud flats indicates that it is part of a church. Against this background, the cross in the sky acquires another meaning; it becomes a sacred symbol to the other set pieces in the photo. Mont Saint Michel exudes an impressive sacred effect, because the giant rock on which it was built rises above the surrounding mud flats in the middle of the Normandy coast. Taking the shot at precisely the right instant strengthened the sacred effect in this photo. The crossing of two airplanes in the sky was quite unexpected. Without the cross in the sky, the photo would only have been half as interesting.

The photo was taken with a 35mm super wide-angle lens of the analog Mamiya 645 (corresponds roughly to a 21 mm small-format lens). A red filter plus darkroom burning of the sky intensified the mystical effect of the image.

16 Panoramic Photography

The art of good panoramic photography is to fill up the entire space of the format with the pictorial composition or to give a vertical photo a stable pictorial structure.

First of all, let's review some basic principles about the various pictorial formats:

- The horizontal format generally creates a more static, quiet composition than the vertical format, because it is more stable.
- The vertical format generally creates a more dynamic composition than a horizontal format, because it can be unstable.

These principles apply even more so to the respective panoramic formats:

- The panoramic horizontal format expresses maximum tranquility, stability, and a static composition, thus creating the look of almost infinite distance.
- The panoramic vertical format looks highly dynamic, unstable, and emphasizes height and length.

Understanding these basic principles about the effects that these formats have on the viewer are essential for a good composition. A panoramic horizontal composition need not be statically composed in addition to the inherent effect given by the format. In the vertical panoramic format, on the other hand, you can also attempt to include the effect of the format.

An additional prerequisite for good panoramic photography is to use the correct camera for it, and two fundamentally different cameras are used: rotating cameras and nonrotating cameras.

The lens on a rotating camera can be turned 180 degrees during picture taking so that an extreme pictorial angle is generated in spite of the moderate focal length. There are rotating cameras for small-format and roll film; the best known are made by Noblex or Widelux. Their advantage is that they can cover the extreme angle of 140 degrees, but their disadvantages are serious indeed, because horizontal lines are not reproduced as parallels when they are away from the central axis. Instead, they curve more or less strongly towards the margins. In landscape photographs, it is sometimes possible to include this effect in the composition, but for classical or architectural photos, rotating cameras are not practical.

Most of the panoramic cameras, however, are nonrotating and have fixed or adjustable optical elements; in some of them, you can even use various focal lengths. I recommend roll-film, nonrotating cameras with various focal lengths that allow shifting. Outstanding middle-format models are made by Fuji, Linhof, Cambo, Gilde, or Horseman. The drawback is that these cameras are very expensive. An economical and flexible alternative is to make your own panorama mask from wood in 22 x 60 cm format (8 ½ x 24 in.) and a cardboard cover for the finder with the same dimensions for your own middle-format camera such as the Mamiya 645. This setup works very well and has the great advantage that you won't need a new camera. With the Mamiya 645, for example, the 35mm super wide-angle lens is good for panoramic photography because of its wide pictorial angle with no curving in toward the edges.

Naturally, you can also use a high-resolution digital camera and simply trim the photos to panoramic format. However, for larger prints (24 in. and higher) I recommend a camera with full-format sensor such as the Canon EOS 5D, because its wide-angle properties suit panoramic photographs and are of better quality than cameras equipped with an APS sensor, which have slightly blurred edges in extremely wide-angle focal lengths even with good lenses (visible in large-sized enlargements). If you want to digitally increase the resolution of a panoramic photo even more, I recommend taking one or more photos for subsequent merging with Photoshop (using the Photomerge tool). Ideally, you should place a shift lens before a digital camera equipped with full-format sensor, because in this case the wide-angle shift lens acts like a regular wide-angle lens. How this works is explained at the end of this chapter.

Rotating Cameras Generate Curves

Of the many types of panoramic cameras, the rotating camera was used here (figure 16–1). In reality, the street was completely straight in front of the camera all the way to the left fifth of the photo. The Widelux rotating camera causes the curve of the street; however, this curve is credible because the actual street ends in a curve at left. Generally, in a panoramic photo the entry point lies somewhat to the left of the vertical and slightly above the horizontal axis of symmetry—in this photo, the windows above the ground floor of the house.

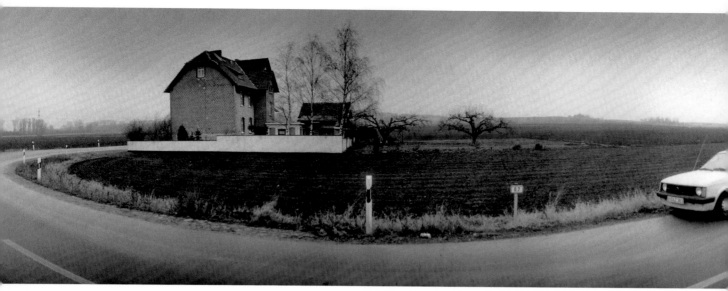

Figure 16–1

From this entry point, the eyes move right over the street and towards the car, where they stop to be guided back to the house.

In rotating cameras, however, the horizon must be in the middle, because otherwise it would look curved. When shooting with these cameras, it's best to have the curves in the upper or lower sections of the composition. In this image, the scene of this otherwise boring northern German landscape is interesting because the street appears to curve almost around the rather isolated house. This effect created a dynamic photo that counteracts the naturally static composition. Rotating cameras allow for interesting horizontal compositions, but are not very suitable for the vertical compositions that are generally used in architectural photography.

Straight Horizon in the Upper Section Tool

A panoramic camera with a fixed focal length and medium-large pictorial angle (in the next photo, 94 degrees) will capture the horizon as perfectly straight above or below the image center. Taken in the western Erg of the Algerian Sahara (figure 16–2), the strength of this photo's composition lies in the curve, but this curve of the sand dune in the foreground actually existed and was not created by distorting optics (as was the case in the previous photo).

The expansive vista of the landscape and the image of the dune crest that crosses the entire horizontal format make this photo come alive. The eye can wander along the footprints and explore the entire expanse of the landscape all the way to the horizon.

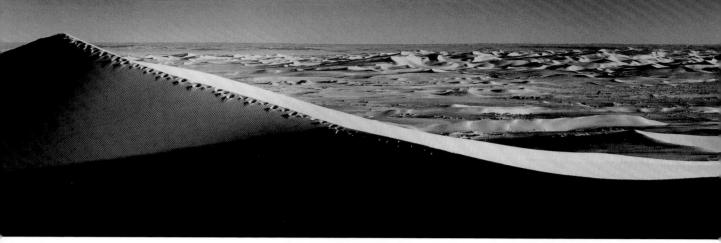

Figure 16–2

The slight side and back lighting provide a contrasty interplay of light and shadow along the frontal dune crest, thereby helping it to become a dominant element. The crest divides the image in two: Below the crest lies a large, almost pure black area, whereas above the crest we see a highly varied area containing many dunes. This division of the image into two markedly different areas creates the pictorial tension that the photo needs.

A Highly Interesting Panoramic Horizontal Format Composition

The composition in this photo (figure 16–3) has been created in such a way that strong tension is created between the former World Trade Center (WTC) on the left and the ferry skipper on the right. The horizontal pictorial space consists of

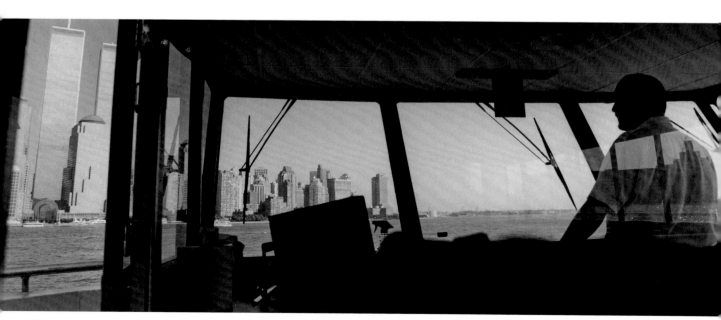

Figure 16–3

many vertical elements: The former WTC, the ship's vertical window moldings, more skyscrapers, windshield wipers, and the skipper himself. The center brace in the image is the vertical axis of symmetry, and a certain folding symmetry finds its origin here: Both essential elements in the photo—namely the former WTC and the skipper—can be more or less folded on top of each other. This is yet another example of an interesting composition in a panoramic photo: the creation of tension by including many elements in the wide pictorial space.

Vertical Use of a Panoramic Camera

As early as the 1930's, Berenice Abbot showed in her New York photo series that one could also take vertical photos with a panoramic camera. Horst Hamann also proved it by publishing his book "New York Vertical". New York is truly a city that cries out for the vertical use of the panoramic camera.

The challenge of vertical panoramic photography is to balance the composition, because this format is inherently unstable and will easily give the appearance that the subject is tipping over. A panoramic camera with a shift lens will counteract this instability by providing a measure of static composition. As you can see in this photo (figure 16–4) of the Empire State Building, all falling lines can be straightened, even if the architecture starts in the lower edge of the picture. A shift lens moves the optical plane of the lens so much to the top that it is possible to hold the camera parallel to the building so there are no more falling lines. This photo is all about the interplay of similar architectural shapes; the small church and the large "temple" of modern architecture, of course. This photo remains static because it presents a relatively stable balance. Naturally, this extreme format reinforces the soaring lines of New York's architecture. I included people in the photo so this architecture would not give a sterile impression. A black man wearing a T-shirt with a colorfully printed pattern rests his elbow on a newspaper stand and chats with a woman pushing a baby stroller: a scene typical of lively and multicultural New York.

Figure 16–4

What I said earlier about traditional analog photography methods being gradually replaced by digital ones also increasingly applies to panoramic photography. It is now possible to achieve outstanding quality in digital panoramic photos as well. The first possibility is to simply crop a photo taken with a super wide-angle lens to a panoramic format. A camera equipped with a full-format sensor and a resolution of almost 13 megapixels (the Canon EOS 5D for example) with a focal length of 16–17 mm allows you to enlarge such a cropped-to-size panoramic photo to a width of over 3 feet. If the pixels are still too large, they can be calculated to a smaller size using Photoshop's Image Size.

Figure 16–5

Figure 16–6

A more professional method for creating digital panoramic photos is the stitching together of several images with Photoshop's Photomerge tool, but this is rather difficult to do without shift lenses. For example, if three photos are taken from exactly the same spot, (one to the left, one in the center, and one to the right) while allowing enough crop areas among them, Photomerge will calculate all of them together to merge them into a single image. This method works reasonably well as long as the objects are at infinite distance, as is the case here (figure 16–5). But as can be seen in the detail (figure 16–6), Photomerge didn't do it seamlessly. Such small impurities can be painstakingly eliminated by displaying the three planes and then shifting them in such a way that the three images fit optimally into one another. Another possibility is to retouch the transitions with the Eraser and Clone Stamp tools, something that can still be done in this photo.

However, if the object photographed was very close, as is the case with these half-timbered houses in Goslar, (figure 16–7) it is almost impossible to seamlessly merge them. Naturally, you should not take the three or four photos of a close object from one single spot, but take them with the camera exactly parallel to the houses (in other words, all photos must be taken at a 33 foot distance from one another). Even assuming this method goes well, there will still

Figure 16-7

be distortions caused by perspective that won't be exactly compatible when calculated together. The result leaves a lot to be desired, as can be clearly recognized in the detail (figure 16-8). It is possible to retouch the result to achieve a usable image, but a substantial amount of time would have to be invested. It's better not to be forced into doing this, so I recommend that you use a shift lens to take panoramic photos!

You can create outstanding professional panoramic photos that do not take much time with a shift lens and then use Photomerge. The technique is very simple:

Figure 16-8

1. Mount the camera on a tripod.
2. Turn the shift lens so it shifts horizontally, not vertically.
3. Screw the shift lens to the left as far as it will go.
4. Measure the light before shifting, and set the exposure manually.
5. Important: Use exactly the same values for both photos!
6. You are ready to take the first picture.

Figure 16-9

Figure 16-10

7. Take the first picture.
8. Turn the shift lens by 180 degrees and to the right on the horizontal axis. You are ready to take the second picture.
9. Take the second picture.

On the previous page, the left photo (figure 16–9) is the first photo taken using this technique. (It has already been converted to black and white using Grayscale.) The photo on the right (figure 16–10) shows the second photo taken using this technique. Photomerge flawlessly joins these two photos together, because the camera was not moved and there is no distortion caused by perspective in the amount cropped. Let's complete all steps:

Figure 16–11

1. Open both images in Photomerge.
2. Go to the File, Automatic menu options, and click Photomerge (figure 16–11).
3. Photomerge shows us the numbers of the two opened files.
4. Click OK.

Figure 16–12

Figure 16–13

The program merges both images and they appear a little displaced height-wise (figure 16–12). No problem, because you can crop the image. Cropping works in the upper part, but you should not touch the reflection of the tower in the lower part. Therefore, a small empty space remains in the lower-right image area (figure 16–13). It's now relatively easy to use the Clone Stamp tool to copy the water of the puddle onto the empty space (figure 16–14). Although both photos were taken with the same aperture and also processed with exactly the same values in the RAW converter, different gray values are nonetheless seen in the reflection interface. The Dodge tool adjusted to a large, 198-pixel radius under an extremely smooth edge (edge sharpness 0%) (figure 16–15), solves this value problem. You can balance the brightness difference with a couple of mouse clicks and a perfect panoramic photograph comes into being! (figure 16–16). The image has a resolution of 2819 x 7075 pixels, which corresponds to a 20-million pixel resolution. Even using this method, a camera equipped with full-format sensor is clearly advantageous because a 28 mm shift lens (in this case, a Nikon 28 mm mounted on a Canon EOS 5D) remains a 28 mm lens, whereas in a camera with an APS sensor, this lens would correspond only to a 42 mm focal length.

The photo is not just technically interesting, but has also an interesting content: The skyscrapers built in Frankfurt in the last 30 years exemplify modernity like in no other German city. Often, old structures were demolished to

make way for modernity, but Frankfurt had the courage to become modern and its skyscrapers (as opposed to the ones in other cities such as Hanover) have their own modern faces that often clash visually with the old buildings. However, this clash between the early 20th century and modernity is precisely what gives Frankfurt its unique character.

Modern and older architecture face each other in this photo taken in the Gallus neighborhood near the main railway station. This urban silhouette is reflected in a large puddle where a new, gigantic construction project will soon close the gap between the trade fair (left) and Gallus (right) neighborhoods. This photo anticipates renewed radical change; it especially heralds the fast urban transformation of modern large cities throughout the world—Dubai, Shanghai, New York, Kuala Lumpur, or precisely Frankfurt—that are becoming more similar to one another and are often planned by western architects.

The puddle gives the photo a certain sense of tranquility; it seems to bestow the image a certain breathing space in the middle of the radical change going on in our modern time. It is this breathing space and sense of peace that lies over the entire metropolitan Moloch, and gives the image its special mood.

The improved Photomerge function of Photoshop CS3 represents a clear advancement for panoramic photography. The final chapter provides a thorough description.

Figure 16–14

Figure 16–15

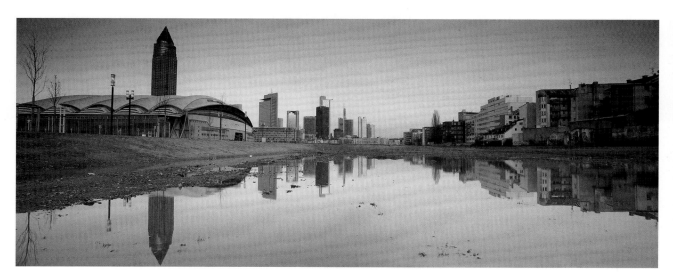

Figure 16–16

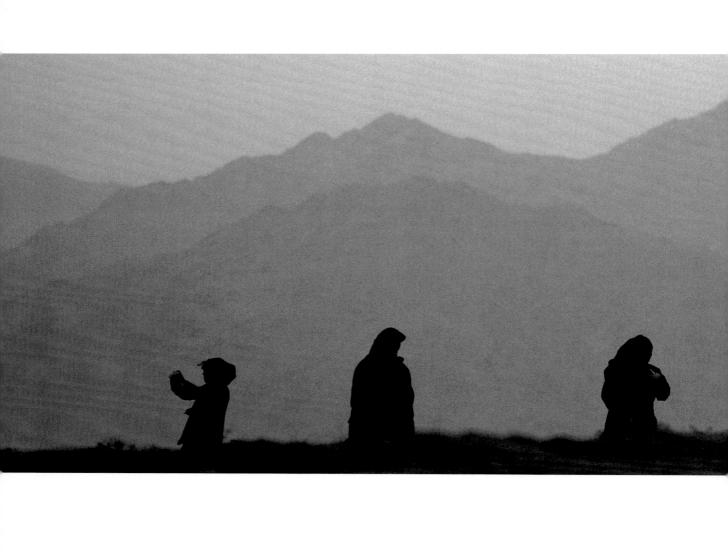

Section 3

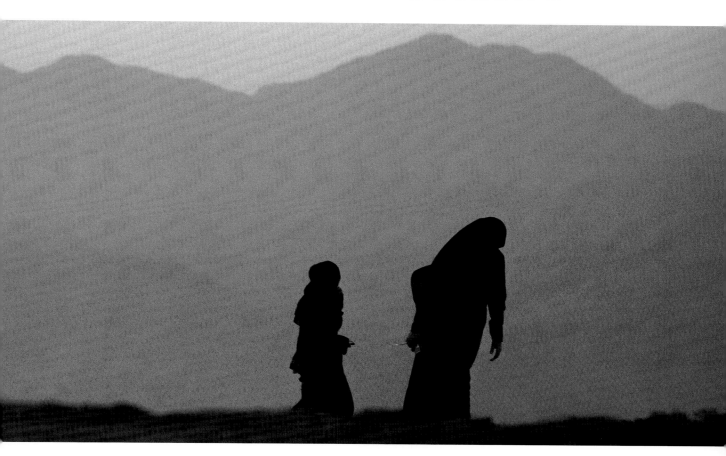

Rules of Composition

shoot while strolling by a subject, it requires a deep power of observation and a lot of time.

The wild, rugged volcanic landscape of Lanzarote, for example, may be impressive at every turn, but it can by no means be condensed into a successful pictorial composition from every spot. The landscape is characterized by precipitous, rocky formations and individual volcanoes that project into the wide expanse. If you want to photograph the landscape with a wide-angle lens, you will have to deal with a large foreground area and a big area in the sky that must have interesting shapes in order to have a tight pictorial composition. If you actually experience the reality of a landscape in its three dimensions and are overwhelmed by it, do not forget that this direct three-dimensional spatial impression disappears in a flat image.

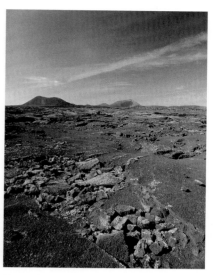

The first attempt to create a perfect image (figure 17–7) is not entirely successful. Although the sky does have a good, diagonal structure due to an interesting vapor trail, the large foreground is not interesting. Looking at the digital display, you can recognize this type of problem early because the display is flat as well. If you have already shot a photo like this and are sincere with yourself, you just can't be satisfied with the result. So you keep looking and will soon discover that the foundation for a perfect composition is not really far: This photo (figure 17–8) is a lot more powerful than the previous one and only because a distinct, contrasty rocky formation in the foreground is reminiscent of an open mouth with teeth. In addition, the shadow of this formation runs at exactly the same angle as the vapor trail, thereby building a counterpart. There is a strong tension between these two pictorial elements.

Figure 17–7

The photo was taken digitally with the 17–40 mm telephoto lens of the Canon EOS 5D at the 26 mm focal length. On this hazy day, it was not very easy to obtain a contrasty black and white photo, and it had to be converted later to Grayscale with a large proportion of Photoshop's red channel in the channel mixer. The photo then revealed a crisp contrast between dark sky and bright vapor trail. These photos show the difference between an insufficiently composed photo and an ordered and powerful composition.

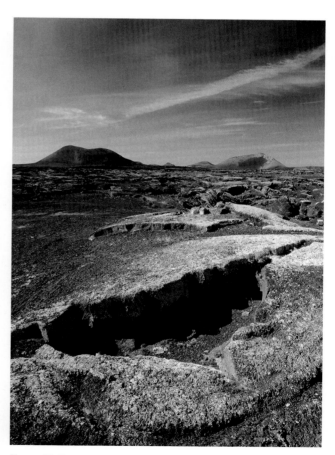

Details Lead to Perfection

However, even if your photo has a relatively good composition, you can still improve on it by taking a couple of details into account. For example, this photo of a palm tree already has an adequate composition (figure 17–9) but it

Figure 17–8

Figure 17–9

lacks a final touch. The composition is not yet satisfactory, because just by taking a few additional steps a difference becomes noticeable (figure 17–10): The palm tree is now in the left image area and the terraced landscape becomes much more interesting. In addition, the sky has a considerably better cloud formation compared to the previous photo. The line separating light and shadow that ran parallel to the lower edge of the picture in the previous photo, now runs somewhat diagonally until it meets a second line that runs obliquely in the opposite direction. These two diagonal lines make the composition more dynamic. To summarize, this improved

Figure 17–10

photo has a lot of atmosphere and lets the viewer's eye wander over the wide expanse of this unusual, terraced landscape, while the initial photo depicts just an average landscape.

Both photos were taken digitally with a focal length of 25 mm and a polarizing filter. They were also converted to Grayscale using more than an 80% portion of Photoshop's red channel. The effect achieved resembles the analog use of a red filter. The medium tone contrast has been increased even more in the second photo, and the sky was burned approximately 30% using the Burn tool. The shaded areas in the foreground, in turn, were dodged by about 20% with Photoshop's Dodge tool. This photo is one more example of what a digital darkroom can achieve: perfect dodging and burning procedures that leave no tracks whatsoever. To achieve such an impressive result in the analog darkroom, you have to be either a perfect shadow creator or have very good templates.

Getting to the Heart of an Image

The purpose of this small photographic series was to bring together the interplay of Lanzarote's typical whitewashed architecture, strongly influenced by César Manrique, with the dark volcanoes rising everywhere on the island. It becomes quite clear that a more condensed composition achieves a better effect.

The first example (figure 17–11) is certainly a pretty good vacation photo, but in spite of the attempt to unite houses and landscape in one single composition, the image looks cluttered, because it still has too many elements to be really powerful. The shape of the house in the foreground is too undefined and its flat construction looks uninteresting. As it so often happens, the solution was found just 70 feet to the right. Here a house with a pointed roof has a more distinct shape.

Now, the time has come to wait for the right light. In the second photo, the upper half of the volcano is dark, and the dark window in the lower right corner is a distraction. The window in the lower right corner is the largest dark spot in the photo and keeps pulling our attention towards this unimportant corner of the picture. It is, therefore, better to walk a couple of meters to the left and make sure that this dark spot is omitted from the composition. In the photo taken now (figure 17–12), the perspective is perfect, and you can see that with a little additional patience you can wait for the light to provide the finishing touch as it illuminates the volcano's summit. A dark area remains

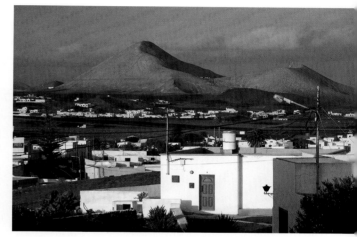

Figure 17–11

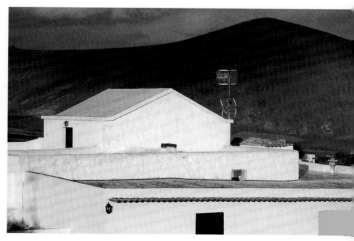

Figure 17–12

between the whitewashed house and the volcano; the antenna clearly stands out from the dark volcanic mass and indicates modernity in this seemingly oriental scene. The illumination of the volcano's summit and the dark volcanic mass contrast strongly and attract the eye.

The photo was taken digitally and converted with the channel mixer to Grayscale with 80% red and 20% blue. The 154 mm focal length of Canon's 70–200 mm telephoto zoom lens creates a nice compositional fusion of architecture and landscape (figure 17–13). Aperture 9 provides just enough depth of field to have both pictorial elements in focus.

This photo series clearly demonstrates what it means to condense elements of reality to a pictorial composition. Especially if you photograph digitally, it is possible to create sketches (as in painting) in the display. Thus, with the help of several photographic sketches you can easily achieve the perfect composition. Digital photography does not necessarily make you sloppier and more careless, as some critics assume, just because it lets you to take many more photos. On the contrary, this apparent photographic wastefulness creates many photo sketches that serve the purpose of letting you gradually and carefully feel your way to a truly perfect pictorial composition.

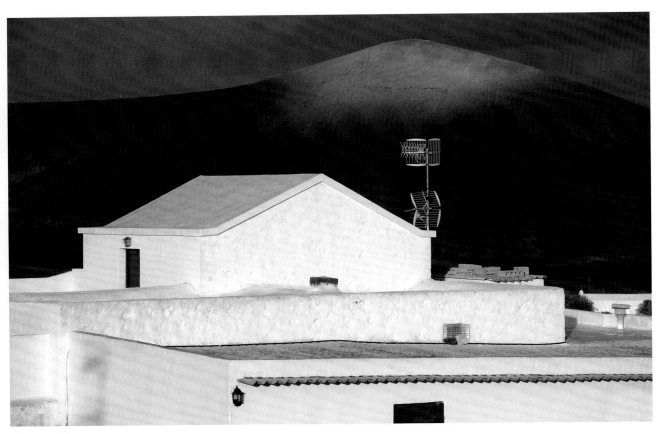

Figure 17–13

- The two legs of a woman appear to be walking on the roof of a bus, while three persons walk on the crosswalk.
- The woman in the foreground looks sideways.
- A man approaches her and also looks sideways, but they take no notice of each other, depicting a typical scene in a big city.

But where is the Golden Ratio? Well, here it is:

- The imaginary vertical line of the woman's right leg on the advertisement (left in the photo) continues with the man below and the left arm of the woman in the foreground, and describes very well the left vertical harmonic dividing line.
- The white stripe under the bus windows corresponds to the horizontal axis of symmetry.
- The stripe of the bus's roof above lies almost exactly on the upper horizontal harmonic dividing line.

The photo is, in fact, significantly better composed than it seems at first glance. It plays with the omnipresence of oversized advertising that slowly creeps into everyday life, but creates the impact that it should really get due to its size.

This photo was also taken with an analog camera using a 28 mm lens.

19 Triangular Composition

Triangular composition is one of the best-known classical ways of composing an image. The triangle is a harmonic entity, and this is especially true of isosceles or equilateral triangles, which are optically harmonious. In older buildings, pointed roofs were often built with exactly the same angles so they would form an equilateral triangle.

The well-known German Romantic painter Caspar David Friedrich often composed his canvases with a pair of compasses and a geometry triangle to attain triangular composition in his paintings—to the point of even frequently arranging the clouds in his majestic skies in the shape of a triangle.

As far as photography is concerned, the same principles used in classical painting apply; a difference is that you must search your surroundings to find so-called "optical triangles". In a photo, you can either hint at or clearly show a triangle. The optical triangle in a photo has a very orderly, harmonizing function, similar to the Golden Ratio; but it can also have an excessively static effect that is perceived as too rigid. Although generally static, you can use an optical triangle to create a dynamic composition, such as using a blurred movement to create a triangular shape, as described in the following section.

Dynamical Triangle

This photo (figure 19–1) typifies the modern pictorial language that is featured in photojournalism. It is an example of how you can create dynamic photographs with the help of triangular composition.

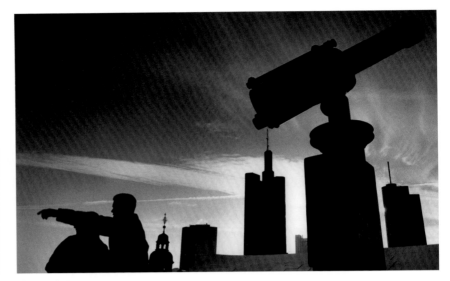

Figure 19–1

What characterizes a dynamic composition? Dynamic compositions live from oblique or diagonal lines, especially when movement is suggested. It's no accident that modern photography so often works with blurred movement, which has almost become a fad.

The dynamic quality of this photo (figure 19–1) is created by two opposite movements leading out of the picture: The man points left and out of the image, and the large telescope leads your gaze to the right and out of the image. A strong pictorial tension results from these opposing movements. In addition, the telescope's shape resembles the silhouetted Commerzbank skyscraper. We see that is enough for an optical triangle to be hinted at:

- The arm of the person represents the base of the triangle.
- The telescope's pedestal represents the second side of this triangle.
- The telescope, continuing to the lower left corner as an imaginary line until it reaches the man's fingertip, represents the third side.

Running counter to the triangles' upward diagonals (which create this dynamic property), a streak of clouds runs parallel to the man's arm. The composition would have lost most of its tension if the man had not raised his arm at that instant.

The photo was taken with an analog camera and a 20 mm wide-angle lens, which is highly suitable for dynamic compositions owing to its distorted perspective and significant depth of field.

Figure 19–2

Interlocking Triangles

If the optical triangles were only hinted at in the previous photo, they are clearly defined here (figure 19–2):

- A triangle is formed by a sloping window strut, its shadow, and the upper corner of the image.
- Another triangle is formed by the dark area and the left edge of the picture.
- A triangle is formed by the oblique line of the dark area, the shadow of the first triangle described above, and the left railing.

The numerous oblique lines in this photo give the image its dynamic quality, yet the repeated optical triangles provide some order.

The slats of the window blinds and their shadows create an interesting graphic structure—yet even this entire architectural pattern would have been only half as interesting without the woman and her shadow. The human embedded within the architecture is the subject matter of this photo, which, by the way, has a touch of a "Hitchcock feel" in it, enough to make it interesting.

The photo was taken digitally with the 12 mm wide-angle lens of the Nikon D70s, which is equivalent to an 18 mm lens. It was important to make sure that the areas illuminated by the sun's reflection did not lose their detail. To prevent this loss from occurring, the photo was underexposed by 1½ stops, and the shadow areas were slightly lightened with the Shadow/Highlight tool.

Figure 19–3

Central Triangle

Classically speaking, a triangular composition is regarded as rather static, so the following examples will show two relatively static photos, as opposed to the previous two dynamic compositions.

In this photo (figure 19–3) of the newly built boat mooring in Frankfurt's western harbor, the vanishing perspective creates the optical triangle. The photo has a very static composition because the optical triangle created by the mooring extends over the entire pictorial space. In other words, the base of the triangle extends from the lower left to the lower right corner, and the tip is found in the vanishing point of the photo's upper central edge. The three central boat docks also give the image a graphic impact. The photo gets its mood from the backlight of the setting sun.

The photo was taken with the 29 mm focal length of the full-format sensor of the Canon EOS 5D. This photo had to be slightly underexposed so the reflections of the setting sun in the water would not get lost. The shadow areas to the right were dodged by about 20% with Photoshop so the texture would be more readily seen.

Figure 19–4

Onion in Stone

Although a special stone is the subject matter of this photo (figure 19–4), the mood is also very important—emphasized by the dark sky and the vapor trail in the image's right edge. These elements also create a second, imaginary optical triangle apart from the stone's triangular shape. The base of this triangle is the photo's upper edge, the first side is the right vapor trail, and the second side is the line formed by the distant mountains and another vapor trail to the left. Both sides penetrate the stone because the eye extends them all the way to their intersecting point in the lower part of the stone.

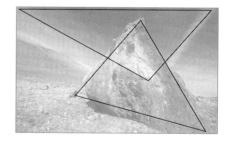

With this interesting, onion-shaped stone in Lanzarote it was necessary to "examine the object", as former LIFE magazine photographer, Feininger once said. By that, he meant to explore a subject by walking around it and carefully looking at it from every perspective. When exploring the subject, I decided to include the vapor trail in the composition because it was the most interesting element in the sky.

The photo was taken digitally with a 17 mm extreme wide-angle lens and a full-format sensor. A somewhat hazy day called for a polarizing filter to be used. The photo now had a nice contrast, and a conversion to black and white using a 95% share of the red channel did the rest to create a dark sky with a mystical effect.

20 Rhythm—Recurring Elements

As in music, pictures can also be characterized by a certain rhythm. When you include rhythm in a photo, it is important to make the pictorial content abstract and to master the language of shapes.

In fact, the concept of rhythm comes from music, because one thinks of the bars that give the rhythm, but rhythm generally implies something like the constant repeat of similar things, for example, the seasons. However, the recurrence of something does not refer only to time; the space of a pictorial area can also be structured by rhythm. If in music this is the basic structure of how time is divided, then rhythm in an image is the basic structure of how a space is divided by the elements.

The four photos presented in this section gain their strength of design from their pictorial rhythms; their compositions are simple and they have very few elements. Yet, it is precisely the constant repetition of these few elements that gives these photos their power. Some modern musical pieces (techno, for example) also gain their strength from the constant repetition of a basic musical form. Some African drumbeats are repeated over and over again in ritual ceremonies to generate a trance in the listener. Naturally, with such constant repetition, whether in music or images, an antithesis can prevent monotony.

Arches, Lines, and Rhombi

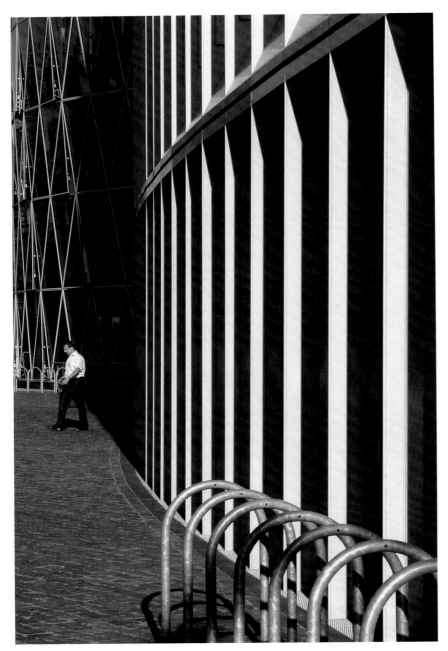

Figure 20–1

In this photo (figure 20–1), the vertical window structures provide the main pictorial rhythm. The arches of the bicycle stands in the lower right corner continue with a variation of this rhythm, and a third rhythm is provided by the rhombi and triangles of the Western Harbor Tower. A man in the middle of these shapes walks by, and his black and white clothes also fit into the composition. The man, in turn, is the antithesis to the excessively rigid linear forms in the photo. He has been photographed in the best possible instant because he has just emerged from the shadow but is still far enough from the image border. He is exactly in the middle of the Western Harbor Tower. Without this man, the architectural forms by themselves would make the photo look too rigid; he is the essential final touch.

In such a photo it is good to set up the composition and then to have enough patience to wait for the right person to walk by to shoot at precisely the right moment.

The photo was taken digitally with Nikon's 105 mm lens and the Nikon D70s, which if converted to full-format, would give us an approximate focal length of 160 mm. (You can recognize the telephoto lens perspective by the lines that get only slightly smaller.) The image was converted to black and white with the Grayscale tool of Photoshop, and medium-tone contrast was increased a little with the Shadow/Highlight tool. While taking the photo, it was important to check that both the white shirt of the man and the bright window elements still have some texture. Before the actual shooting, it was a good idea to shoot one photo as an exposure test.

Rhythm of Window Lines

This photo (figure 20–2) of Berlin's Potsdam Square also has a minimal composition, with the rhythm being provided by the repeated window sections, which taper off towards the top. If you compare this pictorial composition with a musical piece, you can find parallels: "Bolero" by Ravel is one such piece in which the same basic structure is played throughout, from a quiet beginning to a loud, dramatic ending. The same rhythm applies to the minimal images seen in this double page. The same element is repeated in almost identical form; in this photo, the distances between the lines become gradually greater towards the bottom. However, the antithesis to the rhythm of the lines is also indispensable here in the form of the young man. Without him, the photo would be dead formalism, a rigid linear structure. But, here a unity of man and space has been created in a cool, down to earth atmosphere. Nevertheless, the image is powerful owing to the absolutely minimal rhythmic composition.

The photo was taken with the analog Nikon F4 and a 105 mm lens on Ilford Delta 100.

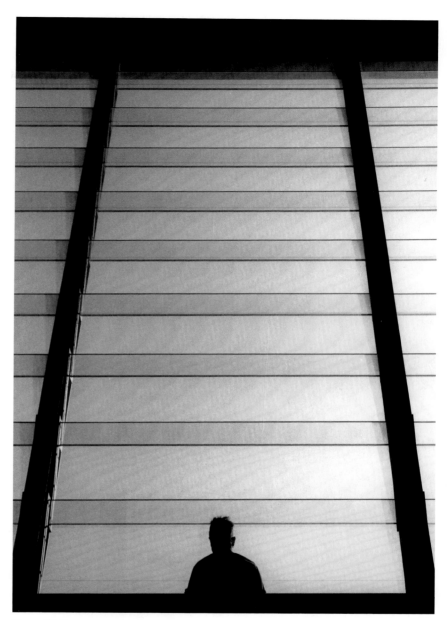

Figure 20–2

Minimalistic Structure

If the intention is to let a photo stand out solely due to its minimal graphic structure, it is essential to ensure that this graphic structure does not look sterile. This photo (figure 20–3) of Frankfurt's "Maintower" has a simple composition: The corner of the skyscraper runs exactly along the vertical axis of symmetry. From this corner, the horizontal lines of the building extend to the left and right, providing folding symmetry. The constant repetition of these lines is what gives the image its rhythm, but it would still be sterile if this rhythm were not broken by individual accents. The windows, opened in various places by coincidence, resemble a melody that is being played according to the basic rhythm. This melody is by all means necessary in order to make the photo interesting.

The difficulty in this photo was to check how the "Maintower" looked with various focal lengths and to find out in what spot and with what focal length the opened windows would play the most interesting melody on this basic rhythm. In this case, it was the 235 mm focal length of Canon's zoom lens in the Canon EOS 5D. As in most digital photos, contrast was increased by about 20% with the Medium Tone Contrast tool.

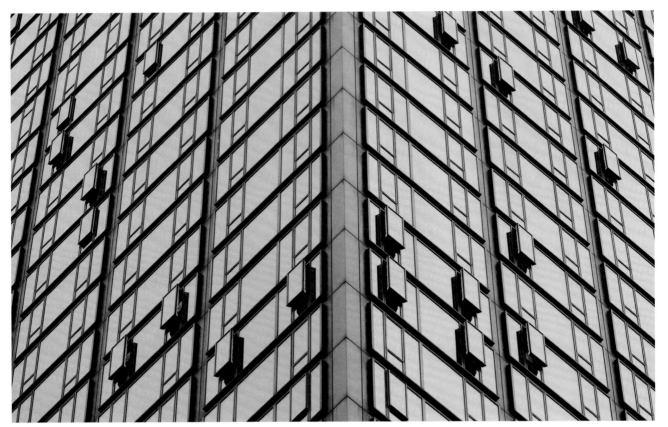

Figure 20–3

The clouds in the sky add another clear element to the arch, which is the optical triangle, here hinted at by the perpendicular opening in the sky. This line extends all the way to the left (and right) border of the picture. The base of the triangle is the beginning of the cloud formation in the horizontal line above the horizon.

Thus, five basic elements are arranged within the image: dot (sun), arch, triangle, line (horizon), and rectangular surface (sea), and there is also an organic texture (within the clouds).

This uncluttered and reduced pictorial composition is the formal basis to convey the special atmosphere of this place (the Canary Island of La Palma) in this instant. The red filter placed before the analog Mamiya 645 reinforced the atmosphere of this photo.

Figure 21–3

Reduced Nude

The small photo (figure 21–3) attempts to convey the tension existing between the backlit female body and the folds in the bed, but the photo isn't 100% convincing. Therefore, it was essential to take one more step: In the larger photo (figure 21–4), the studio lighting was reduced to only one floodlight that provides a slight backlight (foreground, right). A black cardboard was used to darken the foreground. Now, light has been reduced to a hard backlit spotlight that illuminates both buttock halves so they resemble arches.

The camera was placed considerably closer to the subject until the best composition was found—and this composition shows us that, formally speaking, it is enough for the photo to have just two sickle-shaped elements.

The photo was taken with an anolog Nikon F4 and normal focal length. The camera was mounted on a tripod.

Figure 21–4

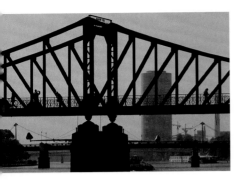

Figure 21–5

Digital Control

Digital photography has many advantages, but a big advantage is the ability to use the LCD to control the composition of the scene you want to photograph. In the digitally photographed Iron Pedestrian Bridge in Frankfurt (figure 21–5), the display readily showed that the photo—although a nice idea—left a lot to be desired with respect to its execution. Too many forms engage with each other causing the image to appear a bit cluttered (figure 21–5).

The solution was relatively easy: The focal length of the telephoto zoom lens had to be increased from 180 mm to 280 mm so the image could be reduced to its fundamental graphic composition; all the disturbing elements have thus been eliminated. The task then was to make sure that no passer-by would be hidden from view by the bridge braces. The display is ideal for spotting, enlarging, and perfectly controlling these details.

The most convincing image is this one (figure 21–6), in which only one man is seen walking in a triangle between two bridge braces; his silhouette clearly stands out from the bright sky. He is the counterpart to the West Harbor Tower; the bridge almost looks like a scale whose two pillars are anchored in the middle and that could tilt to the right or left at any moment. The left figure and the right skyscraper seem to keep the "scale" balanced. Otherwise, the composition is static and almost characterized by folding symmetry.

Because gradient filters are almost useless with long focal lengths, I subsequently added in a 15% grayscale gradient in the sky with Photoshop's Gradient tool to darken the sky a bit towards the top.

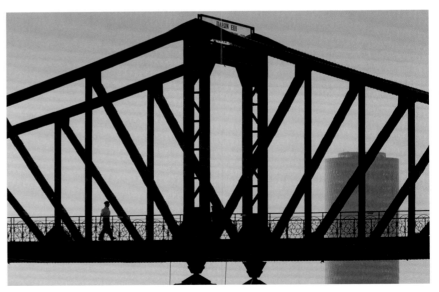

Figure 21–6

always keep returning to the arch, from which it will move to the most varied spots in the image only to return over and over again.

The photo was taken digitally with a 25 mm focal length, aperture 14 and ⅟₈₀ s, so both the plant and the background are in focus. A polarizing filter increased the contrast between sky and hazy clouds in the color photo, which was later converted to black and white. The 95% red channel of the channel mixer also helped to create a magical effect in the sky.

More Complex Pictorial Scene

Even in more complex pictorial compositions the viewer's gaze can be consciously guided. Here, several youths play table soccer on Frankfurt's fair grounds, a scene that would normally tend to look rather boring. Without a good compositional idea, the result is, in fact, boring (figure 22–4): Everybody is in the shadow, but are nonetheless not used as interesting silhouettes— quite the opposite, in the right half of the picture they cover one another and create a dark muddle. The huge floodlights towering above the left youth lead the viewer's gaze to them because of the contrast they create with respect to the sky, but they have nothing to do with what is really happening in the picture. Therefore, the floodlights have no place in the composition. What can be done here? A change of perspective would be a good idea, because only a perspective from below would make the photo interesting. This superior view does away with the clutter and guides the viewer's gaze; the youths stand out as silhouettes and no longer cover each other (figure 22–5).

The composition uses silhouettes as elements to lead your gaze through the photo as follows:

Figure 22–4

1. Your eye enters the photo at the face of the left youth.
2. Your eye moves quickly to the tower.
3. Your eye moves to the face of the other kid on the upper right, because the kid stands out well from the sky.
4. All the faces have something in common: They all look at the small soccer field.
5. Your eye follows their gaze toward the soccer field.

I used Photoshop's Dodge tool so the players would be bright enough and a rather bright corner would attract the viewer's attention. The projecting head in the upper right also looks interesting because it seems to be detached from the torso and gives the impression of almost falling into the scene. It is precisely this head that makes the rather banal scene a fully composed picture, which guides your gaze back and forth between four objects: the second youth from the left, the tower, the head without torso in the upper right, and the lower part of the soccer field.

Figure 22–5

23 Balance in a Photo

You have seen that every image has an underlying abstract structure that determines its pictorial composition. There are infinite possibilities for creating such a structure, but among all these possibilities one essential thing should not be forgotten: The structure must be balanced; it should not appear to tip over to one side.

Let's look at this photo (figure 23–1): A window cleaner swings high over Frankfurt in his suspended balcony. This photo should really appear to tip over to the left, because the window cleaner's box dominates the left side of the picture and there is no counterweight on the right. But, the photo does not become unbalanced and moves to the left as well. The reason is that we read images from left to right. Your eye enters the photo on the right side of the suspended balcony, looks briefly at the man but then moves quickly to Frankfurt's Western Harbor. The main

Figure 23–1

point of interest is the tower located in the center, which is, at the same time, the perpendicular axis of symmetry. Above the tower, you can see a cloud moving in that leads your eye from left to right and out of the picture. This reading movement is precisely what creates the movement to the right that serves to counteract the strong dominance of the balcony.

If you turn the photo around, however, the balance is gone (figure 23–2). Now, your gaze is quickly led by the floating cloud to the window cleaner and his base. The unbalanced photo definitely tips over to the right because there is too much weight on the right. Its left side desperately needs a much

Figure 23–2

173

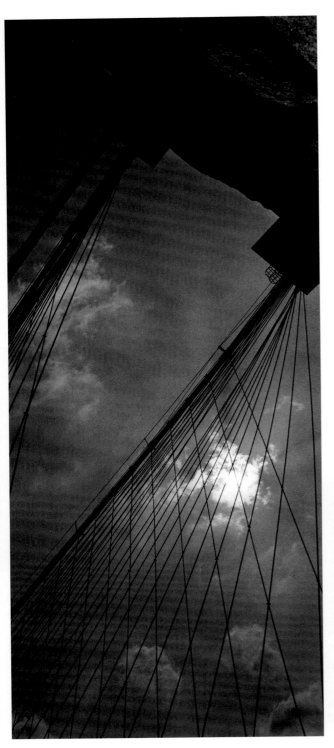

stronger counterweight than what the passing cloud can provide to restore balance. It's amazing how deeply the left to right reading direction is ingrained in Western civilization, even when you perceive and analyze images.

Formats and Diagonals

The creation of balance in an image is one of the most basic criteria of pictorial composition and it can be expertly used in many applications. Various formats and their principles are an important basis for this:

- A horizontal format is likely to be static and resistant.
- A panoramic horizontal is the most static, and is therefore a stable and calm format. (See the chapter on panoramic photography.)
- A vertical format is generally dynamic and less stable in the sense that it can appear to tip over and lose its balance more easily.
- A panoramic vertical format intensifies vertical properties.

A panoramic vertical format is wonderfully dynamic here (figure 23–3), where oblique lines create a balance. The photo shows one of the large buttresses and both steel suspension cables of the Brooklyn Bridge in New York. They have been photographed in such a way that the per-

fectly balanced oblique lines infuse it with life and don't allow the image to tip over. The steel cables of this gigantic bridge stress the so-called "positive diagonal" (the diagonal moving upwards from bottom left to upper right), because our gaze follows it from left to right. In this photo, the suspension lines lead us to the stone buttress of the bridge.

If we flip this photo over (figure 23–4), the effect is radically different. The eye is now more likely to be led out of the image because the so-called "negative diagonals" that move downwards are emphasized here.

Figure 23–3

Figure 23–4

The next photo is somewhat more static (figure 23–5). At least the city of New York appears to be resting on a horizontal axis, while two oblique lines move towards the same vanishing point in the upper and lower sections of the image. The oblique lines of the Brooklyn Bridge suspension cables and the shadow of the railing in the lower part make the photo dynamic, yet this dynamic quality is embedded in a certain static order, because the two oblique lines are mirror images of each other and can be reflected on the horizontal axis of symmetry. Therefore, this photo is very carefully balanced: Its compositional strength comes not only from the graphic detail of the wire cables, the railing and its shadow, but also from the mood created by the backlight. In order to intensify the mood in this photo (taken with an analog camera) it was important to burn in the sky in the darkroom.

The next picture also has a certain atmospheric quality (figure 23–6). Here we have a highly statically composed photo taken in an extremely dynamic format. The photo is perfectly balanced; the frame intensifies the static impression and it is almost a "photo within a photo". The urban silhouette lies more or less on the horizontal axis; the railing below lies almost exactly on the lower horizontal harmonic dividing line. In the upper part there is yet another "photo within a photo" in classical rectangular format subdivided by an arched brace. What makes the photo especially attractive, however, is the courting couple so intensely interested in each other that they did not notice having been photographed. The same principle applies in this picture: Backlight creates a mood. The sun shines through a hazy sky, but it is precisely this slight haze that gives the image its special mood.

This photo was taken with an analog camera and had to undergo a long darkroom manipulation to make the sun stand out in the sky; such a lighting situation is the biggest challenge for digital cameras. You can manipulate the lighting by using a gradient filter, and underexpose in way that will resemble the result obtained with the Mamiya 645 middle-format camera. Such a lighting situation will really put to the test the actual quality of the digital sensor.

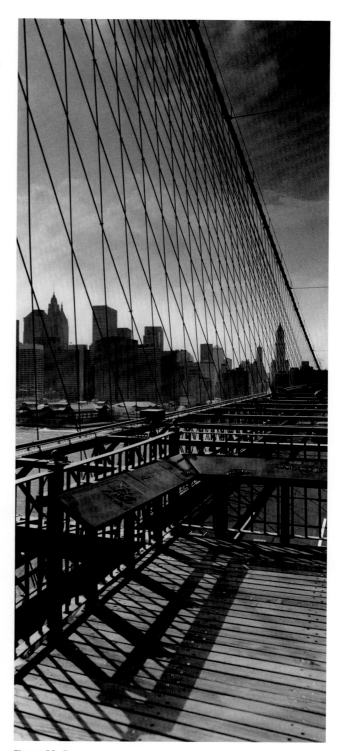

Figure 23–5

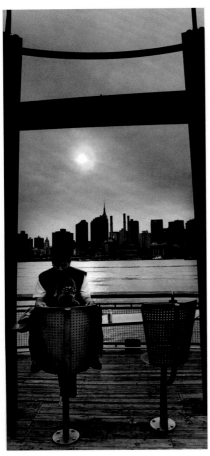

Figure 23–6

It is difficult to make this panoramic horizontal photo "lose its balance". This picture (figure 23–7) was also taken in New York and shows the towering skyline of Manhattan's Upper Side, located in front of a lake in Central Park. Yet the idyll can be seen only through a fence. Father, mother, and child "hang on" to this fence—family idyll and urban idyll are separated from one another by this fence. Is this photo trying to say something once again? Why has this small lake in Central Park been fenced in and was it necessary? Why must nature be protected from humans in such small-scale idylls in the 21st century? In any case, the fence does not seem to bother the family, as they enjoy the urban idyll by looking through the small openings of the fence.

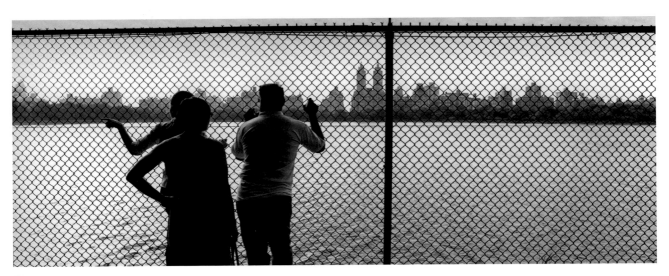

Figure 23–7

24 Unusual Perspectives

Good photography means that the photographer has developed an individual style and uses it for expressing what he/she really cares about. Perspective, used to photograph the subject within its surroundings, plays an important role in this expression. To best use perspective, it is essential for you to know the principles of the various focal distances. Please allow me to repeat this once again, as it cannot be stressed often enough: Reality is three dimensional, but photography forces this three dimensional reality onto a two-dimensional surface. And on this surface, different spaces are placed in certain relationships to one another that often have no connection to each other in real life. The wide-angle lens is the most suitable tool for joining two radically different premises. The wide-angle lens has other advantages for making use of unusual perspectives:

- It distorts perspective.
- It makes objects stand out from the normal visual horizon.
- Faces look strange.
- Buildings acquire dynamic vanishing points.
- The foreground and background look completely different.

Thus, wide-angle lenses are particularly suitable for playing with unfamiliar perspectives. (Telephoto lenses, on the other hand, compress spaces and can make them look like a jumbled mass.)

The Russian photographer Alexander Rodchenko, mentioned earlier, was a pioneer in the use of unfamiliar perspectives. One of his best-known pictures shows a trumpet player photographed from below and his cheeks are filled with air. However, with regard to architecture, he turned the world literally

upside down—the most unusual views of the world were his trademark. To follow his steps means to analyze the objects that you want to photograph from all possible angles. When doing so, a true enthusiasm is needed to even lie down on the ground and get your clothes dirty or to climb a ladder or shoot from a rooftop; these are small prices to pay to capture the unusual photo.

Another master of unusual views was Otto Steinert (mentioned earlier as well), who became known for "subjective photography". This former teacher in Essen's Folkwang School was one of the most important postwar German photographers. He taught his pupils to utilize the photographic media for expressing the various facets of their personalities. To bring such a subjective expression into their own photos, it was necessary to surrender to one's own intuition in the search for subjects. Once the place was found in which the "inner pendulum" had swung, the moment had come to explore this place thoroughly. Apart from snapshots, it was essential to be disciplined and look at the subject from all perspectives first, allowing unconventional views to be discovered before photographing it. These unconventional views, in turn, were one of many requirements for developing an individual pictorial language.

Headstand

Everybody will think that this photo (figure 24–1) has been printed upside down. Not so! The woman appears to be upside down because the photo is of her reflection. The photo was taken in an interesting building complex in Frankurt's suburb of Taunus, where there are bridges made of glass that link one building to the other. And these bridges are reflected from below. In the upper part of the photo, we see the lower part of such a reflected bridge in which the woman is mirrored and she seems to be doing a headstand. A certain distance behind, we can recognize a section from the main building. In the foreground, we see the top sections of a moving sculpture. Because these sections were constantly changing, it was very important to make sure that they would fit into the composition. They have a vital function in this photo because they break the strict dual division of this image and bring a dynamic quality into it. Even here, it was essential to look carefully at the subject first, and then to turn the world upside down later.

Figure 24–1

The photo was taken digitally with the Nikon D70s and a focal length of 105 mm, which in full-format corresponds to approximately 160 mm. The photo was converted to black and white with the Grayscale mode and brightened a little bit with the Shadow/Highlight tool, which was also used for increasing the medium-tone contrast of the entire image.

Person from Below

This photo (figure 24–2) captures a rare look at a person made possible by Berlin's Potsdam Square, because from the basement of the Sony Center, one can look up to this lath floor. It was important to shoot at the instant when the woman had both feet on the ground to achieve this unusual perspective of a walking person. It was also important to make sure that the woman would be in the middle: Her centered position structures the pictorial composition and makes her stand out from a calm, medium-gray background. She would not have stood out well had she been in the right part of the photo, and the left part would have been too cluttered. However, it is advantageous for pictorial tension that we can see a couple of graphic shapes in the image (the roof of the Sony Center) that provide some tension with respect to the round light in the lower right. Without this light, the entire right side of the image would have been dead.

This photo was also taken with the 105 mm focal length of the Nikon D70s at full aperture and a shutter speed of ⅟₆₀ s, which led to a slight blur because it was shot without a tripod. Photoshop's Smart Sharpen tool counteracted this blur a little bit.

Figure 24–2

Indian Primal Tribe Village

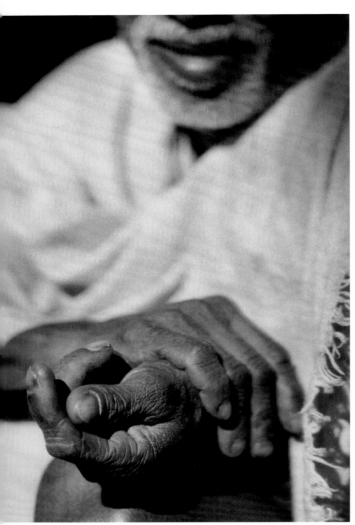

A divergence from the classical viewpoint was also the crucial design element in this photo: Instead of focusing on the face, why not focus on the hands? To achieve this, it was necessary to intimately get to know the life in a primal Indian village and become so familiar with the villagers that as photographer I could move around freely and people would regard it as normal as I would take their photos.

This photo (figure 24–3) is of a man who leads a very simple life, compared to our standards, and has devoted his entire life to farming and cattle breeding. His worn hands tell his story. The man's face is somewhat blurred in the background, though his gray beard suggests the person must be old. The photo also indicates a totally different way of handling time, because especially in Indian villages, people have an exceptional amount of time at their disposal and are not as overactive as people in the West. Thus, people can just squat down for hours on end. The pictorial tension of this photo is found in the way the two poles (e. g., the two hands) and the blurred part of the face relate to each other.

The photo was taken with an analog camera and a 50 mm lens.

Compositional Poles: A picture with more than one center of attention, which are usually placed toward the edges to achieve a so-called bipolar pictorial composition. If the two poles are equivalent, the composition does not let the eye rest because it will always keep moving back and forth between the two.

Figure 24–3

New York Subway

This photo (figure 24–4) tells the story of a different world: A young man wearing sunglasses and a jacket holds on to the handle of a New York subway car. Here, we have once again an unusual perspective from below that makes the image interesting. The man's arm running diagonally through the image greatly dominates the composition and makes it highly dynamic. The braces in the roof of the subway car run obliquely in an opposite direction, and one brace even runs across the man's face almost giving the impression that he has been skewered.

In contrast to the photo of the Indian, this man radiates coldness; the subway is only a fleeting place of residence in the fast-paced microcosm of urban life. Whereas the photo of the Indian conveys deep roots and tranquility, this image shows us the dynamic hustle and bustle of New York urban life in which the individual remains anonymous, even hiding behind sunglasses in the rather dark world of the subway car.

Edward Weston started photographing people in the New York subway as early as in the 1920's. He hid his camera behind his jacket and shot the photo through a buttonhole. To take this photo, I placed the camera on my knee and the composition was a calculated guess because I could not see through the viewfinder. With a little practice, it is possible to shoot people without them noticing it (in this case, the "clicking" of the Mamiya wasn't heard owing to the loud sound of the moving subway), and thus obtain acceptable pictorial compositions with unusual perspectives, as is the case here.

This photo was taken with an analog Mamiya 645 and a Fuji Neopan 400 pushed to 800 ASA using a super wide-angle lens.

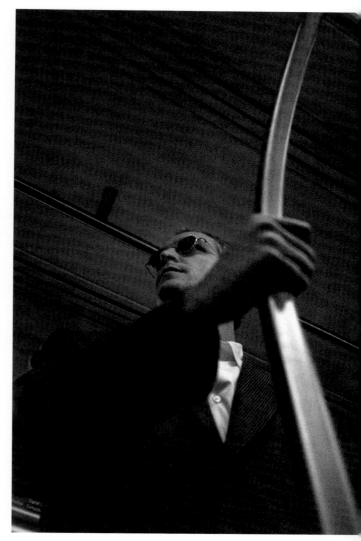

Figure 24–4

New York Street Scene

In this photo (figure 25–4), your eye is disappointed at first because the center is mostly empty, filled only by surface lines created by the skyscraper's structure. A person stands before this sterile wall, and a rapidly moving, slightly blurred dark-skinned person wearing a cap walks by in front of the camera. An essential element in this picture is the view of the background seen in the right edge because it creates pictorial tension and spatial depth. If you cover this edge, the photo becomes flat and loses tension. This proves that even the edge of a photo can be essential for pictorial composition: Although not much occurs in the center, the narrow edge teems with structures and activity. Piet Mondrian often composed his abstract canvases with centers filled only by large, white surfaces and edges filled with small surfaces painted with the three primary colors.

I must remind you that this photo—a typical, every-day scene in an urban setting, in which three persons just walk by each other without engaging in any mutual contact—would have looked boring without the two persons in the foreground. Their surroundings are sterile and almost capable of crushing and converting them to small, scurrying little wheels amid the urban hustle and bustle.

This photo was taken with an analog camera using a 28 mm lens. I composed the elements by placing the centers of attention in the right and lower edge of the image, rather than in the center.

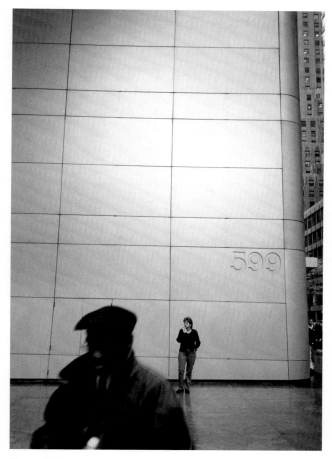

Figure 25–4

Circular Composition

The circle, a compositional element of calmness, symbolizes unity in the visual arts and architecture. Interestingly, the builder of this uniquely designed, modern building in Bad Homburg near Frankfurt did not place the brace exactly through the middle of the circle, and therefore, this element of the centrally composed photo (figure 25–5) is not its exact axis of symmetry either. As I have already mentioned, the eye loves dissimilar sizes that cannot be immediately comprehended. Here, the circle provides a framework for perspective and leads your gaze to the inner patio of the building; the woman walking by makes the photo come alive. After all, this is a structure built for people, and it was especially important to show the relationship between humans and their spatial surroundings.

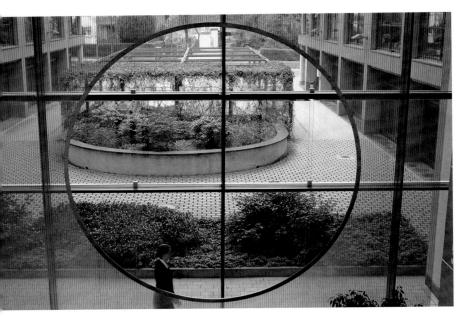

Figure 25–5

The photo was taken digitally with the 32 mm focal length of a Nikon D70s (equivalent to the 48 mm of a full-format camera) and was converted to black and white with the Grayscale mode. I increased medium-tone contrast by about 30%.

However, a circular composition does not have to be dominated by a circular shape; an ellipse also has the same impact of unity. In this photo (figure 25–6), several cars have left their circular tracks in the foreground as the drivers turned them around. The small cemetery chapel in the background has a layer of dark slate, and this dark chapel is precisely what intensifies the photo's surreal effect, whereas the circle in the foreground represents unity and harmony. Here, it would have been inappropriate to attempt to create tension through an asymmetrical composition, but a symmetrical pictorial composition, supported by a circle, intensifies the archaic or—as is the case here—sacred impression of this image.

This photo was taken with an analog camera with a 28 mm wide-angle lens.

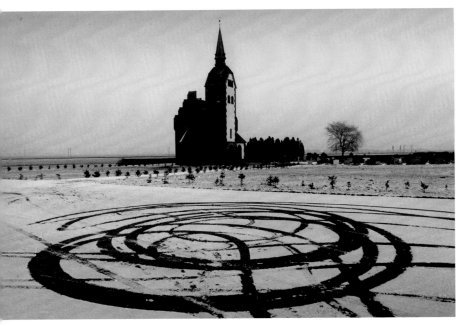

Figure 25–6

26 Pictorial Tension Between Two Elements

Two opposing poles create magnetic tension, and something similar happens with pictorial tension. However, how do you provide tension in a photo?

You already saw how a photograph with good composition consciously leads you through the image, and you also learned how photographs could be rhythmically composed. Now I am going to explain how to achieve pictorial composition by concentrating the center of attention in two poles and including some rhythmic elements in it.

If you reflect a bit about composition in photography, you probably tend to choose a particular subject such as a pretty house, a person, or a special tree, and then place the subject either in the middle or (a better alternative) in the Golden Ratio. This is not necessarily bad; in most cases, you get rather calm photos, but in the worst-case scenario, you get boring images.

To avoid boring compositions, you can compose a picture with two centers of attention and place them preferably toward the edges to achieve a so-called bipolar pictorial composition. If the two poles are equivalent, the composition does not let the eye rest because it will always keep moving back and forth between the two centers. Our eyes love this kind of restlessness, which imparts a dynamic quality to the photo.

Airplane on the Line

Man and technology are two poles of tension that have influenced our world in an amazing way in the last 100 years. Aviation is only one example demonstrating that humans can surpass their own limits in many different ways.

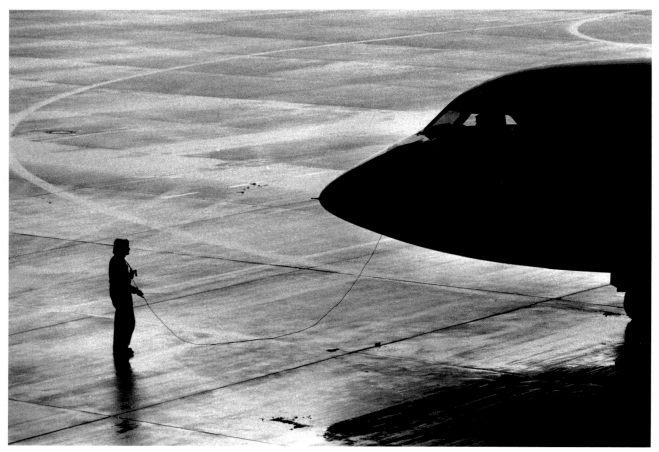

Figure 26–1

Here (figure 26–1), pictorial tension is created both by the abrupt crop of the airplane and the backlight that reduces man and machine to strong silhouettes. However, the composition is also determined by a third element, namely the repeating shape of the arch that also provides the pictorial rhythm: The arch not only determines the form of the airplane nose and its shadow, but the shape of the cable and the two traces on the airport surface.

In the next photo, pictorial tension has a formal and content-related component, because it might provoke philosophical talk about the tense relationship between man and alleged technological marvels. In the meantime, this image could very well represent not only something positive—how mankind has advanced technologically—but also something negative, because aviation can contribute to global warming. Humans invent outstanding technology, but they may become technology's victim in the future.

The photo was taken with the 200 mm telephoto lens and an analog Nikon F4.

Dunes in the Sahara

The Sahara is one of the most fascinating regions on this planet. The region's seemingly endless expanse of sand dunes cries out for a good composition. In this photo (figure 26–2), the early morning or late afternoon hours create an interesting interplay of light and shadow because the sun is very low. To make sure the landscape does not look too monotonous, the sand dunes provide pictorial tension. In this sea of sand dunes, an especially large dune provides a counterweight to the smaller dunes in the bottom left. However, what provides most of the tension is the large dune that has been placed too much to the right. A rather large dune

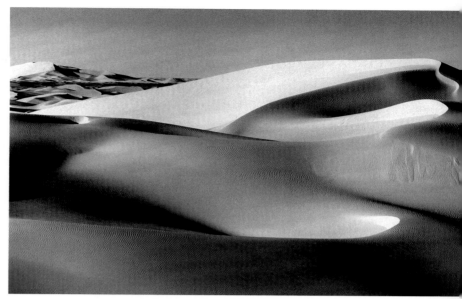

Figure 26–2

in the background (left border) creates a counterweight. If you cover the left third of the image, you can notice how the photo loses its balance and seems to tilt to the right. The total picture is balanced, however, because the sand dune chain located in the upper left is the counterweight to the large dune that is placed too much to the right. All these elements provide a strong tension in this balanced photo. The photo was taken with an analog camera and a 105 mm telephoto lens.

A Glance Out of the Picture

For a long time, serious photo clubs emphasized a classical rule of composition: People should not move out of, but rather into the picture. This seems logical at first, because such a composition leads your gaze into, not out, of the picture. Modern pictorial language, however, no longer follows this classical rule, because it is perceived as overly conventional. In photojournalism, we often see people in the edges of pictures looking away from the camera or their blurred images moving out of the photos.

In the next photo (figure 26–3), instead of humans, two camels turn away from each other. Each one leads your gaze out of the image—yet, this is what gives the photo considerably more tension than if both camels had turned toward each other. The eye is forced to move back and forth between the two directions indicated by the camels, and yet the photo has sufficient calmness, because it has an axis of symmetry (although this axis has been slightly broken, because only the shadow of the right camel can be seen). This prevents

Figure 26-3

the composition from becoming too rigid. The photo was taken with an analog camera using a 105 mm tele-photo lens.

Spotlight

An Irish landscape is usually characterized by dark clouds and saturated greens, therefore black and white photography may not be the ideal medium to photograph it. And yet, precisely because black and white will not register these saturated colors, the interplay of light and shadow, rather than color, composes the image (figure 26–4). A green mountain such as this one would be completely uninteresting for a black and white image if not for the exciting, endlessly changing lights and shadows falling on it which made the landscape exciting. The trick is to make use of this interplay of light and shadow to compose and create tension; in this photo the lower circular spotlight is what gives the image all its tension. If you cover the spotlight, the photo loses its tension and the entire lower part looks dead. You have learned that the eye is led through an image by contrasting spots, and in this photo there are two contrasting spots or poles that provide tension: the light spot in the cloud to the left, and the elongated light spot on the mountain that leads the eye in read-ing direction (left to right) and stops just before it reaches the edge. (A third tension pole is located between this elongated light spot and a smaller one in the lower part of the image.)

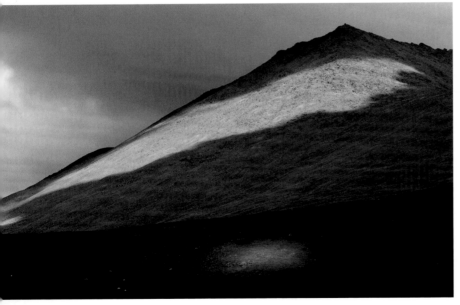

Figure 26-4

The photo was taken digitally with the 87 mm focal length of the Canon 70–200 mm telephoto lens. I used Photoshop's Dodge tool to brighten the light falling on the mountain by about 15%. The medium-tone contrast of the image was also increased by about the same factor.

27 The Image Within an Image

The so-called frames of perspective (an image within an image) create a view and concentrate the viewer's gaze. This form of pictorial language was employed by the Old Masters; one of the best-known examples of the use of an image within an image is Caspar David Friedrich's "Woman by the Window".

The easiest way to create an image within an image is to photograph the views seen through a window. The inclusion of windows in a photo is fascinating owing to several reasons:

- They connect two spaces that possibly have nothing to do with each other in order to create a whole in the photo—inner and outer space are blended into one.
- They give the illusion of three-dimensions in a two-dimensional photo; after all, photographers aim to achieve this illusion as much as possible.

However, you can use the "image within an image" concept more freely. For example, the frame does not always need to be rectangular. The framing can also be implied, as you will see in the photo of the power lines in the chapter "Interesting Irritations". Regardless of how the frame of the perspective is composed or hinted at, it does create two pictorial planes and that's what makes this kind of composition exciting.

Generally, the wide-angle lens is the best tool to use for achieving such a composition, because its strong vanishing perspective coupled with the immense depth of field makes it ideally suited for blending two spaces.

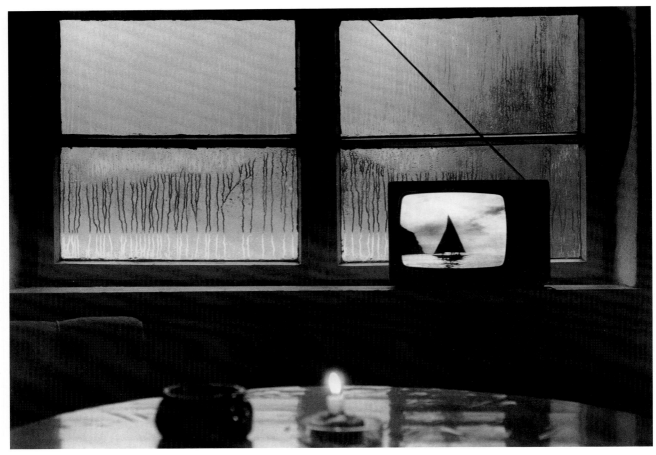

Figure 27–1

1 Upper horizontal harmonic dividing line
2 Lower horizontal harmonic dividing line
3 Vertical symmetry axis
4 Breaking the line pattern

Melancholy with Binoculars

As we have seen before, melancholic moods can be poetic. This photo (figure 27–1) has four planes that create this poetry: the table with the candle, the window with the raindrops, the blurred background, and the television screen. The image within an image is taken literally here because the image of the sailboat on the television screen and the opaque window achieve the main tension in this photo. The promising virtual reality contrasts with the sobering reality. This is surely a photo that could tell a story; a story about yearning and wanderlust. (In the language of classical painting, the sailboat often symbolized yearning.) Here, the sailboat is placed in rather dull premises: The window frame looks somewhat worn and the windowpane looks steamed up from the inside and rainy from the outside. Both the television and the barely recognizable sofa beneath it do not look so modern either. Only the candle seems to break through this melancholic mood, providing a bit of relief.

The photo was taken with an analog camera using a rather large aperture of a normal lens. Table and background are blurred, but this lack of sharpness actually helps the image.

Backlight Projection

As I mentioned before, the frame created by perspective does not have to be rectangular. In this photo (figure 27–2), the sail of an Indian fishing boat serves as a projection screen for the image within an image. Here, the sun acts as projector for the silhouettes of the seven persons who are hoisting the sail. It was essential to shoot the photo at precisely the right moment, because only a few seconds later the people moved and the composition was gone.

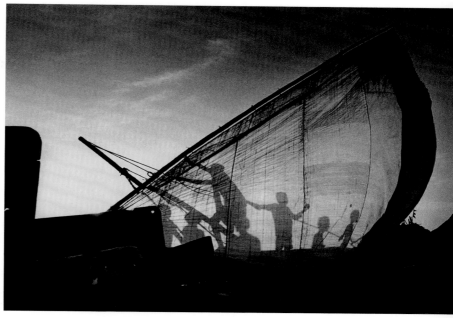

Figure 27–2

Because the photo was shot with an alanog camera, it was very important to burn in the sky in the darkroom to intensify the framing effect. The sky that gradually becomes darker towards the top helps to lead the eye towards the bright part of the image within the image, where the action is concentrated and the distribution of light is strengthened.

It would have taken forever to create a template for every photo, therefore hand-blocking was used to shadow areas of the image where less exposure was desired. Naturally, a 100% clean result was never achieved, because this complicated dodging act had to be performed during a certain exposure time. In this photo, the dodging is not uniform (the upper part of the sail is too dark and the left area is too bright). Such slight imperfections characterize analog photo manipulation.

This photo serves as an example of how the digital darkroom allows for more precise dodging and burning compared to the traditional darkroom. Digital dodging tools can be adjusted to all sizes, thus allowing you to take your time to gradually dodge and burn until the perfect result is achieved.

The photo was taken with the 28 mm wide-angle lens.

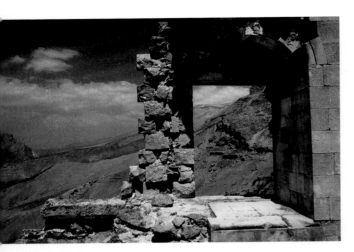

Figure 27–3

Ruin in Kurdistan

This photograph (figure 27–3) of a landscape illuminated by the flat light of the midday sun needed pictorial tension to be good. The mountainous terrain and the ruin divide the image into two halves, providing the necessary pictorial tension. In the left half, the eye can wander freely along the wild, barren expanse of the eastern Turkish landscape, while the right half is dominated by the ruin—and the view through the ruin towards the barren mountains creates yet another image. This creates the pictorial tension and a lot of depth that would otherwise be practically nonexistent.

Here, it was important to intensify the contrast between sky and clouds, something easily controlled in analog photography with color filters. In this case, I used a yellow filter, although an orange or red filter would have increased the effect to the mystical realm (such a ruin is reminiscent of another age), but I didn't have one with me. If available space is an issue, the yellow filter is the universal filter for analog black and white photography.

This photo was taken with a 28 mm wide-angle lens.

Square Concrete Blocks in the Landscape

If the image within an image of the previous photo stressed the wildness of the landscape, this photo expresses the joy of a landscape idyll. Two gigantic-looking squares block the view of the boundless beauty of a mountainous landscape on the volcanic island of Lanzarote, which opens up behind a flower-filled meadow. The square concrete blocks create the frame of the perspective and act like two images within the image that taper off in the central perspective and lead your eye to the center of the picture. The square block in the middle makes the landscape in the background look like it appears on a television screen.

The image triggers a feeling of uneasiness. What are these blocks for? What is going on here? Such an image might force you to think about a deeper issue: Will concrete someday cover the earth? The mood evoked in this photo may express such a general feeling of uneasiness, which certainly reflects the mood of the times.

The photo was taken with an analog camera using the 20 mm wide-angle lens. I later scanned the negative and manipulated it with Photoshop to increase the medium-tone contrast by 35%. I then used the Burn tool to expose the sky in the upper edge of the photo by about 20%.

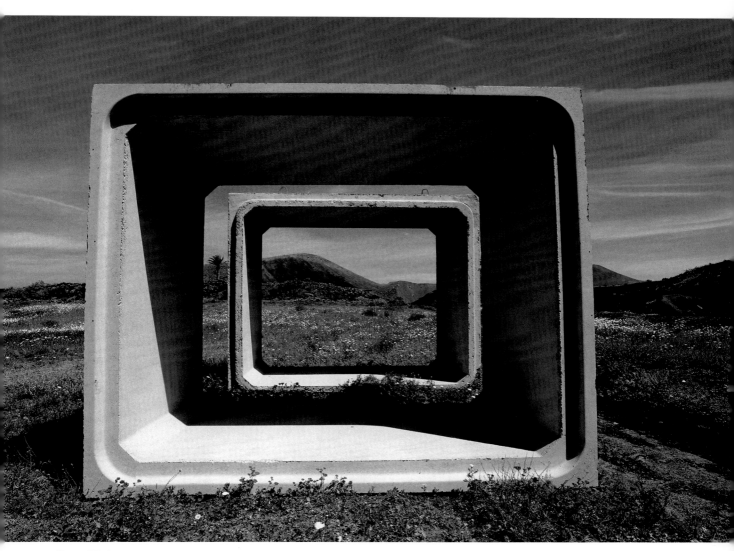

Figure 27–4

29 The Play of Forms— Conscious Repetition of Pictorial Shapes

During the course of this series, we have seen that there are parallels between pictorial and musical languages. Pictures can have the same rhythm as musical pieces; images can be composed in such a way that they have a leitmotif (i. e., recurring theme) that is repeated in a modified way. Many classical musical pieces have such a basic leitmotif that is repeated throughout the composition, albeit in slightly varied forms.

You have already seen that most of the time, a photo is successful when its basic pictorial structure—from the purely abstract viewpoint when it is fully separated from its object—is also interesting to look at.

The first step should be to recognize and analyze these pictorial patterns in photos that have already been taken. The second step should be to identify the abstract patterns that underlie reality when actively taking photos; in other words, to think abstractly and pictorially when looking at the real world. This is especially hard when we are trying to shoot content-related subjects whose composition is already demanding full attention. Even more difficult is to apply this kind of pictorial approach in street photography, for example in the hustle and bustle of an urban setting, where everything is in flux and the abstract pattern of an image is constantly changing. If you also use a wide-angle lens, it becomes especially challenging to keep all edges of the picture simultaneously in sight while making sure to control form as well as content. Of all photographers, Cartier-Bresson was probably the one who mastered this challenge the best, because his news photos not only have an interesting content, but also have outstanding abstract patterns.

Photography is, so to speak, "multiple choice": From an endless variety of places and moments, the photographer must choose the most interesting moments and compose them in such a way that interesting and abstract pictorial patterns are the basis of content. Cartier-Bresson was certainly the undisputed master in this, but as far as form creation is concerned, he was not as successful. In his later years, he devoted his time to drawing, but his greatest talent remained in photography.

In order to approach the many varied abstract forms with the camera, it is first of all easier to identify only two similar form patterns in totally different objects that will later develop a certain relationship in the image. This kind of practice trains the eye to find abstract shapes in objects and is suitable for creating exciting images out of rather banal landscapes or objects, as the following three examples will show.

What makes photography so exciting is that it brings together and blends two spaces that, in reality, are far away from each other and are often unrelated on the two-dimensional print. Thus, with regard to content, elements may be formally linked that actually have little or nothing to do with each other.

View from Schauinsland Mountain

The mountainous region of Germany, although refreshing and pretty, is difficult to shoot in real life, because it frequently ends up looking very conventional in photographs. After all, the identical spruce plantings seen in the Harz or Black Forest do not look particularly photogenic. Another problem is that the three-dimensional view inspires enthusiasm, but this depth is almost impossible to capture on a flat surface. And yet, this

Figure 29–1

two-dimensional pictorial space begs to be composed. In this case, the landscape by itself would not have been enough for creating an interesting photo, but the two projecting corners of the observation tower do provide the much-needed pictorial tension. The corners are just as angular as the upper lines formed by the mountain crest: Similar lines having a similar angle are therefore repeated. The railing breaks up the quiet harmony of the landscape, and the soft shapes of the clouds contrast greatly with the pointed forms of the foreground.

The photo was taken with an analog camera using a 24 mm wide-angle lens. I had to burn in the sky considerably in the darkroom to achieve texture in the clouds.

Umbrella and Sky

This landscape photo (figure 29–2) taken on the tranquil Mediterranean would have looked too calm by itself, so it was essential to include an element that would slightly disturb this calmness. The cropped umbrella was the ideal candidate for inclusion, because its triangular shape resembles the triangle formed by the clouds in the sky. Both fleecy clouds give the image the symmetry it needs and lead your eye to the center of the image, which looks a bit surreal. The upper end of the umbrella looks quite abstract at first, and is only recognized as such after a second glance, triggering the idea of unbroken nature. What is going on behind us? Is the area teeming with tourists? All this is left to the imagination of the viewer. The photo was taken with an analog camera using a 20 mm wide-angle lens. I used an orange filter to increase the contrast between sky and clouds.

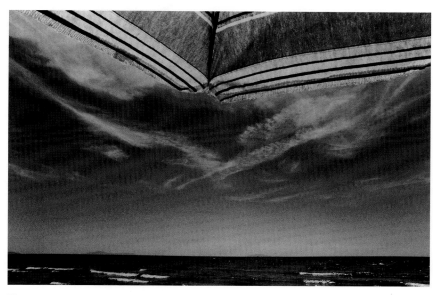

Figure 29–2

Reflection in the Sky

At first glance, a cornfield does not usually trigger the impulse to photograph it. However, the one single plant backlit by the sky, and the two abstract shapes that resemble each other, can create a rather exciting photo. In this photo, the form of the plant is "reflected" in the sky, albeit mirror inverted. The photo (figure 29–3) uses the plant's leaf as the axis of symmetry, and both leaves are

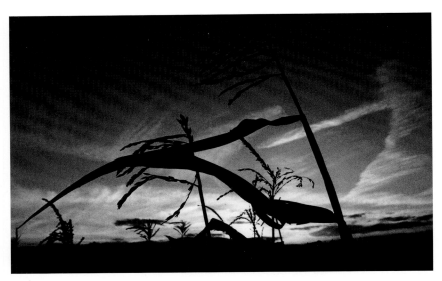

reflected in the sky. The composition is very dynamic, last but not least, due to the rising slant and the leaf's sweep that extends into the sky.

The image owes its dynamic quality to the view provided by a 24 mm wide-angle lens. The contrast was intensified by use of an orange filter placed before the analog camera and a slight burning in of the sky in the darkroom. This photo proves that a fully ordinary scene found just around the corner in this "boring and normal" field, can lead to unusual ways of seeing.

Figure 29–3

Water Lilies Without Cliché

Clichéd photos of water lilies are very often used for illustrating rather shallow texts. Thus, the challenge here was to photograph these plants so the photo would not look clichéd. (Sunsets and sunrises present a similarly difficult challenge: Pretty to look at, but most of the time degraded to a cliché on print.) When taking plant photos, however, backlight can come to the "rescue", as was done here. However, in this case it was not enough, because without the sun's reflection, the image would have looked boring.

The photo (figure 29–4) was minimally composed: The composition comes from three pictorial shapes that vary slightly from each other: A larger oval formed by the water lilies in the center, a smaller one to the far left, and the semicircular sun reflection. Without this reflection, the photo would have been boring; it is the decisive final touch that gives the image a mysterious, almost mystical effect—and it changes the shape of the oval into a semicircle. Furthermore, four jagged edges have been "built-in" to the sun's reflection, and the longest one points toward the middle oval formed by the water lilies. The backlight makes the pond's surroundings and the trees appear dark and barely recognizable; only a branch is clearly recognizable in the upper left corner. The photo works due to the extreme contrast of the water lilies, the sun's reflection, and the dark background.

The photo was taken with an analog camera at an 80 mm focal length.

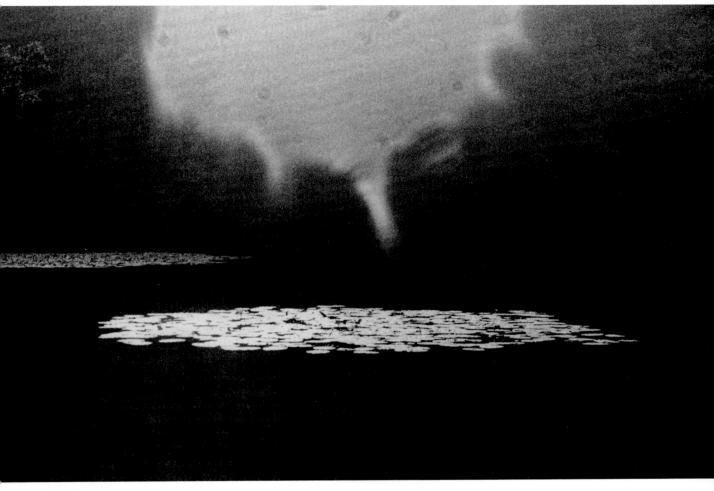

Figure 29–4

30 How to Compose with Blurred Movement

Long exposures play an increasingly prominent role in today's modern artistic photography. A photographer who has used long exposures to the max is Michael Wesely. His yearlong exposures of Berlin's Potsdam Square have been exhibited internationally. Only wall fragments remained stable in his photos, everything else looks dynamic and chaotic, almost resembling a futurist painting of the early 20th century.

It's fascinating how photography is capable of breaking through our conventional perception by blurring what we experience as individual, clearly separated moments strung together. In Wesely's images, these moments just dissolve into a blurred flow from which countless instants of an entire year become one single complete view.

In another series that can be seen as further development of his extremely long exposures, Wesely does not leave his camera on the same spot, but begins twisting it horizontally during exposure. The results are unfocused landscape photos whose horizontal axis is completely blurred, thus becoming a fuzzy interaction of multicolored stripes in which details are no longer recognizable, and which remind the viewer of Marc Rothko's paintings. These photos can also be regarded as allusions to the stripes seen on the bar code stickers that can be found on all kinds of merchandise.

In contrast to long exposures, world-famous photojournalist Henri Cartier-Bresson has formulated the "decisive moment" style of photography by waiting until the fraction of a second that makes the right statement; what has been dormant suddenly breaks out and gets to the heart of things.

With long exposures, on the other hand, this moment blurs, allowing time to flow and mix. Naturally, these long exposures make you think philosophically

about the nature of time. What is it? How can it be grasped? How can time, as a basis of photography, be played with? Almost every photographer has tried to answer these questions.

Long exposures are as old as the beginnings of photography, when the rather insensitive emulsions finally gave way to short exposures, which revolutionized the medium. Currently, we can freely choose between $\frac{1}{8000}$ s and long exposures that last entire evenings or over one year, as with Wesely. Technically speaking, long exposures are no longer a problem; even good digital cameras allow you to go beyond the 30-second exposure and shoot with a "B" (long exposure) setting. The indispensable tool for shooting good quality, long exposures is a stable tripod that is strong enough to withstand a heavy telephoto lens (added weight), a vertical format (less stability), and wind. The tripod should weigh at least 5 pounds, and you should preferably stay away from very lightweight ones made of plastic. It is better to purchase a stable tripod even if height concessions must be made due to weight issues. A shooting height of 51 inches is tall enough for almost all subjects.

Exposure is no longer particularly difficult either: If you use black and white negative film, I generally recommend slightly overexposing by one to two apertures when shooting at night because exposure meters are easily fooled by neon lights, and thus indicate a higher light intensity than is really available.

Handling the exposure using a digital camera is even less of a problem, because you can control the image perfectly with the histogram on the display. If necessary, you can correct the image by reshooting it.

Chapel in a Sea of Grass

In this photo (figure 30–1), the entire foreground is immersed in blurred movement while the chapel in the middle of the image remains perfectly sharp. The photo was taken from the window of a moving train while traveling between Hanover and Brunswick. The shutter speed was $\frac{1}{30}$ s; long enough for making the field in the foreground appear out of focus, yet short enough for the houses, trees, and the chapel on the horizon to be in perfect focus.

The photo suggests that the chapel is in the middle of the sea and not behind ordinary fields. To intensify the magical impression of this photo (taken with an analog camera), I strongly burned in the sky towards the top in the darkroom. Thus, the surroundings of the chapel are flooded with light and an impression of spatial depth is thereby created. All pictorial means have been used to give this small, rather inconspicuous chapel a special charm, and the blurred movement is the main reason for this.

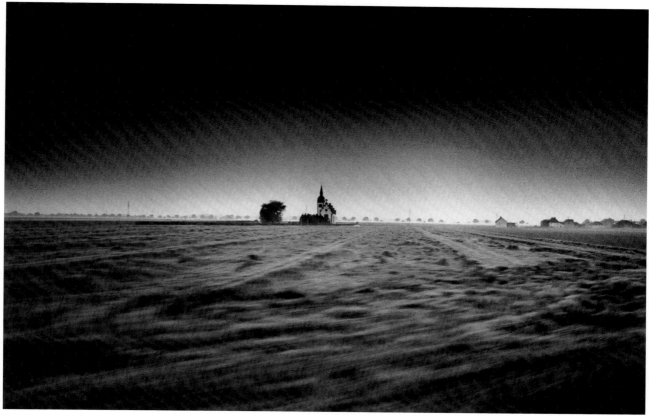

Figure 30–1

Typical Night Photo

When taking a photo (figure 30–2) of the Paris Opera House, I closed the aperture so much that the automatic counter of my exposure meter exceeded 30 seconds—enough time for coincidence, my "companion", to create a composition. In the finished photo, a passing bus going into a side street produced an interesting composition that broke the central perspective fixed on the Opera House. The two elements that make the composition especially interesting are the lettering that is reflected in the windows of the bus and the bright line that goes across from the top to the right edge of the image. However, all other lines created by the long exposure also give the photo a dynamic quality that very clearly expresses metropolitan effervescence: A typical, classic night photo.

One more thing: When shooting long exposures, you must be aware of the reciprocity effect that occurs when aperture changes are no longer proportional to exposure time (i.e., you cannot compensate a very long exposure by changing the aperture). However, in practice this effect plays a much lesser

role than photo clubs often attribute to it. The photo was taken with an analog camera using the 105 mm focal length.

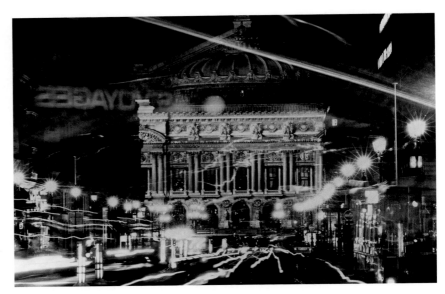

Figure 30–2

Long Exposure with Displacement

I took this photo (figure 30–3) of the World Trade Center in June 2001, not even three months before the tragedy that took place on September 11. Seen in retrospect, it has an almost anticipatory character, although I only intended to use it as a long exposure experiment. The camera was mounted on the tripod to take the photo with a very small aperture (f/16) and exposed for 20 seconds, during which time I displaced the camera vertically. The pictorial effect is disturbing, especially when we remember that three months later the main subject of this photo became the victim of the most brutal terrorist attack ever.

Needless to say, that this long exposure would one day have such significance could not have been foreseen at the time the photo was taken. The effect of this vertical displacement implies, in fact, the disintegration of the solid structure. The elongated lights do give the impression of a fire and the vertical lines emphasize this impression of collapsing stability.

The photo was taken with the 210 mm telephoto lens of the analog Mamiya 645 camera.

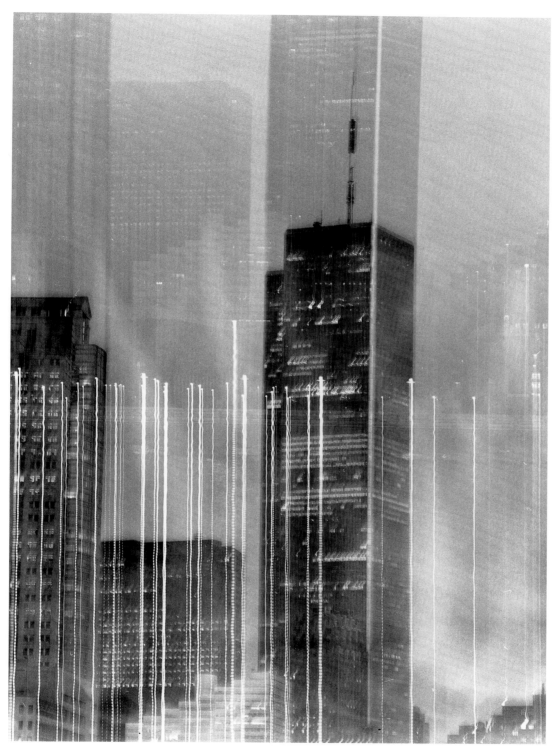

Figure 30–3

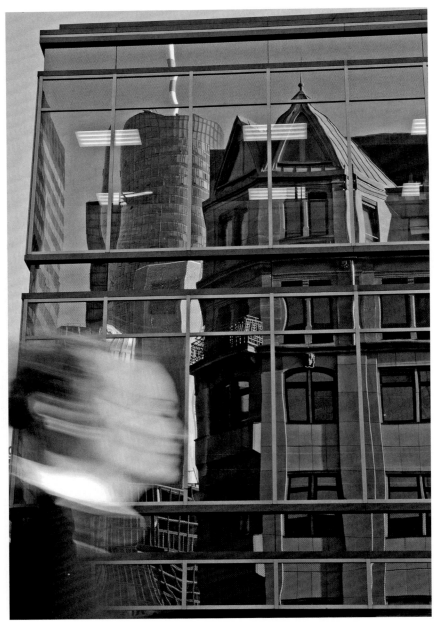

Figure 30–4

Blurred Movement in the Daytime As Well

Long exposures can also be achieved in the daytime. One method is to place a neutral density (gray) filter before the lens to lengthen exposure time significantly. If there is no such filter at hand, another possibility is to use a low ASA number and shoot with the smallest possible aperture to reach speeds of ⅛ or ¼ s.

You can see the result of a long exposure in this composition based on architectural lines that are, by themselves, possibly not exciting enough, but the blurred head creates a tension pole. In a lively city such as Frankfurt with so many passers-by, with patience and some luck, a person will walk by in the "right position". Naturally, you must be a keen observer of the surroundings to know exactly when to release the shutter. Another possibility would be to take a friend and tell him when to start moving in front of the camera.

For these kinds of photos, digital cameras are ideal because the result can be seen at once and you can repeatedly shoot the photo until the image is satisfactory. In this case, triple pictorial tension was created among modern man, late 19th century architecture, and the towering Main Tower as mirror images in a modern glass façade.

This photo was taken digitally with the normal focal length of the Nikon D70s. I used the Shadow/Highlight tool of Photoshop CS2 to brighten the shadows by about 12%.

Section 4

The Digital
Darkroom

31 Black and White from Color

Every serious photographer knows that in analog photography at least half of the pictorial effect is achieved in the darkroom by dedicated laboratory work. With regard to the possibilities of subsequent image manipulation, can digital photography compete against analog photography in the realm of black and white?

The answer is an emphatic "Yes!" because one thing is certain: Modern digital cameras have outstanding pictorial quality. And armed with Photoshop, you have subsequent manipulation techniques of high quality at hand; Ansel Adams would have been envious.

The only disadvantage to digital black and white is that the excellent fiber-based paper is unavailable for the digital process. Although, there are a few laboratories in Germany that print digital black and white on fiber-based paper, it may be expensive. Enlargers that can print digital images on fiber-based paper can cost about as much as a medium-priced car. Therefore, the average, not-so-wealthy user is restricted to the use of ink-jet printers for doing-it-yourself printing. Naturally, good professional labs can also process neutral black and white lambda prints on color photographic paper, but they aren't very economical either, and they certainly do not use fiber-based papers. Fortunately, papers that are almost equivalent to the fiber-based ones are available for ink-jet printing. The high-quality papers from Hahnemuehle, Harman Technology, Sihl, or Tecco do not only look magnificent, but have high archival quality as well.

Nonetheless, this introduction is not a plea for analog photography, but expresses the hope of all passionate black and white photographers that the

industry will soon manufacture fiber-base equivalent papers for digital processing; there are indications that this may happen sometime soon.

The following chapters, however, deal with the numerous subsequent manipulation techniques that Photoshop offers for achieving the best possible digital print results. These chapters focus only on the truly important techniques, explaining them in the clearest terms possible.

The requirement for you to use the techniques are as follows: Photos must be taken in color mode, either in JPEG format or preferably converted from RAW format to a TIFF file with the RAW converter. Even if, in my opinion, the JPEG format is not as bad as it is sometimes claimed, the RAW mode is certainly better, because it gives images a 12-bit to 16-bit color depth instead of the 8 bits in JPEG. These 8 bits correspond to a tone value range of 255 tones, perceived by the eye as a constant gradient. The 16 bits, on the other hand, encompass 65,536 tones, which sounds like a lot, but the differences are barely noticeable to the eye. After a brief optimization, a photo taken in RAW format should be converted to an uncompressed TIFF file in the opened RAW window, in order to manipulate this TIFF file with Photoshop's extensive range of tools.

Conversion from Color to Black and White

In color to black and white conversion, there are several methods that work partly with layers, but I'd only like to recommend the two easiest ones; namely, conversion using the Grayscale or Channel Mixer modes. The former is reached using the functions Image and the uppermost line Mode, the latter using Image and Adjust.

The Channel Mixer method is generally preferred, because it offers more alternatives. As the name already implies, the Channel Mixer is used to mix gray tones at will, and therefore, this method gives you more tonal options than conversion from the Grayscale mode. If you have already taken a picture in JPEG format, then pictorial noise is a bit more pronounced, especially if the mix contains a large share of the red channel. A photograph of the Omega House in Offenbach near Frankfurt clearly demonstrates how differently you can use the channel mixer to convert a photograph to Grayscale. The original color photograph was taken in the twilight with the 17 mm super wide-angle lens of the Canon EOS 5D

Figure 31–1

- The first photo (figure 31–1) was converted to 100% using the red channel.
- The second photo (figure 31–2) was converted to 100% using the blue channel.

Each of these two photos have been translated to gray tones in a different way. We have come to an extremely important point: In digital photography, the classical black and white filters (orange, red, yellow) no longer have any use, as you have already learned in the first pages of this book.

Figure 31–2

If you use good digital cameras to photograph in black and white mode, the effect of the various filters is simulated, but I do not recommend shooting in black and white mode. It is better to shoot in color mode, then later use the channel mixer to reach an effect comparable to one achieved by analog black and white filters. Although this effect isn't exactly accomplished according to the same principles of classical analog filtering, if you spend some time learning the principles of the primary colors red, green, and blue (RGB), you can achieve very similar effects as with the classical colored filters.

You can easily see here, in the image converted with 100% of the red channel (figure 31–3), how the blue sky has been darkened as if with the analog red filter, while the tree lit by the orange light has been brightened. To intensify the effect of an analog red filter, it is possible to darken the sky even more by pushing the red channel to over +100% (to +150%, for example) and subtracting the difference to 100% in the blue channel (in this case, −50%). Using this method, the sky becomes almost pitch-black, but in my opinion the effect doesn't look very natural. On the other hand, in the photo converted using the +100% blue channel (figure 31–4), the blue sky is brightened and the orange tree is considerably darkened, similar to the effect that an analog blue filter would have had.

You have also seen in the various landscape photographs explained in the previous chapters that a conver-

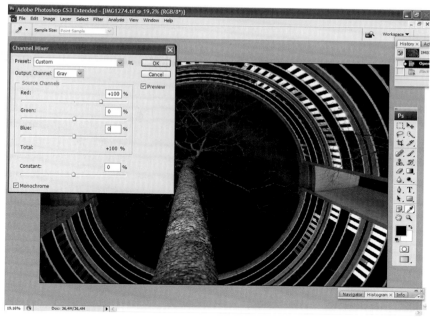

Figure 31–3

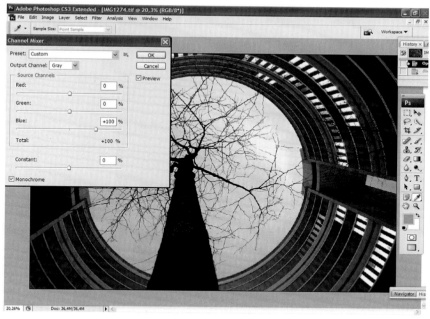

Figure 31–4

sion with a large share of the red channel has an effect resembling that of the classical red filter. It is, therefore, very important to recognize that the channel mixer allows you to strikingly influence the distribution of the gray values on

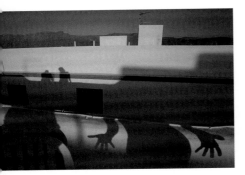

Figure 31–5

the resulting black and white photo. A little experience quickly helps you to get the right mix for various subjects, but don't forget that the sum of the mixture should always be around 100% regardless of its composition. In principle, in black and white conversion it makes a lot of sense to test methods briefly and then decide upon the preferred one.

In this photo, the Grayscale mode allowed quick conversion from a color photo to a black and white image (figure 31–5). Naturally, you should not save this processed photo in the same folder with the same name, because if you do so, the converted file of the black and white image will replace the original color file. Because there is no second layer with this method, the newly obtained black and white image must be saved either in another folder or in the same one but under a different name. In this procedure, the original color photo is saved as an unmanipulated TIFF file, while the new black and white photo is saved as another version with another name. I believe that it's not a good idea to rely solely on saving the RAW file, because every camera manufacturer still works with its own proprietary RAW converter, and I fully expect JPEG and TIFF files to be around for the next 10 or 20 years. The question of how RAW files will develop remains open in these fast-moving times. To be on the safe side, I therefore recommend saving a TIFF file in addition to the RAW file.

In very rare cases, a black and white photo converted from color looks good and will not need any further manipulation, as is the case here. However, most of the time the black and white photo lacks contrast and even the subject of the photo could look better with a bit more contrast. It is very easy to create more contrast:

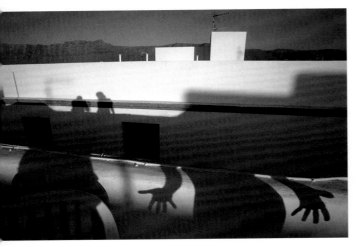

Figure 31–6

1. On the tool bar, select Image.
2. Select Adjustment.
3. Click Brightness/Contrast.
4. This tool works with two simple sliders.
5. Move the sliders toward the plus sign (+) to make it steeper, or move it toward the minus sign (–) to make it flatter.

If you move the contrast by 17 points to the plus sign, as in our example, the photo will look good (figure 31–6): The bright areas retain their texture and the dark shadow areas don't become pitch-black. However, be aware that only in rare cases can you increase contrast with the Brightness/Contrast tool without causing additional problems, therefore, I generally don't recommend this tool for professional manipulation. This photo was taken with the 19 mm lens.

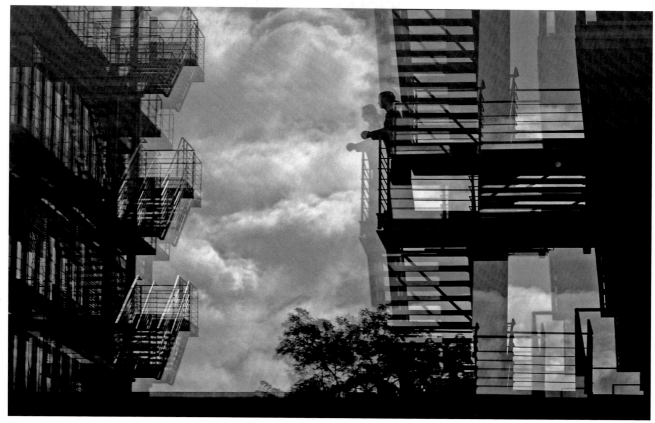

Figure 31–16

photo printed on a much larger size, it's better to save the images as TIFF files. Another disadvantage of a JPEG file is that it recompresses the image every time you open and modify the image. If, against my advice, you have photographed only in JPEG format, you should by all means retain one JPEG image in its original state and finish the black and white conversion in one single step whenever possible to retain maximum JPEG quality. Another possibility would be to convert the JPEG photo into a TIFF file and then save the latter to a hard disk.

As already mentioned, a color photo lacking a second layer that is converted to black and white must either be saved in a new folder or given another name to retain the original color photo in the same folder. To rename and save a photo, do the following:

1. Click File, Save as. The last file used will open.
2. Give the manipulated black and white photo a new, unique name in the File name field.
3. Adjust the TIFF format and click Save

4. If you sometimes intend to save files as JPEG, always select the largest possible size.

5. A small window appears for setting file size.

6. Move the bar all the way to the right in Large file and in Quality, and select the 12 size and Maximum.

7. Click OK.

The black and white photo is saved as a second version without losing the original color image. The lower part of the window indicates how many megabytes of memory a photo needs. If you want to e-mail the photo, move the bar to the left towards Small file to reduce file size. On the left edge of the scale, an image only has 120K, but can still be displayed reasonably well on the screen. Just remember that a 7" x 9.5" print is no longer capable of withstanding such resolution.

32 Partial Manipulation with the Lasso Tool Set and the Magic Wand

Photoshop is an endlessly complex image manipulation program that can appear like a jungle through which you have to hack your way with a machete. However, it is much easier if you have a clear idea of where you want to go. As with modern cell phones, Photoshop has countless functions that are very rarely or never used in practice. There are truly essential tools that will help you to achieve results that are as good as those obtained in the analog darkroom. You can create outstanding black and white photos with subtle gray tones by following the path through the Photoshop jungle to the Lasso tool set and the Magic Wand; these tools allow you to select individual areas in the picture for customized manipulation. By right-clicking on the Lasso icon in your tool bar, three Lasso tools appear: The Normal Lasso, the Polygon Lasso, and the Magnetic Lasso. It is difficult to create a precise edge on a selected area using the Normal Lasso. The Polygon or Magnetic Lasso lets you select areas much better than the Normal Lasso.

Partial Manipulation with the Magnetic Lasso

The next photo (figure 32–1) was a difficult subject to photograph digitally, because it is not easy to shoot a backlit sun shining through a hazy sky in a way to prevent all the lit area around the sun from burning out and losing all detail. Therefore, the first requirement for making this a good picture was to use a gradient filter to gradually darken the sky by one to two exposure values. Then, I used the highlight indicator on the display to control exposure so only the sun

Figure 32–1

itself would blink but not the halo around it. The respective exposure and the filter ensure enough detail in the immediate vicinity of the sun. As far as the image is concerned, all prerequisites have been met for creating a nicely textured, atmospheric photo.

After developing it with the RAW converter, open the color photo in Photoshop and convert it to a black and white image with the channel mixer (Image/Adjustments/Channel Mixer); in this case with 66% red, 28% green, and 6% blue (figure 32–1). The sky now has a pretty nice gray value gradation, but the lower part of the image remains too dark and flat. If you increase the contrast in the entire photo (regardless of the tool you use), you encounter a problem: The pleasing gray tone gradient you had in the sky gets the so-called "jagged look" (figure 32–2) so typical of digital images. To prevent these jagged edges and conserve the nice and gradual gray tonality of the sky, leave the sky as it is and concentrate your manipulating efforts only on the lower part of the photo.

To prevent jagged edges, adjust the edge contrast as follows:

1. Enlarge the photo on your screen.
2. Right-click the Lasso tool and then click Magnetic Lasso (figure 32–3). The Magnetic Lasso appears and recognizes contrast.
3. Guide the mouse to place anchor points automatically along those lines where there is contrast.
4. Adjust the edge contrast (in this case 30%).

You can even adjust the distance between anchor points that adjoin an edge. In this case (figure 32–4) I selected 100, which is the smallest possible recommended distance for organic shapes that have irregular curves. With clear architectural forms, the distance between anchor points can be significantly greater. However, especially with architectural photos, the Magnetic Lasso sometimes is placed on the wrong edges. If this occurs, practice how to adjust the various setting points to rectify the problem. Basically, it is a good idea to set the width of the path to 10 pixels, but you can even narrow it down to 3 pixels with clear architectural shapes.

As the picture shows, you can easily place the Magnetic Lasso around the cropped section you want to manipulate. If the markings do not appear in the desired position, you can also set the anchor points manually by individual mouse clicks. If a point is in the wrong position, you can remove the last point once again with the delete key. After you have carefully moved the tool around the desired section to be manipulated and correctly placed the anchor points, double-click and a line of "marching ants" indicates that you can start

Figure 32–2

Figure 32–3

Figure 32–4

changing the cropped area (figure 32–5). If you now use the Brightness/Contrast tool to increase contrast in the lower part of the image, the result is catastrophic, and you have thus, become aware of another extremely important criterion, namely the "soft edge" setting: This control dictates the number of pixels through which, for example, an increase in contrast number is distributed. If you place the path of the lasso on clear architectural shapes, it might be a good idea to set a very narrow pixel number on the edge of the area to be manipulated (in this case, to 3 pixels). In this photo, however, this is not a good idea at all, as you can recognize here (figure 32–6). The transition from city to sky in the horizon lacks a clear edge, and the increase in contrast brightens the area under the lasso line so much that it creates a totally unnatural dividing line. However, help is easily at hand. You can use the "soft edge" setting to change the harsh 3-pixel transition to 60 pixels, and the eye now perceives

Figure 32–5

Figure 32–6

Figure 32–7

Figure 32–8

Figure 32–9

this as a much smoother transition. You can access the soft edge setting by choosing Select/Refine Edge/Feather from the menu (figure 32–7). Now, the Magnetic Lasso is no longer placed on the edges, but instead cuts the points. This does not represent a problem because when contrast is increased, it is gradually applied within a margin of 60 pixels. The same result was obtained with analog dodging, where it is was also extremely important to move the hand or template during the dodging process to create soft transitions. Photoshop achieves the same result (figure 32–8). The photo finally looks the way we wanted it (figure 32–9): The sky is nice and smooth without a jagged look and the lower part of the photo has a pleasing contrast. The image shows the view of Heidelberg from the castle taken with the 19 mm wide-angle lens.

Partial Manipulation of Architectural Lines with the Polygon Lasso

While I recommend the Magnetic Lasso for edging organic shapes, photos with rectangular forms are better manipulated with the Polygon Lasso. After converting this picture to black and white (figure 32–10), you can see that the lower part is especially dark and flat. If you brighten the entire image, detail in the clouds is lost, so a selective manipulation of only the lower part makes sense. Because the area to be manipulated has exactly four corners, it is very easy to use the Polygon Lasso tool to surround the

glassy bridge that connects the two buildings. Thus, place the anchor points of the Polygon Lasso tool on these four corners (figure 32–11) by clicking once where you want to start the polygon. Then guide the lasso until it reaches the next corner and pull the polygon line like a rubber band behind it. After clicking the second corner, the polygon line will be laid down right along the straight corner. This is certainly the ideal tool for edging straight corners, but it is possible to switch back and forth between the Magnetic Lasso and the Polygon Lasso. It works like this:

1. Start edging with the Magnetic Lasso.
2. Hold the command key down to switch automatically over to the Polygon Lasso and place it on each corner.
3. Release the command key to automatically bring back the Magnetic Lasso.

Figure 32–10

In this photo, however, the Polygon Lasso fully meets your needs. When you have returned to the beginning point after having edged the desired area, a simple click makes the "marching ants" appear to indicate that you can now start manipulating this selected area.

The photo looks considerably better now (figure 32–12) and you can use the Brightness/Contrast tool for brightening the very dark, lower part without worrying about losing texture in the highlights. To further improve this image, brightness was increased by 16 points and contrast was increased by 33 points (figure 32–13). Nevertheless, the total image could still look better with a little more contrast, but this would be hard to achieve with conventional tools. In addition, if you used the Brightness/Contrast tool again, the highlights in the clouds would lose their detail. The new version of Photoshop (CS3) comes to

Figure 32–11

the rescue with yet another wonderful option, the already mentioned middle-tone contrast of the Shadow/Highlight tool. With this tool, you can increase middle-tone contrast without burning out highlights or allowing shadows to go under. In the photo, the middle-tone contrast was increased by 22 points and has achieved a perfect picture (figure 32–14). A word of advice: Do not increase middle-tone contrast to an extraordinary degree, because your photos will start looking unnatural and sometimes bright edges will start forming in the bright and dark transition points.

Figure 32–12

Figure 32–13

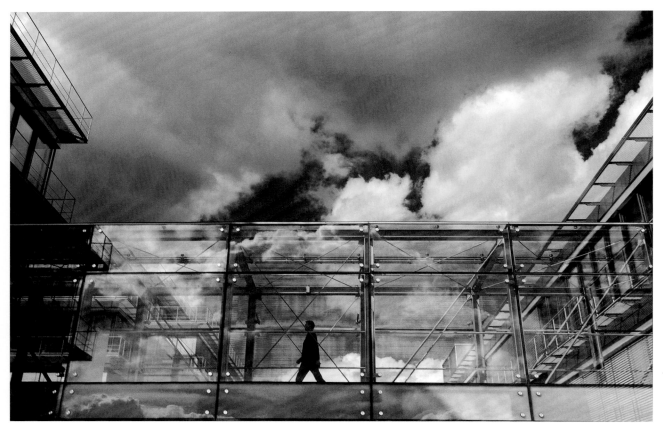

Figure 32–14

Figure 33–4

Figure 33–5

1. Move the circle to a place next to the large dust spot, where the gray tones are the same as they would be under the dust spot; in this case, just to the right of the spot (figure 33–3).
2. Press the Alt key and the circle becomes a small target marking the starting point of the transfer.
3. Left-click and while holding down the Alt key and the mouse, move the circle to where you would like to copy the structure of the starting point, which in this case is the upper part of the dust spot.
4. Release both keys and the distance and angle in which the structure of the starting point will be copied are set. Distance and angle are maintained as long as they are corrected again by pressing on the Alt key.
5. Move the dust spot downwards with the selected circle while left-clicking and holding down the mouse.

Figure 33–6

The left structure is now copied onto the entire fuzzy dust spot in the selected distance (figure 33–4). It doesn't take long for the spot to disappear (figure 33–5). However, you must remember to copy the correct gray tone onto the dust spot. If your attempt was not successful, you can undo every single copying step with the help of undoing the history. In other words, with this tool you can experiment with which cropped area from the surroundings will be the most suitable for copying.

However, retouching does not have to be restricted to large dust spots. In our photo, the young woman's nose has strong reflections in spite of indirect lighting. These reflections can also be easily eliminated with the Clone Stamp (figure 33–6). Her face has now been retouched and Photoshop has improved the facial make-up (figure 33–7). If retouching proves difficult, you can enlarge

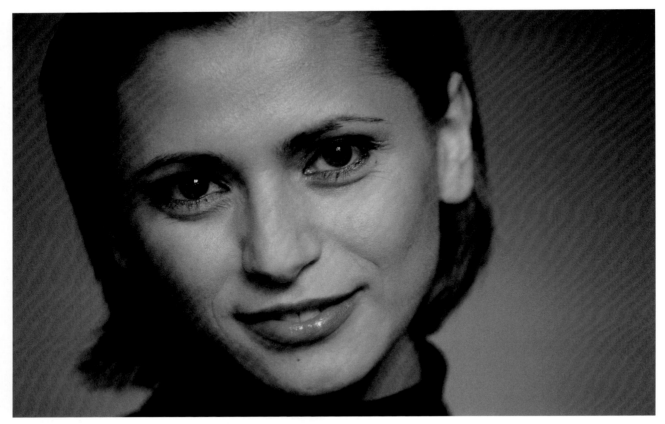

Figure 33–7

the image until you can even work on the individual pixels with precision. However, this requires plenty of time and is very seldom needed.

More Precise Dodging and Burning than the Analog Darkroom Ever Allowed

The essentials of analog black and white image retouching were to control the tonality range by skillfully dodging and burning in the darkroom. There was hardly a black and white photo that did not need this for optimizing the mood of the picture. While hard to believe for analog fans, it is true: This procedure can be accomplished easier, faster, and more precisely with Photoshop. Let's illustrate this with a backlit photo of an old Irish castle: It is extraordinarily difficult for a digital camera to register the light range in a backlight photograph that includes both the sun and the shadows of an old wall. Therefore, I remind you once again to use the gradient filter of almost two apertures. Another "must" to be applied in such lighting conditions is to photograph in RAW mode, because the recording of RAW data allows the camera to register a significantly

wider light range compared to JPEG format. After taking both into consideration, it's essential to underexpose the photo until the lights around the sun are no longer broken up; in other words, until the indicator light on your LCD blinks only in the sun itself and not around it any longer. After making sure to follow all these recommendations, you should get a somewhat dark photo. Here, our old castle ruin looks dark and flat at first. If you intend to convert it to black and white and create a more dramatic sky, use the red channel with a very large proportion of the red channel, as already recommended. After black and white conversion (figure 33–8), the castle looks almost pitch-black and lacks detail, but don't worry, this is a photo taken in the RAW format and converted into an uncompressed TIFF file that has, nonetheless, retained all information. One possibility would be to brighten it with the Shadow/Highlight tool mentioned in the first part of this series. Brightening the image by about 20% will have the unfortunate effect of making the sky brighter as well, especially the upper part (figure 33–9), and then the image will lose part of its heavy, mystical effect. We could also use the Magnetic Lasso for the partial manipulation of the castle, as explained above, but then the sky seen behind the ruin's window openings would also become brighter, and these parts of the sky would look considerably brighter than the other parts of the sky situated at the same height. Therefore, this second possibility should also be discarded.

Instead, you should use the ingenious Dodge tool (in your tool bar). Before using it, first enlarge the old castle on your screen and then adjust the circle to a large size. Here, I have set the main diameter to 501 pixels (figure 33–10). It's best for edge sharpness to stay at 0% (as with the Clone Stamp) so the circular shape is not reproduced anywhere, not even partially. The intensity of the brightness effect also has various settings under Exposure. In my opinion, a good value for careful dodging is 20%. Now you can still decide whether you want shadows, lights, or medium tones to be taken more into consideration. In this photo, it would in fact be logical to set the tool to Shadow because we are dealing here almost exclusively with nearly pitch-black areas. Nonetheless, I recommend the Medium Tones setting because you want to retain the almost black personality of the old fortress. Using the Shadow setting will quickly turn a saturated black into a dark gray, but this

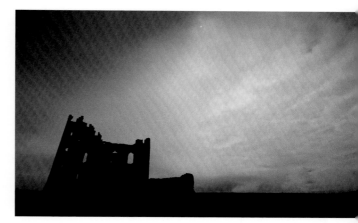

Figure 33–8

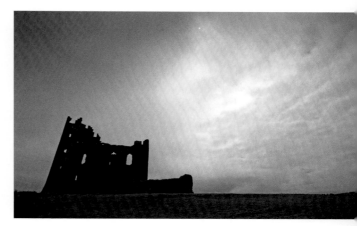

Figure 33–9

Figure 33–10

Figure 33–11

Figure 33–12

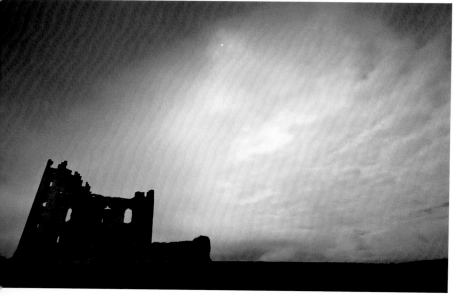

Figure 33–13

would not make any sense here. You want to retain the impression of an almost black castle and merely add a bit of detail into it, something you can achieve admirably with the Dodge tool set to medium tones. Position the circle over the area to be lightened, and every click of the mouse means 20% more brightening, so you have to keep clicking until you get the right brightness. If you have used the large circle for performing the rough work, in the next step you can choose a much smaller circle (here: 62 pixels) for the more precise work of brightening the castle's borders and upper sections (figure 33–11). The entire procedure should not take you longer than two minutes; after you have finished, the old walls should have the ideal texture (figure 33–12). Looking at the whole picture, all available technical means have been used to support the mystical effect of these old walls and we are indeed amazed at the enormous light range that digital photography is capable of dealing with (figure 33–13).

Just as easy as it is to dodge with Photoshop, you can also naturally burn. Let's use this somewhat mystical winter scene as an example. Once again, you have a backlit photo with an extreme light range that the sensor must deal with (figure 33–14). The RAW format has been able to capture this range quite well but the highlights in the sky (right) lack some detail. Find the same tool as

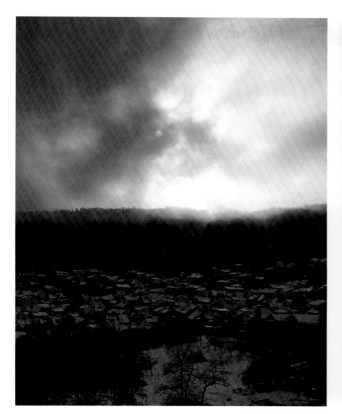

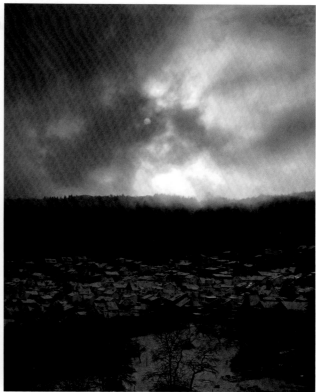

Figure 33–14

Figure 33–15

above and right-click on it to select the Burn tool option. Proceed in the same way as with the Dodge tool. In this case, I recommend a diameter of 180 pixels. You could choose Highlight for burning, but it's not a good idea because the bright areas should remain bright. You can add detail to the bright lights by setting the Burn tool to the medium tones. Sure enough, now a nice texture appears in the sky's highlights (figure 33–15).

The third tool, the Sponge, should not be used for black and white photography, because it is used to intensify or reduce color saturation.

Include Gradient Sky Tones

I don't get tired of recommending the use of a gradient filter to make sure that the sky will have enough detail, not only in a backlight photo, and to make a boring sky more exciting.

The next photo of St. Malo shows the organic growth of the historical district (figure 33–16). I took the photo on a dull day, something that certainly does not harm the mood, but the sky is a little too bright. However, help is readily available as follows:

Figure 33–16

Figure 33–17

1. Choose the Gradient tool (on the toolbar).
2. Select the kind of gradient, and set a gray gradient (figure 33–17) by clicking the uppermost box to the right. If you then go farther to the right in the settings bar (top), you will see five additional small symbols.
3. Choose the first symbol, namely linear gradient.
4. Keep moving to the right to reach the mode and click darken.
5. Adjust the gradient's opacity; 20% is reasonable for this picture.
6. Check all three fields: Invert, Dither, and Transparency.

You have finished with the preparation and can now set the starting and end points of the gradient with your mouse:

7. Start your gradient a little above the roofs and chimneys.
8. Select a starting point and left-click, and while holding down the left-click button, move the mouse upwards until you reach the upper border of the picture. You will see that a line has formed from the starting point to the end point.
9. Release the mouse button. Photoshop will exactly calculate the constant gray gradient along this line and will distribute it from the left to the right image border.

It's that easy to include a gradient in the sky after shooting a picture! Your photo is much more exciting now; there is a kind of "roof" over the houses (figure 33–18).

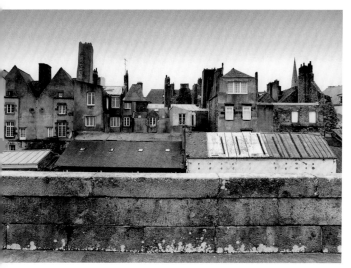

Figure 33–18

34 Corrections with the Distortion Filter

Wide-angle lenses have the property of distorting perspective provided they are not shift lenses, and the zoom lenses of most manufacturers distort more often along the edges; ,in other words, they produce barrel or pillow-shaped distortions in architectural photos. In addition, these zoom lenses can also cause vignetting when used with a fully opened aperture. With regard to digital photography, a special problem of wide-angle lenses is chromatic aberration or color fringes in the edges of images, of interest only in color photography, of course.

Since Photoshop CS2, all these problems can be corrected with one single tool, namely the aperture correction of the distortion filter. In this photo taken with Canon's 17–40 mm wide-angle zoom, we see barrel distortion at the 17 mm focal length in close-ups (figure 34–1)—reason enough to discard this lens for a photo such as this one. But Photoshop makes it useful: Go to Filter/Lens Correction, and a rather large window appears (figure 34–2) in which a grid composed of small

Figure 34–1

Figure 34–2

Figure 34–3

squares appear over the image. As soon as you use the option Remove Distortion in the uppermost lever (figure 34–3), the curved lines of barrel distortion have been straightened out (figure 34–4) by just moving the lever to the right. The pillow-shaped distortion along the edges, seen after the architectural lines are straightened, must subsequently be cut with the Crop tool (figure 34–5). Another option would be the Edge Extension tool, as you will see further below.

The photo shows a view into a children's music school from outside, as seen through the curtain. Two children wave as they stand beside a grand piano.

Figure 34–4

Figure 34–5

Figure 34–6

However, distortions caused by perspective occur even with the finest wide-angle lenses. Let's use this photo of an Irish graveyard (figure 34–6) as an example. So that the Celtic cross would be recognizable, I had to take the photo of the tomb from a position that was a little to the right of the center, but the 24 mm wide-angle lens created a distortion, which I could compensate for by using the Lens Correction tool: I moved the horizontal perspective by 22 points into the minus range (figure 34–7 and figure 34–8), and the tomb was also straightened out by setting the ver-

Figure 34–7

Figure 34–8

tical perspective control. The image is not finished, however: The image must now be cropped and slightly rotated (figure 34–9). Placing the cursor about 2 mm under the center of the lower crop line, I turned the frame. Two rounded arrows appear and by dragging them, I can rotate the frame in both directions. The rotating operation concludes when the horizontal lines run parallel to the edge of the image. The formerly distorted photo has been straightened out, the horizontal lines of the tomb are parallel to the lower and upper edges of the photo, and the vertical lines are parallel to the right and left edges (figure 34–10). The impact of the photo is clearly greater and it doesn't hurt the composition that the image has been cropped a bit owing to the resulting tilted corners. When

Figure 34–9

you work with the Lens Correction tool , Photoshop saves the converted image as a PSD file by default, but you can also save it as a JPEG or TIFF.

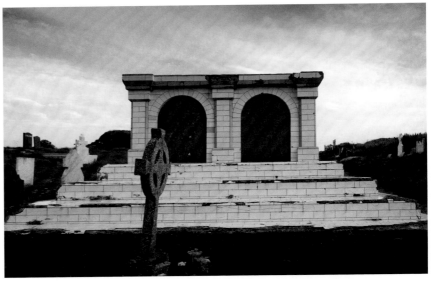

Figure 34–10

Shift Lenses Almost Superfluous

It is well known that wide-angle lenses distort architectural lines if you place the building on the lower edge of the photo, because then the camera is no longer parallel to the architecture. To compensate for the resulting falling lines, so-called shift lenses can be used to displace the entire optical plane upwards so the camera can still be held parallel to the building, as long as the latter begins in the lower part of the image. Because shift lenses are very expensive, the serious amateur will question if they are really needed. As we have already seen, Photoshop provides the answer and it's not a bad one at all. In this photo (figure 34–11) showing the two towers of the Deutsche Bank in Frankfurt, it may not bother you that they are blurred in the background, but the fact that they tilt to the left is more bothersome. So, the time has come to adjust the grid of the Lens Correction tool (Filter/Distort/Lens correction) again. If you move the vertical correction lever by −50 to the left, you straighten the towers, but the edges have been displaced so much that you have to crop the image considerably, thus losing a pretty large chunk of it (figure 34–12). Another option would be to work with the Edge Extension tool (on the same tool panel as the perspective sliders), but its use is rather limited, because it calculates the edge of your photo and extends it beyond the image. You have probably heard that computers can be very intelligent, yet very dumb at the same time, so let's see what Photoshop does when we select the Edge Extension tool (figure 34–13).

Figure 34–11

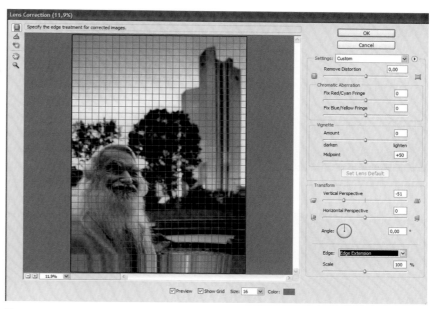

Figure 34–12

Figure 34–13

The calculation yields unusable results in the left and lower parts of the image, but on the right side it works quite well. If you now crop the photo to the left and right, so the calculated areas are left out, the two towers of the Deutsche Bank remain in the photo without crop because the Edge Extension tool did create a believable result on the right side; at least the result is satisfactory in a small enlargement such as this one, but it wouldn't stand up to a truly large size (figure 34–14).

You learned that Photoshop can definitely replace a shift lens, although you must take into account while taking the photo that beveled edges will be the result of shifting with Photoshop, and they will generally have to be cropped. It's best to know this beforehand while looking through the viewfinder.

Figure 34–14

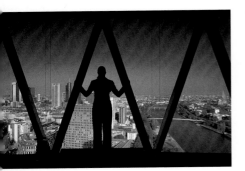

Figure 34–15

Figure 34–16

Figure 34–17

Figure 34–18

Subsequent Sharpening: Yes or No?

Everyone knows that Photoshop can sharpen images after they were taken, but beware that excessive subsequent sharpening often makes a photo look unnatural. When you click Filters, Sharpen, five options are available: Sharpen Edges, Sharpen, Smart Sharpen, Sharpen More, and Unsharp Mask. For high-end correction, I recommend only two options: Smart Sharpen and Unsharp Mask, but before explaining them let's first look at the disadvantages of sharpening. This photo taken on top of the new Westhafen Tower in Frankfurt shows the city's skyline with plenty of detail. To demonstrate very clearly the dangers of sharpening, look at a section at 100% and click the Sharpen More tool. You can now recognize (as opposed to the unsharpened image) white edges along the contours of the silhouette in the foreground (figure 34–16). These edges are naturally unwanted and allow the experienced viewer to immediately recognize that this is a digital photo, even if a grain layer has been added to it. Pictorial noise is also significantly greater.

More suitable is the Unsharp Mask tool. The name does not quite indicate sharpening, but it comes from a technical method employed in analog photography in which an unsharp positive is placed on a sharp negative and then projected onto contrasty paper. A similar result occurs on the computer: Contrast is reduced in large areas of the picture, and they become a little softer. In abrupt tone transitions, however, contrast is increased and the overall result is that the photo looks clearly sharper without appearing artificial (figure 34–17). Another advantage is that several options are available for this tool: Intensity, for example, determines to what degree the contrast in areas with abrupt tone transitions should be increased. The standard setting is 50%, recommended for the subsequent sharpening of almost all digital images. The Radius restricts the width of the area to be sharpened and has been set to one pixel, another recommended standard setting. Finally, the Threshold Value can be set for determining the intensity of tone transitions, so the filter can be effective in the first place. Its standard setting is 0, which means that the filter affects all areas of the picture. For example, if you would like to prevent a subject's skin blemishes from being intensified during shapening, you can increase the Threshold Value, and the filter then leaves softer transitions unchanged. In cases like this, it's well worth your time to try it out.

Even more detailed sharpening alternatives are provided by the Smart Sharpen filter. If you choose the Advanced setting, you can selectively regulate sharpness according to lights and shadows. In this case, you can use the tone width regulator for preventing large areas from being sharpened too, and thus stop pictorial noise in the sky, for example, from being increased automatically with the sharpening process.

The Remove options allow you to correct blurred movement or soften sharpness. Don't expect too much from these functions, however. If the Remove option remains set on the Gaussian Blur, the Smart Sharpen tool will have an

effect similar to the Unsharp Mask filter. In our example, the standard setting was selected (figure 34–18).

Let's remember that it takes longer to work with the Smart Sharpen filter than with the Unsharp Mask filter, and therefore, it is not as useful when processing many pictures. The sharpness performance of a subsequently sharpened image is clearly superior to the impression we get when looking at a print from a small-format slide or negative, and the defenders of the analog bastion will not be able to dispute it. Thus, photos taken with a good digital camera can be easily enlarged to a width of 40 inches and the pixels would still not be visible to the naked eye.

35 New Black and White Conversion with Photoshop CS3

In the previous chapters, you saw how black and white conversion worked with Photoshop all the way to the CS2 version, but the new Photoshop CS3 has introduced an important innovation for converting color photos to black and white, making black and white conversion easier for photographers. A new tool named "Black and White" has been added to the old channel mixer with the three RGB channels, found also under Image/Adjustments. Upon opening it, six color channels appear (red, yellow, green cyan, blue, and magenta) with which you can more precisely regulate the gray tones of a black and white photo, as with the RGB channel mixer, to obtain more natural-looking images. If you did not quite know how to mix yellow with RGB in the old channel mixer, yellow has been included here.

The standard setting for black and white conversion is red 40%, yellow 60%, green 40%, cyan 60%, blue 20%, and magenta 80% (figure 35–1).

Let's use an example to see how the new black and white conversion works: This photo shot in Germany's Rheingau region looks a little too flat with the standard conversion to black and white (figure 35–2), but the wonderful new method allows you to determine which tones you want to brighten or darken. For example, in this photo it makes sense to darken the blue tones (and the sky as well), so reduce the blue tone from +20% to −100%. As a countermove, increase the red tone from +40% to +160% (figure 35–3), and the photo already has a better, stronger contrast without even touching the contrast or tonal value correction options (figure 35–4). This new, more perfected method for modulating the various tonal values for black and white photography is a pleasing innovation in Photoshop CS3.

Figure 35–1

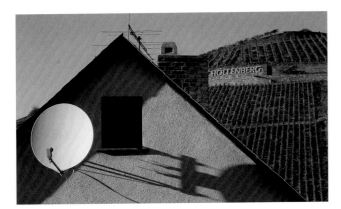

Figure 35–2

An additional innovation is the Eye Dropper tool, which you can move directly over the image with an open Black and White dialog. If you now left-click, you can lighten or darken the tonal value of the clicked area. In the photographic example, if you click on the sky, moving the mouse to the left darkens the blue channel, but if you move it to the right, the blue channel moves in the plus range, and therefore the sky is brightened. Thus, when the Eye Dropper is clicked in CS3, the program always chooses the color tone that most closely resembles the clicked area.

Another practical innovation of the new black and white conversion is the option of toning images. After having converted the image to the correct gray tones with the six color channels or filter modes, check the "Tint"

Figure 35–3

box below the channels and adjust the color tone and its saturation with two regulators. Because a slightly brown tone is the most preferred, the color regulator automatically sets itself on a pleasing brown tone as soon as the function is clicked. If you want a less saturated tone, just move the Saturation lever a little to the left.

Figure 35–4

Simulating Filters

In all previous Photoshop versions, the color filter calculation for black and white photography was missing, in spite of it being extremely important in analog black and white photography for correctly applying the various color filters, from blue and yellow to orange and all the way to red. You already learned how to circumvent this missing element in the chapter about filters in the beginning of this book. Although you can naturally still use this circumvention in Photoshop CS3, the new black and white conversion tool lets you directly calculate the different filters (with the exception of orange) in the conversion to black and white. These filters can be found on the Black and White panel under Preset. They work quite well as long as no polarizing filter was used when taking the photo. In photos that were taken with the polarizing filter in a crossed position, Photoshop CS3 overcalculates the effect of the yellow or red filter by way too much and the photos look unnatural, but luckily they can be easily corrected once again.

Let's first see the effect of filter simulation with the help of a photo taken in Germany's Rheingau region without a polarizing filter.

- Yellow—If you select the yellow filter, the result definitely looks very similar to an analog image taken with a yellow filter (figure 35–5): The sky is a little

Figure 35–5

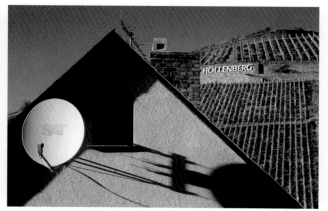

Figure 35–6

Figure 35–7

Figure 35–8

Figure 35–9

darker and the photo has slightly more contrast. To simulate the effect of a yellow filter, Photoshop sets the color channels to the following values: red +120, yellow +110, green +40, cyan -30, blue 0, and magenta +70.

- Red—An orange filter option is not available, so use two red filters instead, a standard red filter and one with high contrast. If you select the high contrast red filter for this photo, the resulting picture (figure 35–6) does look like an analog photo taken with a darker red filter: The sky and the shadows are darker, but the greens in the vineyard are brighter and total contrast has intensified. The effect of this high contrast red filter is simulated by the values: red +120, yellow +120, green −10, cyan −50, blue −50, and magenta +120.

- Infrared—It's harder to simulate an infrared filter, though: Looking at the photo in small size (figure 35–7), the effect appears to be quite convincing because the vegetation in the vineyard is almost white and the infrared film shows the chlorophyll in the leaves as a very bright white, an effect Photoshop achieves especially by increasing the yellow channel by +235. However, this excessive increase results in the lack of detail in the vineyards. If you now compare a 100% enlarged crop of the photo that was converted with an infrared filter (figure 35–8) to the photo that simulates the effect of a yellow filter (figure 35–9), you can see how much sharpness the green tones lack in the former photo. Here, at least you should place a strong grain structure (minimum 40 or 50) over the photo (as I already recommended for the infrared simulation with the channel mixer). Photoshop calculates infrared simulation with the values: red −40, yellow +235, green +144, cyan −68, blue −3, and magenta −107.

When the Filter Calculations don't Work

In this autumn photo taken with a polarizing filter in the Rheingau region, a problem with Photoshop's preset filter calculations appears: The standard black and white conversion (figure 35–10) makes the image look too flat, because the radiant yellow leaves of the vines are not translated into the correct tonal values. If you use the yellow filter function (figure 35–11), Photoshop translates the tonal values too much: The yellow tones become so bright that they totally burn out in the upper right and the sky becomes too dark compared to the effect of an analog yellow filter. The red filter function translates the tones even more excessively and the infrared function changes the image to a fully overexposed and blurred "something" that

Figure 35–10

Figure 35–11

Figure 35–12

has no resemblence to an image taken on infrared film (figure 35–12). Looking at the grape vines in detail (figure 35–13), you can notice that the excessive opening of the yellow channel has totally flatened the detailed texture in the yellow tones. Luckily, this is no serious problem, because when you use the yellow filter or infrared function, the menu with the six regulators appears and it is, therefore, easy to return the photo to the adequate, more natural looking tonal values that an analog yellow filter would impart to it.

Figure 35–13

The best solution for this image would be a user-defined conversion to black and white tonal values (figure 35–14): In this case, it is easy to increase the yellow channel moderately from 60% to 110%, and the green channel from 40% to 100%. On the other hand, reduce the blue channel from 20% to –35% to convert the image in such a way that the vibrant yellow tones of the leaves look just as bright as in the black and white picture without burning out or becoming blurred, and the darkened sky provides a dramatic contrast to the entire scene.

Photoshop's preset values work better when you do not use a polarizing filter, but in any case, their correlations are not 100% reliable with regard to adequately simulating the effect of analog color filters on black and white photographs. Just as before, you need expertise for regulating the tonal values of black and white photography with the new black and white conversion of Photoshop CS3.

Figure 35–14

Figure 35–15

Panoramic Photography with Photomerge of Photoshop CS3

The automated merging of several photos to create a panoramic image still left a lot to be desired in Photoshop CS2 and previous versions, as was already discussed in the chapter about panoramic photography. Fortunately, the merging of images works much better with Photoshop CS3.

Let's compare these three photos taken with a focal length of 280 mm from the same location with a tripod. I shot them so the photos would slightly overlap and the buildings would roughly have the same height. The exposures were also identical, and yet the photos have slightly different gray tones. This tonal difference is precisely what Photomerge (choose File /Automate) of Photoshop CS2 could not master. Looking at the image calculated with CS2 (figure 35–15), you clearly see seems between the pictures after they were stitched together. Even the merging of the architectural lines does not work perfectly. Before the merge, the individual images should have been manipulated to equalize their

Figure 35–16

Figure 35–17

brightness values. The Auto function of Photomerge in Photoshop CS3 calculates these same images much better (figure 35–15). The tonal values have been adapted to each other and the architectural lines have been stitched together almost perfectly. By cropping and slightly increasing the contrast in this photo, a quite acceptable panoramic photo (figure 35–16) (that did not even need a shift lens) is obtained.

Figure 35–18

Figure 35–19

Figure 35–20

Photoshop CS3 is also capable of stitching together images taken without shift lenses that Photomerge of CS2 still "refused" to tackle. The Munchenhaus Museum of Modern Art in Goslar (Germany) has been photographed here three times (figure 35–18 – figure 35–20) with the same 17 mm lens from three different locations. In each case, the camera was placed on the tripod at the same distance from the house facade and was positioned exactly parallel to it. It was also essential for the photos to overlap. First, the photos were stitched together using the Auto function of Photomerge, and the program did a clean job of merging the fine transitions together (see, for example, the curb or the half-timbered architecture)

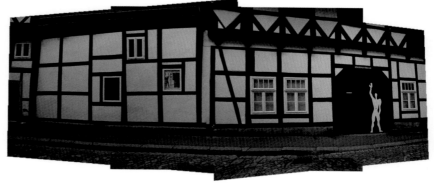

Figure 35–21

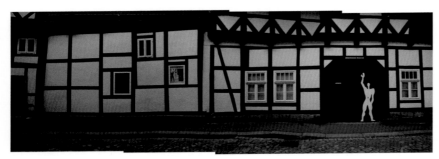

Figure 35–22

as opposed to the attempt with CS2 (figure 35–21). However, the new perspective reduces image size in the edges, but Photomerge of CS3 can also do the calculation, so the three photos are woven together parallel to each other and without noticeable changes in perspective. In these images, it works best with the "cylindrical" function if the field "reposition only" is checked. A surprisingly clean and good-looking photo is the final result (figure 35–22). In the image of this narrow street filled with medieval half-timbered houses, the combination of cropping and a slight increase in contrast presents a panoramic photo whose 8458 x 2995 pixels (i.e., over 25 million pixels) would permit a considerable enlargement (figure 35–23). End result: Panoramic photography really benefited from this new release of Photoshop.

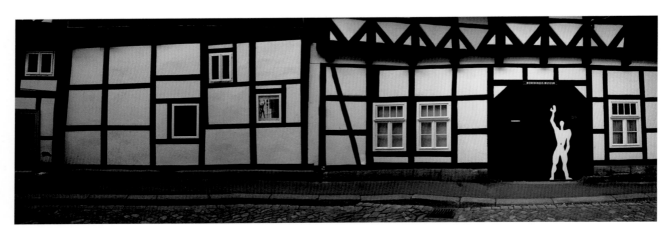

Figure 35–23

I now wish the reader a lot of fun in the creative aspects of black and white photography, which has maintained its relevance and persuasive power even in the digital age!

Torsten Andreas Hoffmann
www.t-a-hoffmann.de

Signed prints from this book can be ordered as premium fine art prints (ink-jet prints). Approximate size is 12 x 16 inches. For information on how to order, please contact me at: info@t-a-hoffmann.de